Franklin Jasper Walls Lectures

Franklin Jasper Walls, who died in 1963, bequeathed his residuary estate to The Pierpont Morgan Library to establish a lecture series in the fine arts, iconography, and archaeology, with the provision that the lectures be ultimately published in book form.

Throughout his life, Mr. Walls was interested in the fine arts and in the study of art history. When the Association of Fellows of The Pierpont Morgan Library was organized in 1949, he became one of the founding members. He was particularly concerned with the Library's lecture program and served on the Association's lecture committee. Without ever revealing his testamentary plans, he followed with keen attention the design and construction of the Library's new Lecture Hall, completed a few months before his death.

Professor Wilton-Ely's lectures, here printed in revised and expanded form, are the eleventh series of the Franklin Jasper Walls Lectures to be published.

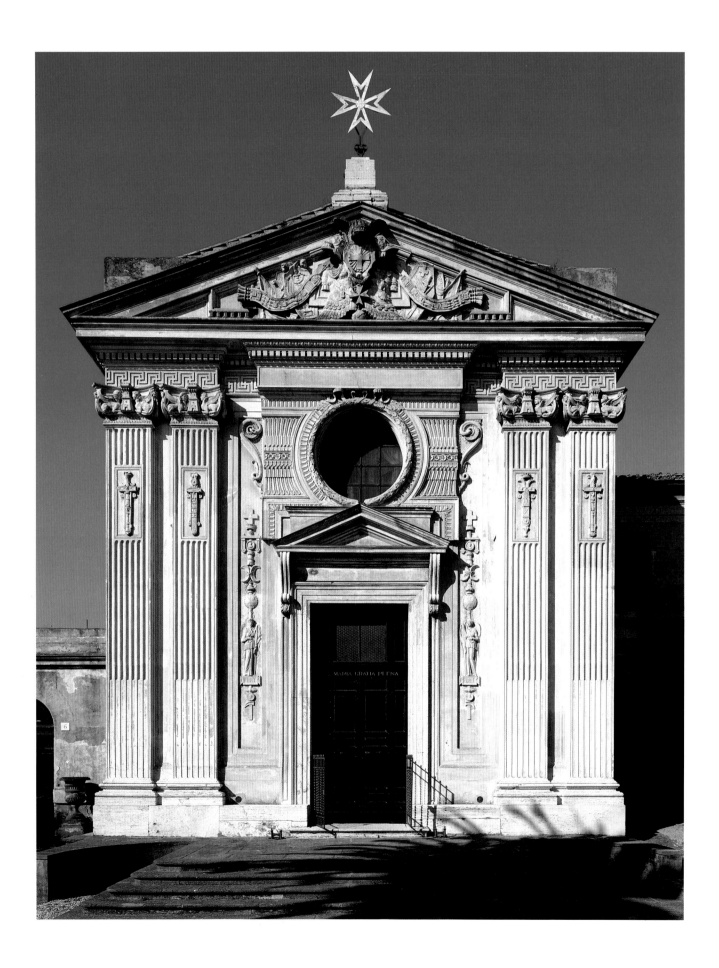

PIRANESI

as

Architect

and

Designer

John Wilton-Ely

The Pierpont Morgan Library
New York

Yale University Press
New Haven and London

To Felice Stampfle

Publication of this book was made possible by funds provided
by the Franklin Jasper Walls Lectures Series

frontispiece: Facade of S. Maria del Priorato, Rome

Library of Congress Catalogue Card Number 93-085191
ISBN 0–87598–099–6
ISBN 0–300–05382–7 (Yale)

Contents

Preface

When I was invited to deliver the Franklin Jasper Walls Lectures on Piranesi, there seemed no question that the Pierpont Morgan Library's unrivaled collection of the artist's drawings should feature prominently and that one particular aspect of the artist's multifarious genius should be discussed. In 1948, Felice Stampfle's magisterial catalogue of the Morgan's holdings of the artist's drawings (reissued in an expanded form in 1978) had already indicated Piranesi as a highly original and versatile designer in architecture and the decorative arts. During the bicentenary year of 1978 and the years to either side, a considerable amount of new literature had appeared, and by 1980 a reassessment of these particular aspects of Piranesi was well overdue. Moreover, nowhere other than New York could one study Piranesi's design process so thoroughly—given this dominant emphasis among the Morgan drawings—and other crucial material in the Avery Architectural Library at Columbia University.

It is with special gratitude that I wish to record the generous help and hospitality of the former director of the Morgan Library, Charles Ryskamp, his successor Charles E. Pierce, Jr., and the staff of the Library. I would like to record particular debts to Felice Stampfle, curator emerita, for her friendship, advice, and constant encouragement of my Piranesi studies, marked by my dedication of this book to her; also to Cara D. Denison for her ready support and guidance, along with her former colleagues, Herbert Cahoon, Helen B. Mules, and Christine Stenstrom; and to Kathleen Luhrs, Julianne Griffin, Mimi Hollanda, and Noah Chasin for their important contributions to the final stages of this book. I should also like to record my appreciation for the hospitality and privileges of the Avery Library, offered by Adolf Placzek, his successor Angela Giral, and their colleagues, especially Herbert Mitchell and Carol Falcione; matched by the welcome and resources of the Cooper-Hewitt Museum through the former curator of Decorative Arts, Elaine Evans Dee, as well as of the Department of Prints and Drawings at the Metropolitan Museum of Art under the late Jacob Bean.

My early work on the New York collections was also made possible by the British Academy, which awarded me a visiting fellowship at the Morgan Library in 1977. The final stages were accomplished, together with the delivery of the Walls

Lectures themselves, while I was a visiting member of the Institute for Advanced Study at Princeton in 1980. To the director and his colleagues, in particular Irving and Marilyn Lavin and to Homer Thompson, I owe debts of gratitude, especially for the stimulating interdisciplinary discussions that are an essential feature of that institution. Work on the lectures was also closely bound up in its early stages with my selection of material and preparation of the catalogue for the Piranesi Bicentenary Exhibition of 1978 at the Hayward Gallery, London. Much help was received from many friends and colleagues in this productive interchange of activities, but I should like to record specific debts to the following: Carlo Bertelli, Alessandro Bettagno, the late Anthony Blunt, Alan Braham, the late Anthony M. Clark, Howard Colvin, Frederick A. den Broeder, Pierre de la Ruffinière du Prey, Johannes Erichsen, John Fleming, Sir Brinsley Ford, Sven Gahlin, Eleanor Garvey, Alvar Gonzáles-Palacios, Alain-Charles Gruber, John Harris, Francis Haskell, the late Henry Russell-Hitchcock, the late Philip Hofer, Hugh Honour, Simon Houfe, David Irwin, the late Spiro Kostof, Suzanne Lang, Lesley Lewis, David Lipfert, the late Wolfgang Lotz, William L. MacDonald, Michael McCarthy, the late A. Hyatt Mayor, Thomas J. McCormick, Henry Millon, the late Peter Murray, Konrad Oberhuber, Werner Oechslin, the late Mario Praz, Nicholas Penny, Carlo Pietrangeli, John Pinto, Sir John Pope-Hennessy, Andrew Robison, Alistair Rowan, Joseph Rykwert, Janos Scholz, Jonathan Scott, Damie Stillman, the late Sir John Summerson, Peter Thornton, Principe Frà Toumanoff, the late David Udy, Arthur and Charlotte Vershbow, Anthony Vidler, Ulya Vogt-Göknil, Peter Ward-Jackson, David Watkin, the late Sir Francis Watson, Ben Weinreb, Margot Wittkower, Richard P. Wunder, and Silla Zamboni.

The final revisions to this text were greatly enhanced by the unique opportunity offered to me in 1992 by the American Academy in Rome to help produce the pioneering exhibition *Piranesi Architetto*. This was done with the collaboration of the then director, Joseph Connors, and his staff, especially Patricia Weaver, director of programs. It was also the first time that the larger part of Piranesi's surviving architectural drawings had been shown in Italy, thanks to the generosity of the Morgan and Avery libraries, as well as the Biblioteca Vaticana, which lent Borromini's designs for the Lateran. I owe many fresh insights to informal discussions with Joseph Connors and his colleagues, notably Elisabeth Kieven and Louise Rice, as well as to the seminar proceedings on the architectural history of the Lateran, arranged by the academy during the exhibition.

Finally to my wife and family, I wish to record a very special debt—one which can never be repaid—for their sustained encouragement, advice, and support during the production of an exceptionally demanding series of Piranesian commitments over the years.

London, January 1993

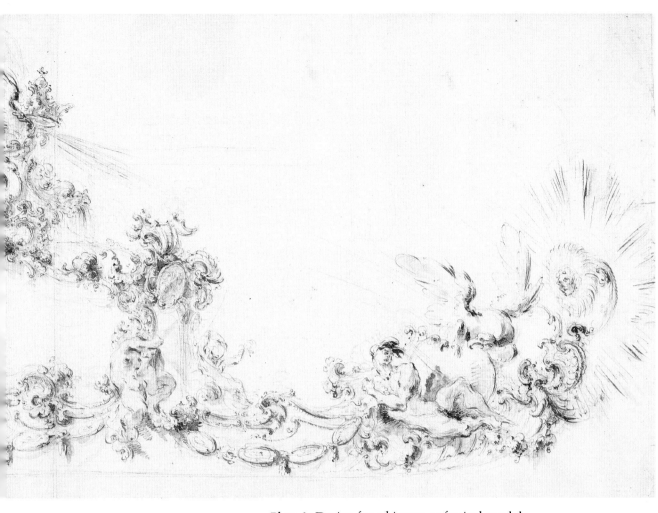

Plate 1. Design for a *bissona* or festival gondola.

Plate 2. Transverse section through the choir of the projected tribune for
S. Giovanni in Laterano (Drawing No. 15), 1764-67.

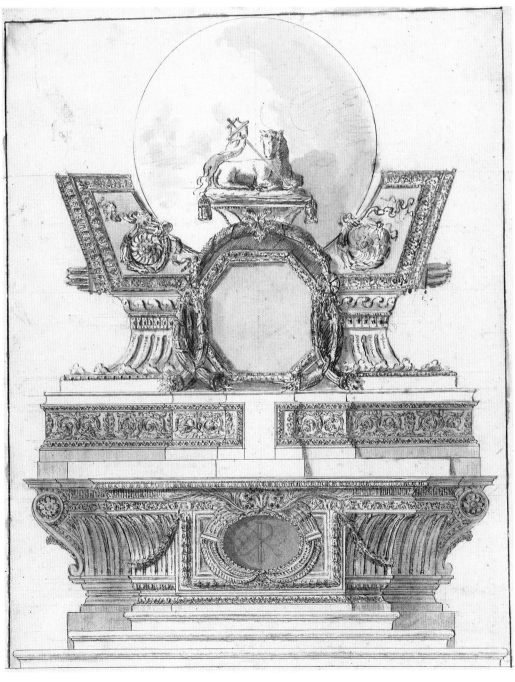

Plate 3. Design for high altar, S. Maria del Priorato, 1765-66.

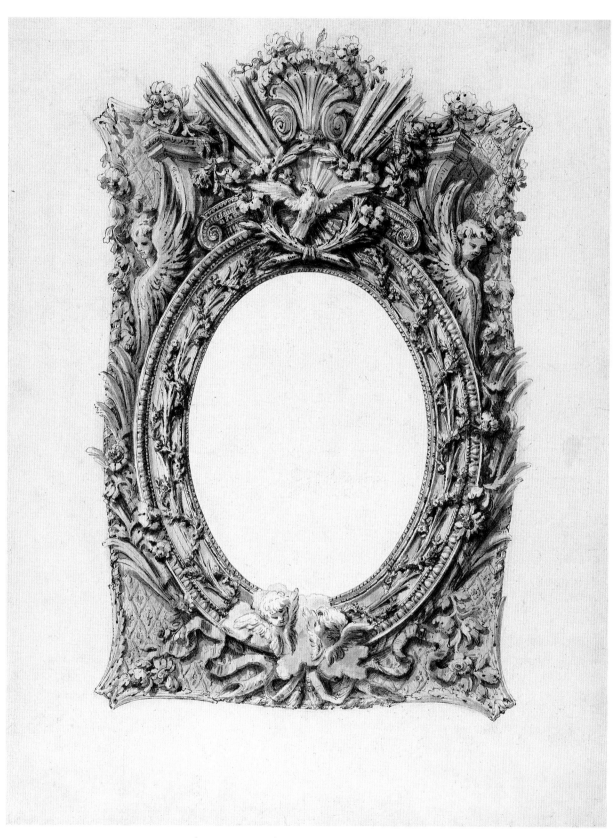

Plate 4. Design for a mirror frame.

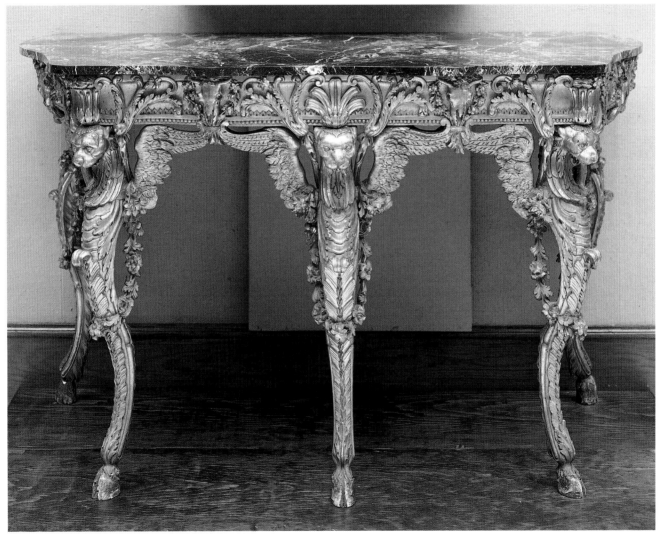

Plate 5. Side table for Cardinal Giovambattista Rezzonico, before 1769.

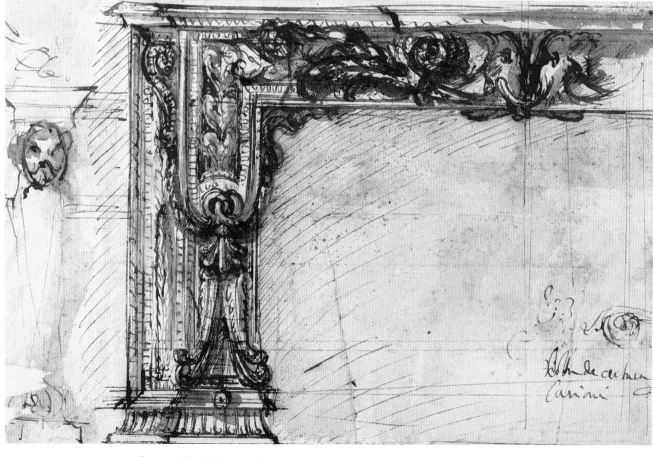

Plate 6. Sketch design for chimneypiece with confronted elephant heads.

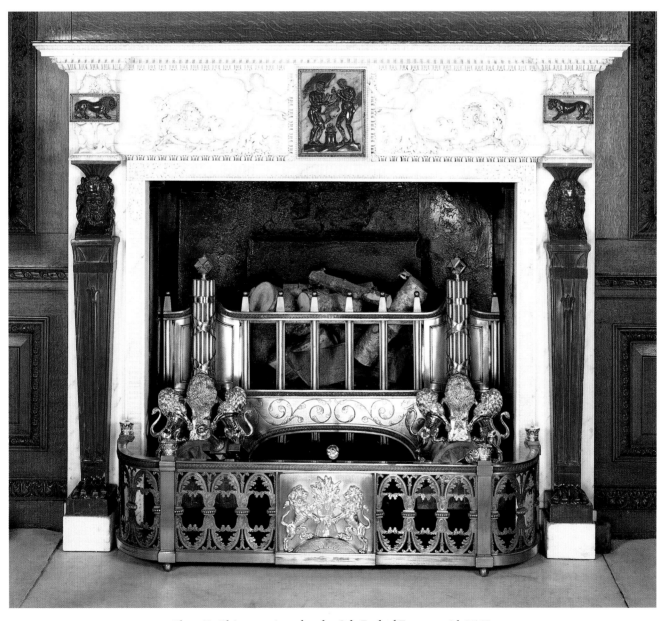

Plate 7. Chimneypiece for the 9th Earl of Exeter, mid-1760s.

Introduction

Piranesi requires no apologia as a key figure in European Neoclassicism. While his achievements as a topographical engraver and a graphic fantasist of genius have long been recognized, his roles as architect and versatile designer remain to be explored more fully. This book sets out to indicate certain lines of inquiry and to discuss the broader implications raised for late eighteenth-century art. Inevitably much still remains to be explored, for the very nature of Piranesi's importance lies in the oblique and often elusive course his ideas have taken through generations of European designers.

Despite the major pioneering studies of Werner Körte and Rudolf Wittkower, Piranesi's activities as a practicing architect have been largely neglected.[1] This is somewhat surprising given the dramatic reappearance in 1972 of a magnificent set of presentation drawings for the projected Lateran tribune, which confirmed Piranesi's ability to work out in comprehensive detail a particularly ambitious, richly ornate, and monumental scheme.[2] Similarly, Giuseppe Pelosini's rare working accounts for Piranesi's Aventine church and its related buildings (now together with the Lateran drawings in the Avery Library, Columbia University) demonstrate Piranesi's rigorous control throughout a building operation from basic matters of structure to the subtle refinements of ornamental vocabulary.[3] A unique group of drawings for this commission (now in the Pierpont Morgan Library, together with key preliminary studies for the Lateran scheme) also shows the same meticulous concern within the executed work.[4] However, since the lectures on which this text is based were delivered, the situation has been rectified further by the exhibition *Piranesi Architetto*, held in Rome in 1992.[5]

Recent recognition has also been given to Piranesi's significance as an architectural theorist and a source of powerful stimulus for the ideas of others. His catalytic role in the development of international Neoclassicism is being more fully appreciated through the reassessment of other innovative architects and designers, such as the Adam brothers, George Dance the Younger, and Soane; Boullée, Delafosse, and Ledoux; Gilly, Schinkel, and Klenze. A fresh understanding of this seminal function has been aided by the greater attention paid in recent years to Piranesi's published

writings which span some twenty-five years.[6] These texts—ranging from prefaces and explanatory passages in archaeological folios to polemical treatises—which emerged from the exchanges of the Graeco-Roman controversy, represent a considerable body of speculative discussion on the nature and philosophy of design. The need to evolve a contemporary system of expression from a widely based study, encompassing the imaginative riches of antiquity, is a central and consistent theme throughout these writings.

Piranesi's influence on the applied and decorative arts is perhaps the least recognized aspect of his contribution to European art. A few surviving works based on his own designs—the twin Rezzonico side tables, certain marble chimneypieces in Britain, Holland, and Spain, together with a quantity of imaginatively restored antiquities—represent his achievement as a practitioner. While the original setting of the tables, like his painted Egyptian scheme for the Caffè degli Inglesi, has long since vanished, of far greater consequence is Piranesi's attitude toward the entire integrated interior, with furniture and fittings, as a conscious attempt to project a contemporary style. In this latter respect, the considerable wealth of ideas represented in the Morgan Library's holdings, augmented in specific areas such as the ornamental chimneypiece designs from the Berlin Kunstbibliothek collection, is the theme of the closing part of this book.[7]

While the idea of invention through a wide-ranging study of the past was shared by contemporary theorists as diverse as Winckelmann and Reynolds, Piranesi's recognition of the creative function of fantasy in this process was rarely equaled. The sheer abundance of artistic ideas revealed by the Morgan Library's drawings—many of them outstanding examples of fine draughtsmanship in their own right—reveal an extensively speculative imagination at work. These conceptions were often at variance with the more orthodox attitudes of Piranesi's own time but were readily assimilated by those contemporaries who were prepared to embark on similar voyages of formal experiment. Piranesi himself was frequently prepared to risk censure and even ridicule for the sake of visual excitement and the opening up of new creative vistas for the imagination. In the words of a defiant motto selected from Sallust to ornament one of his more extravagant architectural designs (Fig. 54), "Novitatem meam contemnunt, ego illorum ignaviam" (They despise my novelty, I their timidity).[8]

Notes

1. Körte 1933; Wittkower 1975.

2. Nyberg 1972; Nyberg and Mitchell 1975.

3. Wittkower 1975.

4. Stampfle 1978.

5. Wilton-Ely and Connors 1992.

6. Wittkower [1938-39] 1975; Wilton-Ely 1972.

7. Fischer 1975.

8. The engraved composition with this quotation was added to Piranesi's *Parere su l'Architettura* (1765), shortly after 1767.

PIRANESI

as
Architect
and
Designer

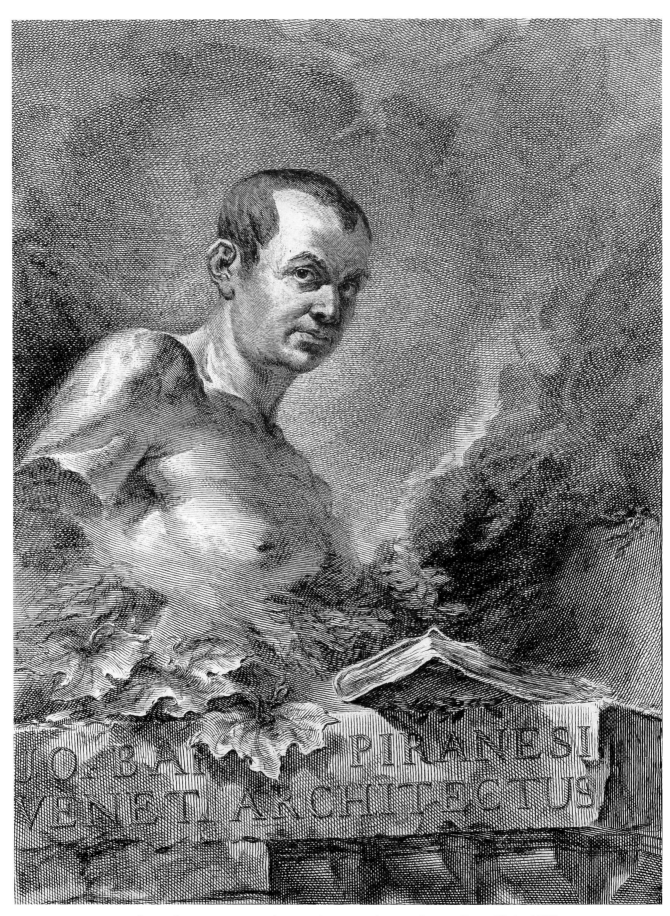

1. Felice Polanzani. Portrait of Piranesi as an antique sculpture. *Opere Varie,* 1750.

1

The Architectural
Fantasies

The key to understanding Giambattista Piranesi's strange originality and widespread influence over the visual arts during the second half of the eighteenth century lies in his insistence on being styled *architetto veneziano.* His initial training as an architect remained the controlling discipline throughout an immensely varied and productive career, while the early years in his native Venice provided many of the crucial influences in his formative development. Felice Polanzani's arresting portrait of the artist at the age of thirty in 1750 conveys the essential ambivalence of Piranesi's concerns—half modern man, half antique fragment—as a self-appointed interpreter of the creative genius of antiquity for modern designers (Fig. 1).[1] Indeed, the early years of Piranesi's career as a designer had already witnessed a fruitful interaction in his activities between the achievements of the past and the concerns of the present, also between an extremely thorough and practical understanding of building science and a lifelong concern with the imaginative potential of the capriccio (architectural fantasy) as a means of experiment and communication.

Piranesi was born in 1720 at Mogliano, near Mestre, on the Venetian terra firma, the son of a prosperous *tagliapietra* (stonemason) and master builder. The young Giambattista was clearly intended for an architectural career from the outset and was initially apprenticed to his maternal uncle Matteo Lucchesi, a leading architect and hydraulics engineer in the *Magistrato delle Acque.* This body was responsible for the Republic's harbor works and the construction of the vast *murazze*—the walls of cyclopean masonry protecting the Venetian lagoon from the predatory Adriatic.[2] Piranesi's family came originally from Piran in Istria, source of the fine white limestone used to build monumental Venice. Indeed, the handling of stone, together with

a practical concern for the properties of all building materials, remained at the heart of his approach to architecture, despite the extravagances of his imagination.

After certain sharp differences of opinion with his uncle (an irascible temper and quarrelsome nature seem also to have been characteristic of the young designer), Giambattista transferred to the studio of Lucchesi's colleague Giovanni Scalfurotto, where he may have played a modest part in the final stages of the latter's church, S. Simeone Piccolo on the Grand Canal, constructed between 1718 and 1738 (Fig. 2).[3] This building, with its austere geometric forms, exemplifies the strong conservatism of eighteenth-century Venice in the face of the Baroque. It also demonstrates the persistence of Vitruvian and Palladian formulae of classical design in the Republic.

Also during these initial years, according to Piranesi's early biographers, he was trained in stage design. Although this was a normal part of architectural practice, especially in a city of many theaters and opera houses, this discipline was to be of crucial importance in his development. While studying under the Valeriani brothers and the perspective expert Carlo Zucchi, Piranesi was clearly familiar with the innovations of the celebrated Bibiena family, especially the scenic device of *scena per angolo.* This revolutionary concept, whereby the traditional center viewpoint was abandoned in favor of several diagonal axes opening up a succession of vistas, offered limitless possibilities for exploring and defining architectural space.[4] The imaginative outlets and experimental field of design provided by the baroque stage were further reinforced by the properties of the engraved architectural fantasy, developed in early

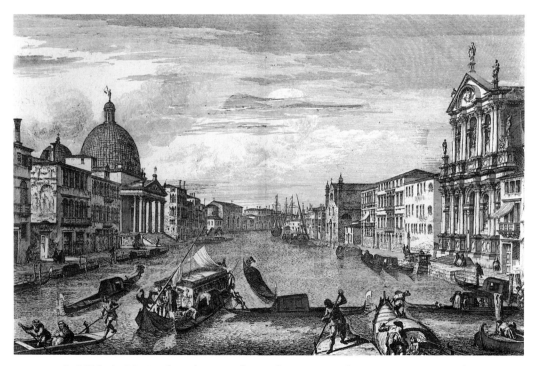

2. Michele Marieschi. The Grand Canal, Venice, with SS. Simeone e Giuda
(S. Simeone Piccolo) on the left, 1741.

eighteenth-century Venice by Marco Ricci and later given fresh dimensions of expression by topographical artists such as Canaletto.

From the start, the architecture and engineering of classical antiquity provided a focus of vigorous debate in the circle of Lucchesi, and lively exchanges were conducted with the Veronese antiquary Scipione Maffei. Dominant in Venice at this time were the highly iconoclastic teachings of the priest Carlo Lodoli, who attacked the entire basis of Vitruvian theories of design and directed attention to the indigenous roots of Roman civilization in the Etruscans—a race particularly admired for their functional uses of stone.[5] A practical study of local Roman remains was the outcome of these discussions, and Giambattista may have accompanied Scalfurotto when he assisted the architect Tommaso Temanza in measuring the Bridge of Augustus at Rimini, as eventually published in the latter's *Antichità di Rimini* of 1741.

Piranesi's imagination was already directed toward Rome during his Venetian years, for we are told how he was brought up on the heroic legends and achievements of antiquity by his uncle Angelo, a Carthusian monk.[6] Thus, well before his first sight of the Eternal City in 1740, Giambattista's mind was filled with visions of imperial splendor and magnificence which were to remain indelibly impressed on his mind for the rest of his life.

When he was given a chance to visit Rome as a draughtsman in the retinue of the ambassador Marco Foscarini in 1740, his new experiences were to prove both exhilarating and frustrating. On the one hand, a confrontation with the vast fragments of antiquity and the majesty of the early Christian basilicas, set within the scenic townscape of the baroque city, acted as a powerful stimulus to his imagination. On the other hand, there was little employment for a young architect with ambitions since the city was then at the end of a considerable building boom that had produced de Sanctis's Spanish Steps, Galilei's Lateran facade, Fuga's Palazzo della Consulta and the facade of S. Maria Maggiore, as well as the start of work on Salvi's Fontana di Trevi.[7] Leading architects such as Vanvitelli and Salvi (both of whom Piranesi met through his first patron, the Venetian builder Nicola Giobbe) had begun to look elsewhere for commissions.[8] Except for the works of these masters, the contemporary building scene evidently did not inspire Piranesi, who was thus thrown back on the resources of his own imaginative world. To gain an immediate livelihood, however, he entered the studio of the Sicilian engraver Giuseppe Vasi, the leading purveyor of souvenir views to the growing number of visitors to Rome, especially the British nobility on the grand tour.

During the early 1740s Piranesi collaborated on a series of small plates for a guide book to the city. These earliest essays already showed a keen sense of the painterly possibilities of the etching medium and the values of descriptive lighting in comparison with the neat linear work of his master.[9] Piranesi also possessed a far greater sense of urban space and the topography of Rome than colleagues such as the French

designer Legeay.[10] Acts of imaginative interpretation, however, were to be of far greater concern to Piranesi than conventional topographical views, and the painted architectural fantasies of Gian Paolo Pannini provided a considerable stimulus.[11]

While Pannini's outstanding skills were directed toward combining celebrated monuments in unfamiliar combinations, Piranesi regarded the capriccio both as a way of creative release and as a means of formal experiment. While his earliest surviving sketches show an understandable reliance on Venetian and Palladian motifs, his speculative processes were enriched by predecessors in archaeological reconstruction such as Fischer von Erlach, as testified by two sheets of studies taken from that architect's *Historical Architecture* of 1721 (Fig. 3).[12]

The first considered results of these investigations was a suite of thirteen plates, published in 1743 as the initial installment of an architectural treatise, *Prima Parte di Architetture e Prospettive,* dedicated to Nicola Giobbe, who had offered the young architect the use of his ample library.[13] The author's intentions were made clear in the dedication, where he asserted:

> These speaking ruins have filled my spirit with images that accurate drawings, even such as those of the immortal Palladio, could never have succeeded in conveying, though I always kept them before my eyes. Therefore, having the idea of presenting to the world some of these images, but not hoping for an architect of these times who could effectively execute some of them—whether for fault of architecture itself, fallen from the highest perfection to which it had risen in the period of the greatest splendor of the Roman Republic and in the times of the all-powerful emperors who succeeded it; or whether the fault of those who should have been patrons of this most noble art. The fact is that in our own time we have not seen buildings equaling the cost of a Forum of Nerva, of an Amphitheatre of Vespasian, or of a Palace of Nero; therefore, there seems to be no recourse than for me or some other modern architect to explain his ideas through his drawings, and so to take away from sculpture and painting the advantage that, as the great Juvarra has said, they now have here over architecture, and similarly to take it [architecture] away from the abuse of those with the money, who make us believe that they themselves are able to control the execution of architecture.[14]

The professional thoroughness with which Piranesi approached the composition of these plates, largely of complete structures but accompanied by a few plates of picturesque ruins in the style of Ricci, is demonstrated by the few surviving drawings of these years. To select one theme—the columnar hall—we find that an early stage in design, represented in the Morgan Library collection (Fig. 4), which clearly originated from Palladio's Venetian church Il Redentore, is first worked out in a sketch plan

3. Sheet of sketches after Fischer von Erlach's *Entwurff
einer historischen Architektur,* 1721.

(British Museum), enabling an effective scenic viewpoint to be selected.[15] The composition for the resulting plate, *Entrance to an ancient temple* (*"Vestibolo d'un antico Tempio,"* Fig. 5), is established in an incomplete design (also in the British Museum) while the final solution, according to Piranesi's acknowledged practice, was probably resolved in the actual process of etching the plate.[16]

The speed with which Piranesi's reconstructive imagination matured during these years is shown by juxtaposing the *Entrance to an ancient temple* interior with that of the sublime *Temple of Vesta* (*"Tempio Antico,"* Fig. 6). Equally striking is the swift development from the etched plate, *Ancient Capitol* (*Campidoglio Antico,* Fig. 7), derived from stage designs in Giuseppe Bibiena's *Architetture e Prospettive* of 1740, to the visionary fantasy drawing on a similar theme in the Morgan Library (Fig. 8).[17] This impressive development is paralleled by comparing the temple in the same *Ancient Capitol* plate with one of the most outstanding and influential plates

4. Interior view of a basilica.

5. Entrance to an ancient temple. *Prima Parte,* 1743.

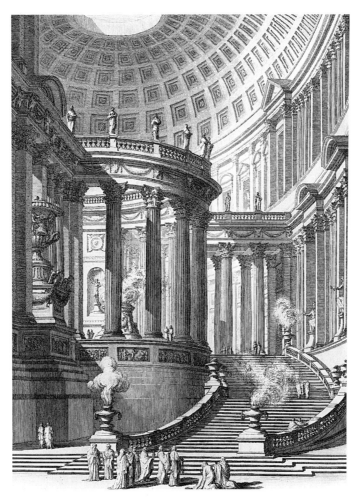

6. Temple of Vesta. *Prima Parte.*

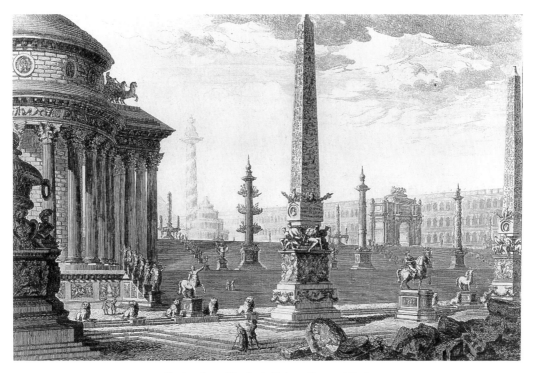

7. Ancient Capitol. *Prima Parte,* 1743.

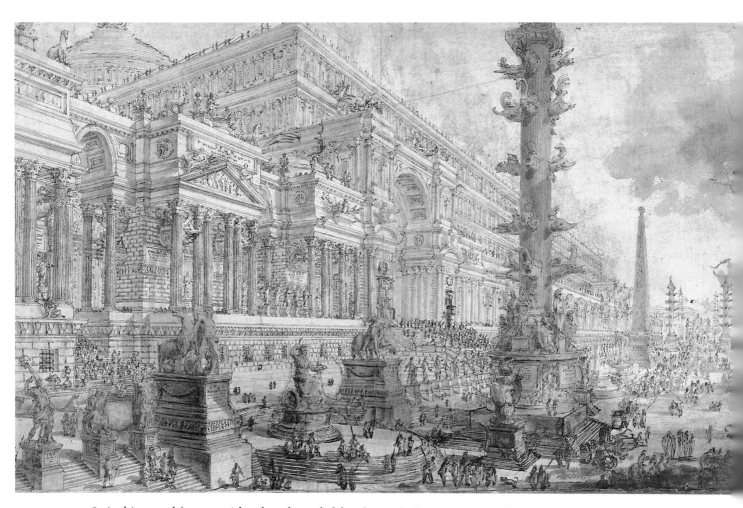

8. Architectural fantasy with colossal arcaded facade overlooking a piazza with monuments.

of the *Prima Parte, Ancient Mausoleum ("Mausoleo antico,"* Fig. 9). The surviving drawing in Edinburgh (the same size as the plate but in reverse, Fig. 10) shows how the young designer has assimilated the extremely idiosyncratic forms of Borromini, whom he already recognized as a forerunner in the creative transformation of the past.[18]

Shortly after publishing the *Prima Parte,* Piranesi made a brief excursion south, around 1743 or 1744, primarily to visit the sensational excavations at Herculaneum, which were already beginning to challenge conventional views of antiquity. Although the site was still largely underground and intentionally shrouded in secrecy, it was becoming clear that a whole new range of antique achievements was to be revealed by the spade. It was Camillo Paderni, future curator of the museum containing the finds at Portici, who suggested to Piranesi that his vocation lay in illustrating archaeological discoveries through compelling images.[19]

Piranesi's financial resources, however, were now running out, and by 1744 he was back in Venice where his first activities as a decorative designer are recorded.[20] While no trace has so far been found of the palace interiors he is said to have produced, there is in the Morgan Library collection a unique group of some half a dozen designs produced at this time in the contemporary idiom of the rococo, displaying a new fluency and imaginative breadth (Fig. 11).[21] The chef d'oeuvre—indeed, arguably one of the finest drawings Piranesi ever produced—is the red chalk design for a cere-

9. Ancient Mausoleum. *Prima Parte,* 1743.

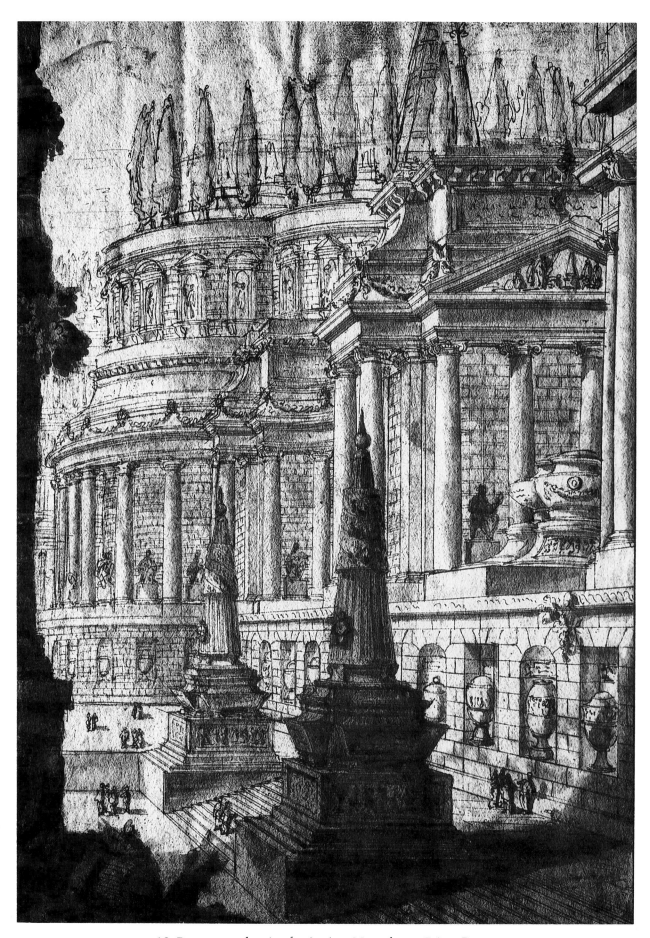

10. Preparatory drawing for Ancient Mausoleum. *Prima Parte*.

monial *bissona* (gondola, color plate 1) as featured in the glittering festivals recorded by Canaletto on the Grand Canal.[22] When compared to a similar subject by Francesco Guardi, however, Piranesi's version is clearly a scherzo on the theme of a navigable craft.[23] As Hylton Thomas observes, "the motifs incorporated into the design are extraordinarily abundant in number and variety, and each echos or balances another with the exquisite precision and buoyant harmony of a Mozart quartet."[24] Reluctant to waste a good design, Piranesi recognized that this creation might at least be mobile, and we find the *bissona* only a few years later transformed into an exuberant coach in front of St. Peter's, etched in a *veduta.*[25]

The new imaginative freedom and fluency of execution in Piranesi's work are clearly indebted to the stimulus of Giambattista Tiepolo, then at the height of his powers in Venice, and are shown in Piranesi's *Grotteschi*, a suite of four etched fantasies executed at about this time. Unlike Tiepolo's *Vari Capricci*, there appears a more serious mood in Piranesi's compositions which, in the context of his later works, may be seen to symbolize the properties of rejuvenation that he saw continually emerging from the decay of Roman antiquity.[26]

After a further return visit to Venice, Piranesi was back in Rome in 1747 with a commission to sell prints for the Venetian dealer Giuseppe Wagner. There he came

11. Design for wall panel.

into contact with the stage designs of Filippo Juvarra for Cardinal Ottoboni's theater in the Cancelleria. Among Piranesi's drawings in the British Museum are some extremely free interpretations of Juvarra's sets for the Filippo Amadei opera *Teodosio il Giovane* (Fig. 12).[27] At this particular point in Piranesi's career a new imaginative frenzy appears in certain architectural fantasies showing explicit features of stage design. Exemplary are the drawing for a theatrical spectacular (now in Paris, Fig. 13) and the rejected plate for *The Fall of Phaeton,* which is among Piranesi's other plates in the Calcografia Nazionale, Rome.[28] It is in the context of this renewed interest in the theater's potential to promote experiments that the celebrated plates of the *Carceri* (Prisons of the Imagination) make their first appearance around 1749.[29] Significantly entitled *Invenzioni capric* [capricci] *di Carceri,* these fourteen plates represent a series of visual and graphic explorations on a given theme. In itself, the choice of subject is unexceptional for the time since the prison scene was a favorite theme in theater design and is found in the work of the Ricci, Juvarra, the Bibienas, and more recently in the designs of Vanvitelli.[30] Indeed, Piranesi himself had included a Bibienesque *Dark Prison (Carcere Obscura)* a few years earlier in the *Prima Parte.* But the unparalleled freedom of etching here matches the daring spatial play of an architect escaping from the limitations of conventional perspective. The *Carceri* are intimately related to his current interests in the architectural fantasy as a means of formal analysis, and this is effectively shown by the transformation of a palace composition, represented by a drawing in the British Museum (Fig. 14), into Plate XI (Fig. 15).[31]

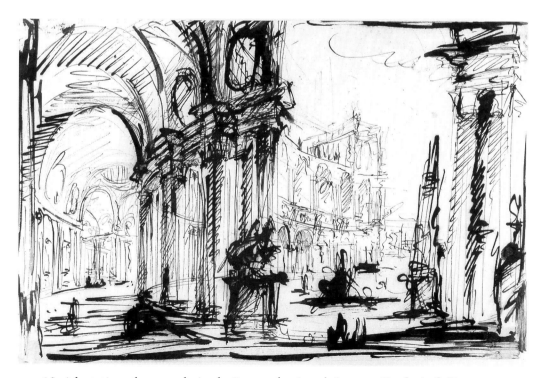

12. Adaptation of a stage design by Juvarra for Amadei's opera *Teodosio il Giovane.*

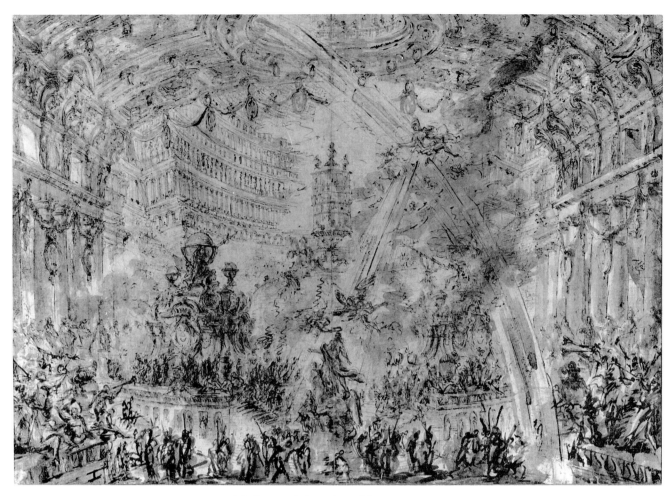

13. Fantastic interior with monuments.

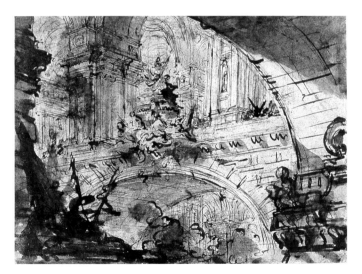

14. Palatial vaulted interior with arch.

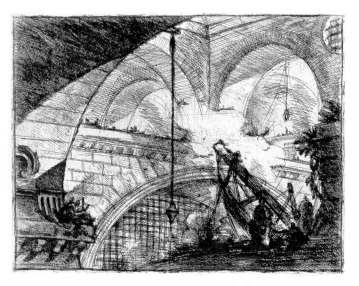

15. Prison interior with arch and shell ornament.
Carceri, 1749 edition, pl. XI.

Since the *Carceri* are products of a complex dialogue between Piranesi the trained constructor of monumental masonry and Piranesi the creator of spatial illusion, it is particularly valuable to be able to plot more precisely the intermediate stages in the evolution of another *Carceri* plate. Taking as an armature a composition suggested by a vast Roman engineering structure (such as the underground reservoir at Albano, Fig. 16), a design at Hamburg states the basic forms—an interlocking system of massive arches entered by a staircase and connected by galleries and wooden gangways.[32] A magnificent study at Edinburgh focuses on the lefthand side of the composition (in reverse to the final print, Fig. 17) and includes such architectural features as the gothic arch and abruptly turning staircase.[33] Vibrant passages of Tiepolesque wash are used to register highly atmospheric effects. By this stage the artist has begun to set up a range of spatial ambiguities, making the final product, which is resolved in a British Museum drawing (Fig. 18), into a highly sophisticated game of contradictory architectural statements (Fig. 19).[34]

While maintaining his livelihood as a view engraver, Piranesi was developing the

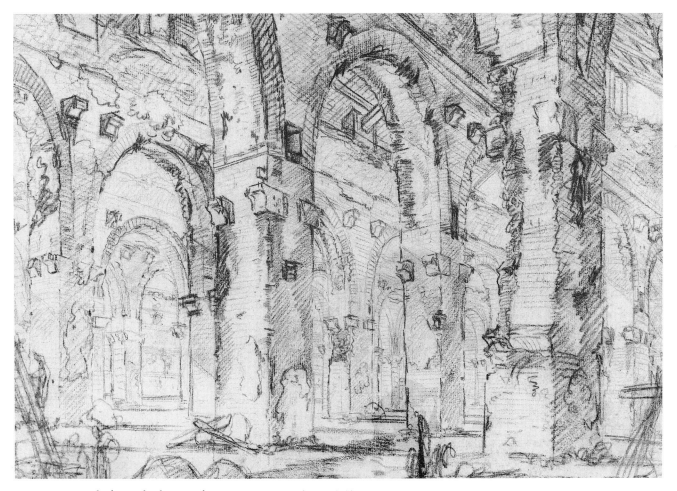

16. Study for etched view of a cistern at Castel Gandolfo. *Antichità d'Albano e di Castelgandolfo,* 1764.

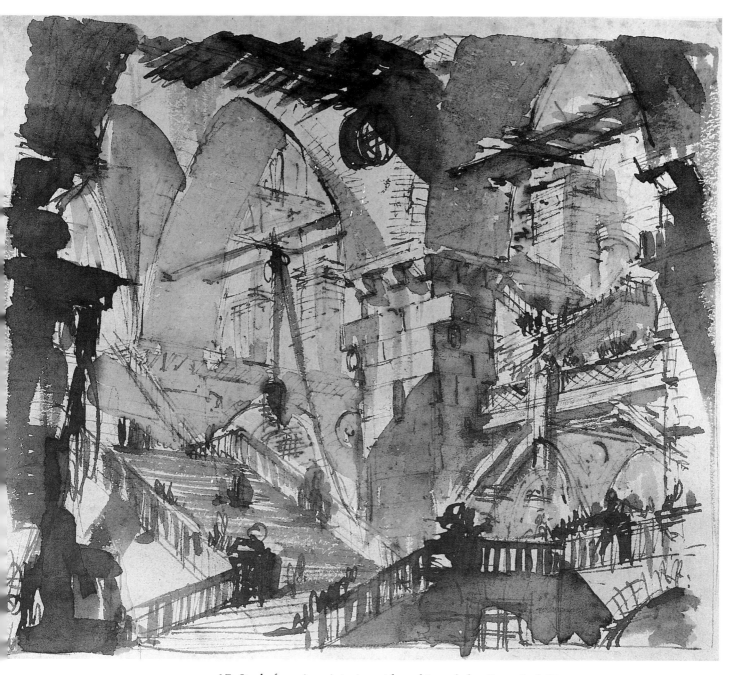

17. Study for prison interior with gothic arch for *Carceri*, pl. XIV.

veduta with his unique powers of architectural perception. A wealth of factual infor-
mation, not only in terms of volume and topographical setting but also in the precise
accidents of physical deterioration, is conveyed within a language of theatrical inten-
sity as shown, for example, in his plate of the Arch of Janus (Fig. 20). These small
plates, known as the *Archi Trionfali,* and published in 1748, soon became inadequate
to convey the range of information perceived. Around this time, in order to satisfy
his architectural appetite, Piranesi inaugurated the series of larger plates of the
Vedute di Roma that were to appear individually throughout his remaining thirty
years. In several of these he returned to the subjects of his early small plates (Fig. 21).

By the middle of the century Rome had become the center of artistic and intellec-
tual ideas regarding the nature of antiquity—today characterized by the movement

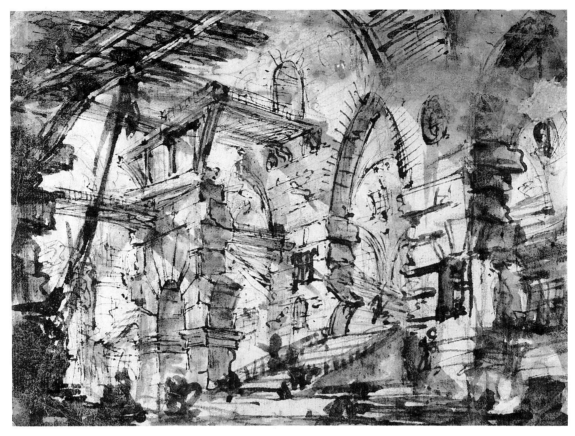

18. Study for prison interior with gothic arch for *Carceri,* pl. XIV.

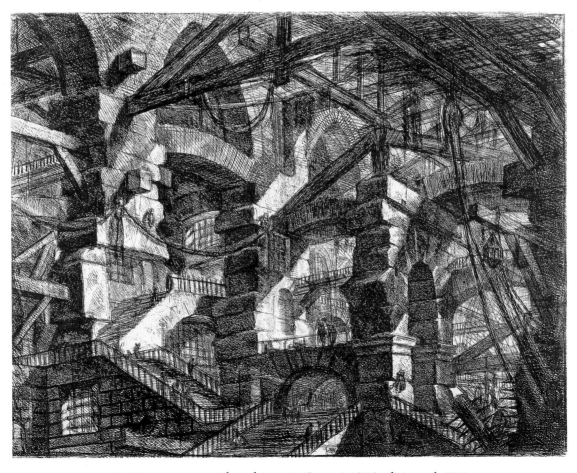

19. Prison interior with gothic arch. *Carceri,* 1749 edition, pl. XIV.

20. The Arch of Janus Quadrifrons. *Archi Trionfali,* 1748.

21. The Arch of Janus with the Arch of the Moneychangers. *Vedute di Roma,* ca. 1770-71.

known as Neoclassicism. A progressive circle of architectural thought had emerged at the French Academy at Palazzo Mancini, then located in the Corso opposite Piranesi's printselling business, and he soon became closely involved in its discussions and experiments. The student pensionnaires were frequently given the task of constructing festival architecture, as occasionally shown in Pannini's *vedute.* However, the late baroque language of these ceremonial structures and painted backcloths was dramatically discarded in 1746 when Louis-Joseph Le Lorrain's *Temple of Minerva* for the Festival of the Chinea (Fig. 22) introduced a novel austerity in expression and stressed new functional concerns in its columnar forms.[35] This and certain other such works were clearly indebted to the catalytic force of Piranesi's earlier fantasies, especially the *Mausoleum* of the *Prima Parte* issued only a few years earlier (see Fig. 9).

Piranesi, meanwhile, continued to pursue his concern with the exploratory fantasy, especially on the theme of centrally planned structures involving colonnades and interrelated systems of monumental staircases. The end result was a particularly elaborate ideal plan, issued in the composite publication O*pere Varie* in 1750, and entitled *Plan for a Magnificent College* (Fig. 23). This exercise in spatial ingenuity was derived from a formidable range of sources including imperial Roman planning as well as more recent works such as Longhena's Venetian church, S. Maria della Salute. A recently discovered sketchbook in Italy indicates some of Piranesi's ideas taken from his surveys of the Roman baths and also suggests the influence of Ferdinando Sanfelice, whose complex baroque staircases Piranesi could have seen in Naples.[36]

Predictably, the ingenuity and sheer extravagance of the college plan was to provide a target for the censure of more conservative designers. For example, the British

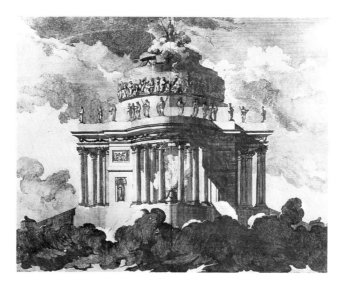

22. Louis-Joseph Le Lorrain. Engraved view of festival architecture
(Temple of Minerva) designed for the Festa della Chinea, 1746.

architect William Chambers, who had been in close contact with Piranesi while studying in Rome during the mid-1750s, was later to single out this particular work as a cautionary exemplar in the third edition of his *Treatise on Civil Architecture,* published in 1791:

> . . . a celebrated Italian artist whose taste and luxurance of fancy were unusu-
> ally great, and the effect of whose compositions on paper has seldom been
> equalled, knew little of construction or calculation, yet less of the con-
> trivance of habitable structures, or the modes of carrying real works into exe-
> cution, though styling himself an architect. And when some pensioners of
> the French Academy at Rome, in the Author's hearing, charged him with
> ignorance of plans, he composed a very complicated one, since published in
> his work; which sufficiently proves, that the charge was not altogether
> groundless.[37]

Despite certain adverse criticism from conservative designers such as Chambers, the *Magnificent College* was to prove to be of far-reaching importance in European neo-classical design as ideal planning became an established exercise. In 1753, within months of his arrival in Rome, the student pensionnaire Marie-Joseph Peyre had already developed the theme in his highly influential *Project for Academies* (Fig. 24), published in Paris a decade later, and the college plan may even have exercised some effect on Vanvitelli's vast scheme for the palace of Caserta.[38]

The *Opere Varie* also contained what is perhaps Piranesi's finest and most potent fantasy, the *Magnificent Port* (Fig. 25). This creation outdistanced his earlier compositions of the *Prima Parte,* with their residual Palladian character, in his growing ability to devise highly original compositions by extracting and amalgamating widely diverse classical motifs.[39] As with the college plan, this powerful eclecticism was to have a highly stimulating effect on the ideas of many contemporary designers, as rec-ognized even twenty years later by Horace-Walpole when decrying the sterile ele-gance of contemporary design:

> This delicate redundance of ornament growing into our architecture might
> perhaps be checked, if our artists would study the sublime dreams of
> Piranesi, who seems to have conceived visions of Rome beyond what it
> boasted even in the meridian of its splendor. Savage as Salvator Rosa, fierce as
> Michael Angelo, and exuberant as Rubens, he has imagined scenes that
> would startle geometry, and exhaust the Indies to realize. He piles palaces on
> bridges, and temples on palaces, and scales heaven with mountains of edi-
> fices. Yet what taste in his boldness! What grandeur in his wildness! what
> labour and thought both in his rashness and details![40]

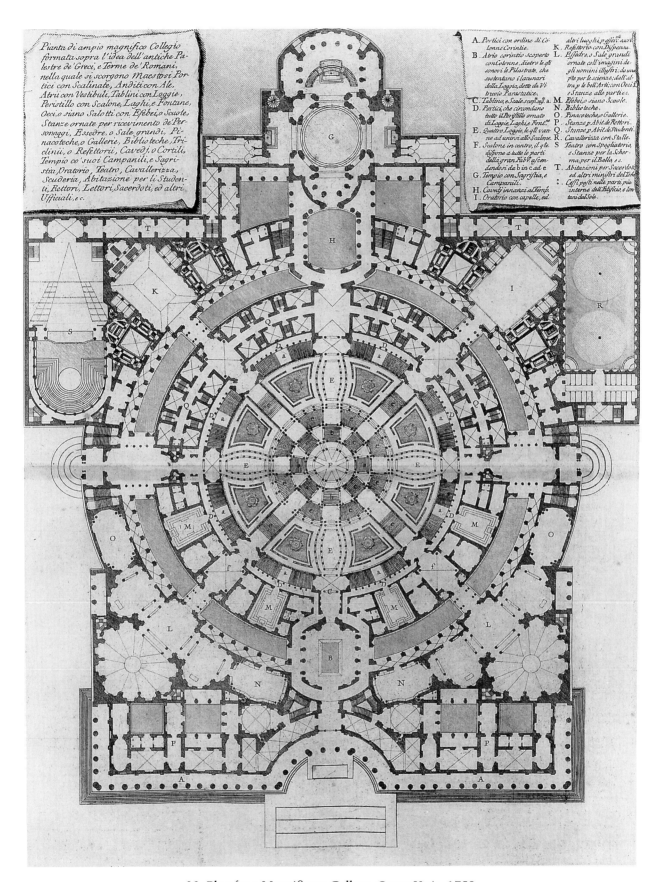

23. Plan for a Magnificent College. *Opere Varie*, 1750.

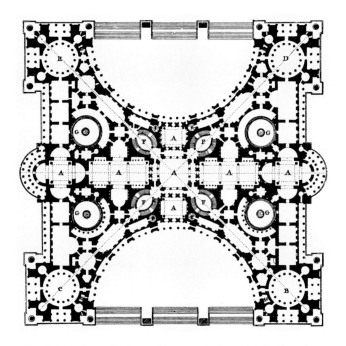

24. Marie-Joseph Peyre. Engraved plan of a *Project for Academies* (detail). *Oeuvres d'architecture*, 1765.

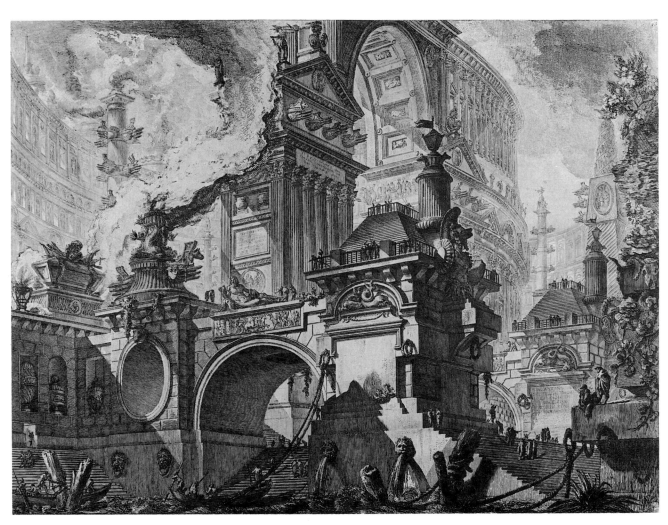

25. Magnificent Port. *Opere Varie.*

The impact of the *Magnificent Port* can be seen in a variety of visionary exercises by young designers of the French Academy, such as Charles Michel-Ange Challe.[41] For all his academic strictures, even William Chambers clearly owed much to Piranesi's compositional grandeur in designing his riverside facade to Somerset House, dramatized even further in Louis-Jean Desprez's magnificent perspective (Fig. 26), now in the collection of the Yale Center for British Art.[42]

However, the early career of the Scottish designer Robert Adam provided the most outstanding demonstration of the influence of Piranesi's fantasies. Arriving in Rome in 1755, Adam perceptively noted the value of the Venetian's imaginative exercises and subsequently returned to Britain with two drawings especially done for him by Piranesi (Fig. 27, now in Sir John Soane's Museum, London).[43] Writing to his family from Rome in June 1755 Adam referred to:

> So amazing and ingenious fancies as he [Piranesi] has produced in the differ-
> ent plans of the Temples, Baths and Palaces and other buildings I never saw,
> and are the greatest fund for inspiring and instilling invention in any lover of
> architecture that can be imagined. Chambers, who courted Piranesi's friend-
> ship with all the assiduity of a lover, never could bring him even to do a
> sketch of any one thing, and told me I would never be able to get anything

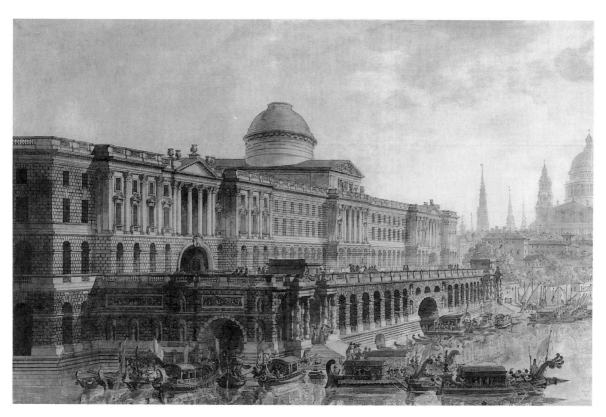

26. Louis-Jean Desprez. Idealized view of the river front of
Chambers's Somerset House, London (detail).

27. Imaginary architectural composition drawn for Robert Adam, 1755.

from him. So much is he out of his calculation that he [Piranesi] has told me that whatsoever I want of him he will do for me with pleasure, and is just now doing two drawings for me which will be both singular and clever.[44]

Adam, however, had also encountered the other side of Piranesi's character, and further observed that he "is of such disposition as bars all instruction, his ideas in locution so ill arranged, his expression so furious and fantastic, that a Venetian hint is all that can be got from him, never anything fixed or well-digested so that a quarter of an hour makes you sick of his company."[45]

The effect that Piranesi's visions had upon the evolution of Adam's own essays has been noted by Damie Stillman with respect to Adam's monumental visionary compositions (Fig. 28), now also in the Soane Museum.[46] Similarly, this can be seen in Adam's contemporary exercises in interior design (Fig. 29) where ingenious combinations of mannerist and baroque motifs incorporate late imperial forms. These were ultimately to exert a powerful influence on the Adam style of the 1760s as developed at Kedleston and Syon (see Fig. 56).[47] This fruitful evolution also owed much in compositional techniques and decorative refinement to the intervention of Adam's close associate Charles-Louis Clérisseau—himself originally schooled in this imaginative process by Piranesi while studying at the French Academy.[48]

During these years Piranesi had become deeply involved in archaeological investigation, less as a disinterested study than as a means of broadening the creative attitude of his contemporaries. In 1753 he published the folio *Trofei di Ottaviano*

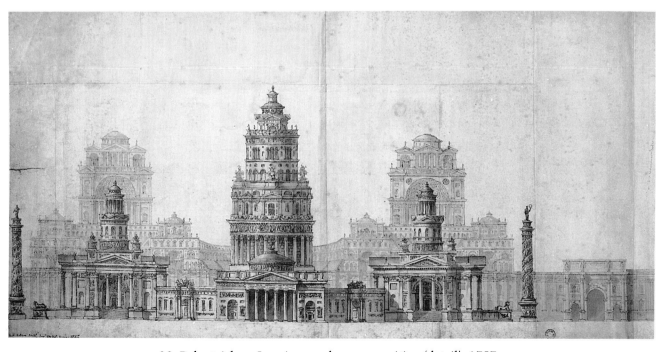

28. Robert Adam. Imaginary palace composition (detail), 1757.

29. Robert Adam and Charles-Louis Clérisseau. Imaginary
interior based on Roman baths, ca. 1755-57.

Augusto as "useful to Painters, Sculptors and Architects." This was followed in 1756, after some eight years of highly concentrated research, by the four volumes of the *Antichità Romane*. Containing over 500 illustrations carefully integrated into a comprehensive system of documentation with cross-references, the *Antichità* established Piranesi's reputation in European scholarship. A range of specialized techniques in illustration showed the remarkable innovations of an inquiring mind that combined a practical architectural understanding with outstanding imaginative powers of reconstruction.[49] In the initial plates Piranesi had reused earlier illustrations from the antiquary Francesco Bianchini's book on the tomb of the family of Augustus and the resulting comparison emphasizes the contrast between Bianchini's simple act of recording the past and the interpretative genius of Piranesi. Theatrical devices of perspective and lighting open up a ruined building and explain its structure and decorative character (Fig. 30). Elsewhere in the *Antichità*, visual techniques for revealing the constituent elements of structure as well as the decorative features of individual finds confirm the close scrutiny that Piranesi as an architect brought to bear on Roman civilization. Certain aspects of engineering—the surviving bridges of Rome, for example—are given particular prominence, and Piranesi's research was to have an important effect on contemporary bridge design both in France and England within the next two decades as exemplified by Robert Mylne's Blackfriars Bridge, London. Piranesi was to produce an etching in 1764 of Mylne's bridge under construction from a drawing supplied by the architect (Fig. 31).[50] On a broader level, his sheer

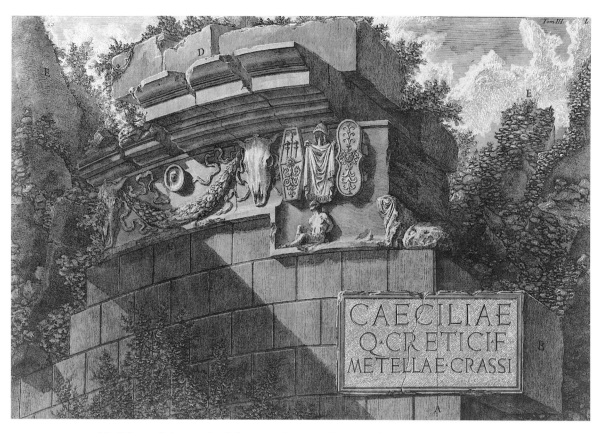

30. Frieze of the tomb of the Caecilia Metella. *Antichità Romane*, III, 1756.

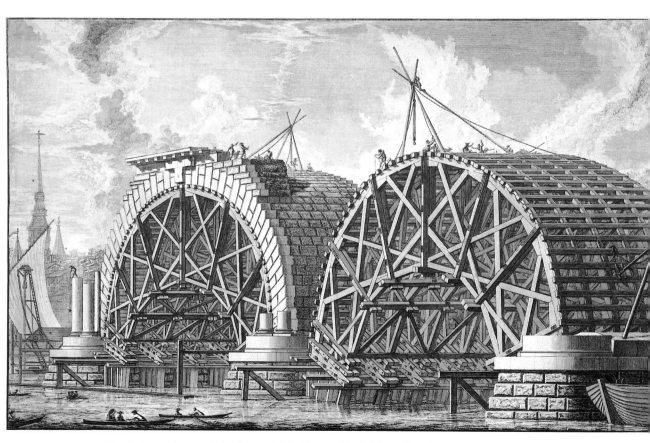

31. A view of part of the intended bridge at Blackfriars, London, in August
1764 by Robert Mylne, Architect, engraved by Piranesi at Rome.

grasp of the topographical nature of Rome enabled him, as no one before, to relate the considerable quantity of isolated fragments to the defensive and aqueduct systems of Rome.

Within this scholarly process, however, there are several striking instances of deliberate exaggeration that go well beyond the didactic objectives of the *Antichità*. For instance, the foundations of Hadrian's Mausoleum (later, the Castel Sant'Angelo, Fig. 32) are shown in superhuman scale and with extravagant complexity, while certain reconstructed plans are almost Borrominian in their sheer ingenuity (Fig. 33). These excesses can only be fully understood in the context of Piranesi's involvement in the Graeco-Roman debate as it developed in the 1750s. Here his artistic standpoint as well as his devotion to Rome were both under attack.

When they appeared in 1756, the four volumes of the *Antichità Romane* not only provided a comprehensive assessment of Roman architectural achievements and engineering, but offered modern architects a renewed challenge, first introduced by Piranesi some thirteen years earlier in the *Prima Parte*. In the preface he continued to be sharply critical of contemporary designers for failing to profit from the antique exemplars surrounding them, both in terms of sound construction and the repertoire of highly original forms.[51]

It was in this spirit that Piranesi introduced each volume with an elaborate capriccio as a secondary frontispiece. Significantly, the one celebrating the Roman genius for funerary monuments prefacing Volume II—a vision of the Via Appia (Fig. 34)—includes specific tributes to his artistic colleagues, Allan Ramsay, Robert Adam, and, initially, his patron Lord Charlemont. Although bearing little specific resemblance to the individual works illustrated in the succeeding plates—the tombs of Caecilia Metella or Lucius Arruntius, for example—the individual confections in Piranesi's fantasies follow the spirit of earlier attempts to re-create antiquity through bold acts of the imagination as the seventeenth-century scholars Giambattista Montano and Athanatius Kircher had done.[52] As seen in earlier instances, the preparatory design (British Museum) simply outlines the basic composition, allowing Piranesi to exercise his imagination while actually etching the plate. Similarly, the circus fantasy (Fig. 35), prefacing another selection of tombs and monuments in Volume III, is an equally impressive composition, dominated in the righthand foreground by one of his most ingenious creations and compiled from authentic yet widely scattered motifs.

However, the considerable industry and deep commitment represented by the *Antichità* was to lead to an extremely bitter quarrel, the outcome of which underlines Piranesi's theoretical and creative position by the mid-1750s. The young Irish peer James Caulfield, 1st Earl of Charlemont, during his brief stay in Rome in 1751, had undertaken the financing of part of the *Antichità* in its earlier stages.[53] His subsequent failure to provide the promised backing after returning to Ireland led Piranesi

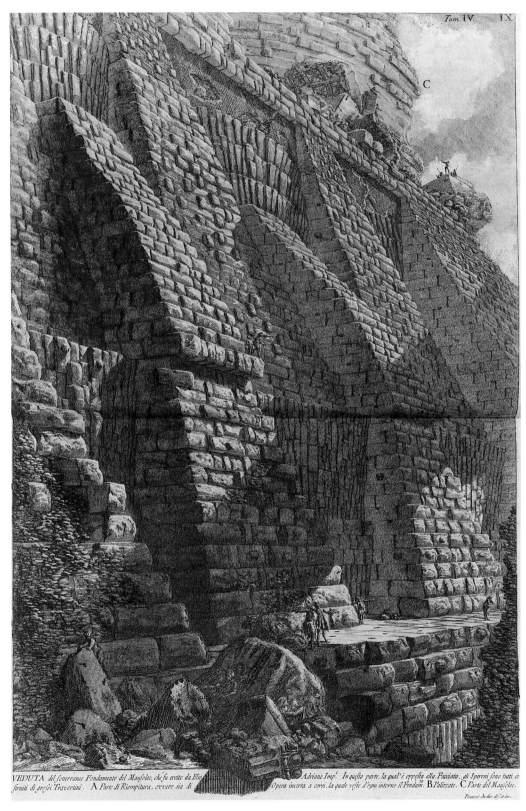

32. View of the foundations of Hadrian's Mausoleum
(later Castel Sant'Angelo). *Antichità Romane*, IV, 1756.

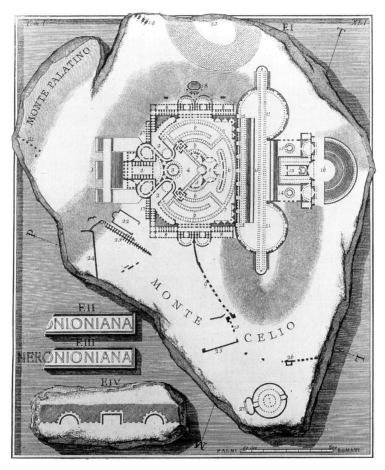

33. Reconstructed plan of the so-called Nymphaeum of Nero
(Temple of the Divine Claudius). *Antichità Romane,* II.

to send admonitory letters, none of which was answered. After a final ultimatum, the
artist erased the fulsome dedication to Charlemont from the frontispiece to Volume
I, together with most references to him in the others, and in a most unprecedented
step, published three letters together with a statement in his defense justifying his
action.[54] Copies of *Lettere di Giustificazione scritte a Milord Charlemont e a' di lui
Agenti,* issued in 1757, which included miniature versions of the original frontispiece
and the deleted portions, were sent to leading members of the art world as well as
some of Piranesi's colleagues.[55] The theme of the *Lettere,* which transcends the
somewhat tedious details of the affair, is the nobility of artistic reputation indepen-
dent of a patron's whim; it also celebrates the imperishable nature of art in terms of
the originality of the creator:

> I believe that I have completed a work which will pass on to posterity and
> which will endure so long as there are men curious to know the ruins which
> remain of the most famous city in the universe. . . . This work is not of the
> kind which remains buried in the crowded shelves of libraries. Its four folio

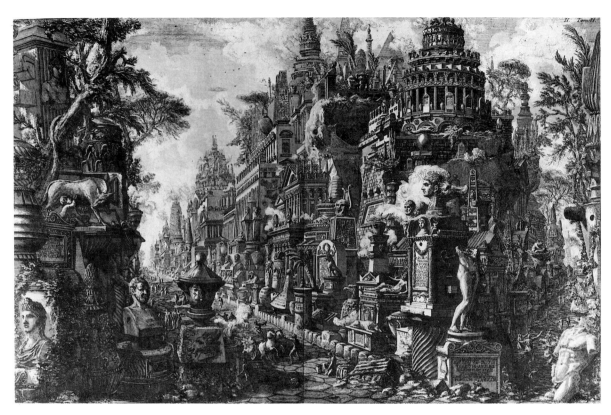

34. Fantasy of the Via Appia. *Antichità Romane,* II, 1756.

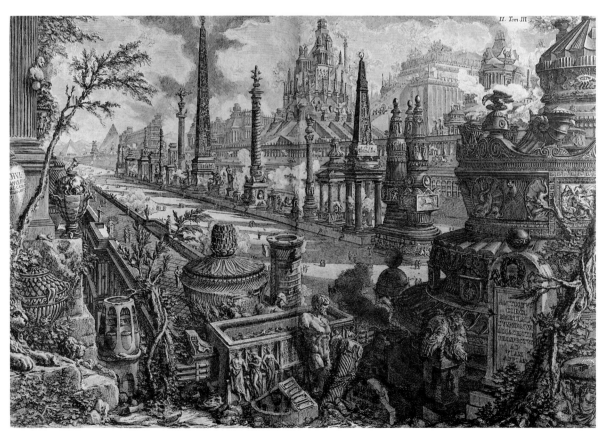

35. Fantasy of an imperial circus. *Antichità Romane,* III.

volumes comprise a new system of the monuments of ancient Rome. It will
be deposited in many public libraries throughout Europe, and in particular in
that of the Most Christian King. And there is reason to suppose that the
name of its author will pass on to posterity together with his work. . . . Is it
not a very unpleasant circumstance, then, that having invested my thoughts,
talents, work, and purse, that having laboured unceasingly for eight years to
make this work worthy of Your Lordship, I should now be insulted? . . . The
time has come, therefore, to think of saving my honour. Should I be forced to
suppress the Dedication, I beg Your Lordship not to take this as an offense
against your forebears, but as a reparation which is owed to me. For when the
story of my life is written, along with that of other artists, I do not want to
stand accused of having been a flatterer . . . who was held in low esteem even
by those on whom he lavished his praise. If Your Lordship do not loosen my
tongue, if you do not render me justice and protect me against calumny . . .
then I cannot, as a man of honour, or without making myself ridiculous, call
you a protector of the arts and myself an artist who received your protection.
And if I have seemed to call you so, in the seventy copies of my work which
have already been sold, then I must face the painful necessity of having to
accuse my own foolishness and of trying to vindicate myself before the
world. For I must ask you to bear in mind that, as a nobleman must consider
his ancestors, an artist who will leave his name to posterity must consider
his own reputation and that of his descendants. A nobleman is the latest of
his name, an artist the first of his; both must act with equal delicacy.[56]

The fantasy, as we have seen, represents a key factor not only in the *Antichità
Romane* but also in the *Lettere,* and embodies for Piranesi a statement of creative
intent. The very intensity with which he threw himself into the vendetta against
Charlemont and his agents also indicates the degree to which he had come to iden-
tify himself by the later 1750s with the material of his archaeological studies. An
attack on Rome had become, in effect, a personal affront to the artistic genius of
Rome reborn in Piranesi. This standpoint, as we shall see in the next chapter, was to
be reinforced as the artist became caught up in the Graeco-Roman controversy. This
new activity was to produce in its course the justification for a novel mode of design
which would emerge during the 1760s.

Notes

1. While likely to have been based on a
self-portrait drawing, this iconographi-
cally original image was etched by
Piranesi's compatriot Felice Polanzani,
who is said to have instructed him in
etching (Bianconi [1779] 1802, 128-29). It
first appeared as a frontispiece to the
Opere Varie (1750) and was reused for *Le
Antichità Romane,* I, 1756. The context
of this unique portrait is discussed in
Mercatelli 1991, 229-38.

2. Fresh light on Piranesi's early architec-
tural training and the intellectual ambi-
ence of the Venice in which he grew up
can be found in Rykwert 1980, 315-26.
The intellectual and artistic world of

early eighteenth-century Venice is also examined in Haskell [1963] 1980, Part III.

3. For Scalfurotto, S. Simeone Piccolo (S.S. Simeone e Giuda), and the architectural scene in Venice, see Rykwert 1980 and Bassi 1962, *passim,* and Wittkower 1973, 387.

4. While both Piranesi's early biographers refer to his training in stage design under Giuseppe and Domenico Valeriani, Legrand (1799) says this was in Venice (in Brunel 1978a, 223-24), while Bianconi (1802), admittedly the less reliable, says it was in Rome (127-28). Although it is unlikely that Piranesi also trained under the celebrated Ferdinando Bibiena, as Legrand states, he was clearly familiar with this designer's influential treatise *Architettura civile preparata su la Geometria* (1711), which sets forth the innovative principle of *scena per angolo.*

5. The polemical atmosphere of the Lucchesi circle, and particularly the dominant influence of Lodoli, is examined in Rykwert 1980, *passim.* See also Focillon [1918] 1967, xxv ff., and Kaufmann 1955.

6. Legrand [1799] in Brunel 1978a, 222.

7. For a discussion of the Roman architectural scene at the time of Piranesi's arrival, see Wittkower 1973, 246 ff., and even more extensively, Rykwert 1980, 338 ff., and Contardi and Curcio 1991, *passim.*

8. For Piranesi's relations with his first main patron in Rome, see Georges Brunel in Brunel 1978b, 77-146.

9. Piranesi's tense relationship with Vasi and subsequent rift with him are first mentioned in Legrand (1799, see Brunel 1978a, 223), and repeated by Bianconi (1802, see 128). Before leaving the studio, Piranesi may have contributed to Vasi's suite of *vedute* in *Le Magnificenza di Roma,* issued from 1747 onward (at least one plate exists, signed by them both), and he may also have had a hand in the preparatory drawing (Getty Museum, Santa Monica, Calif.) for Vasi's large panorama of Rome from the Janiculum, finally published in 1765. See Millon 1978, 345-54, and Wilton-Ely 1978b, 34 (65).

10. Piranesi's earliest engraved views belonged to a group of plates used to illustrate various guidebooks to Rome until the mid-1760s—many of the plates were etched by students at the French Academy in Rome, such as Duflos, Bellicard, and Legeay. For a comparison between Piranesi's works and those of Legeay and others, see Wilton-Ely 1978a, 26-27.

11. For Pannini's significance in Piranesi's development of capricci, see ibid., 31.

12. Stampfle 1978, nos. 17 and 18, xi, xxii-xxiii.

13. The complex history of the *Prima Parte* has been unraveled most recently in Robison 1986, *passim.* For the contents of Giobbe's library, see Brunel 1978b, 77 ff.

14. Translation from Nyberg, see Nyberg 1972, 117.

15. Central view of church interior, Stampfle 1978, No. A2, xxxii; sketch plan in British Museum, 1908-6-16-30, verso.

16. Unfinished sketch of Colonnaded Hall, British Museum, 1908-6-16-23. For discussion of finished plate and related drawings, see Wilton-Ely 1978b, 22; see also Robison 1986, 14-15.

17. G. Galli Bibiena, *Architetture, e Prospettive* (Augsburg, 1740); Stampfle 1978, No. A1, xxxii.

18. National Gallery of Scotland, Edinburgh, R. N. 964, see Andrews 1968, 55. The lasting inspiration of Borromini for Piranesi is discussed in Wilton-Ely 1978a, *passim,* and in Wilton-Ely and Connors 1992, *passim.* See also Chapter 3, note 11.

19. Legrand 1799 (in Brunel 1978a, 224).

20. Ibid., 225.

21. The unique groups of Venetian drawings in the Morgan Library collection are considered in Thomas 1954, 16-17, and Stampfle 1978, x.

22. Ibid., No. 10, x, xxii.

23. While Guardi's various drawings of *bissone* are far later in date than Piranesi's design, they serve to indicate the decorative tradition in which Piranesi's early work developed. See Shaw 1951, 73. See also Thomas 1954, 40.

24. Thomas 1954, 17.

25. Robison 1973, 389-92.

26. Literature analyzing the origins, dating, and significance of the four *Grotteschi* is substantial. For diverse interpretations, see Focillon [1918] 1967, xxv ff.; Scott 1975, 50-52; and Robison 1986, *passim.*

27. British Museum, 1908-6-16-46 (see also 1908-6-16-6/39). Thomas 1954, 43 (25). For Cardinal Ottoboni's theater in the Cancelleria and Juvarra's designs for it, see Scott 1975, 47; Wilton-Ely 1978a, 17-18.

28. "Apotheosis scene within a theatrical setting," Musée du Louvre, formerly collection of Société des Architectes Diplomés pour le Gouvernement, Paris. See Bacou 1971, 114-15 (143). The rejected plate, *The Fall of Phaeton,* is considered in Calvesi 1965, Focillon [1918] 1967, xxxii ff., and Robison 1986, 33-34, 56 notes 56-65.

29. For the considerable literature on the origins and dating of early plates of the *Carceri,* see Wilton-Ely 1978a, 81-91, 132, 298-300. Of prime importance are Vogt-Göknil 1958, Sekler 1962, and Robison 1986, *passim.*

30. Wilton-Ely 1979, 89, fig. 2; Robison 1986, 16-17, figs. 11-14.

31. British Museum, 1908-6-16-20. For further discussion of this see Sekler 1962.

32. Hamburger Kunsthalle, Kupferstich-kabinett (1915/648); Robison 1986, fig. 51.

33. National Gallery of Scotland, Edinburgh (RN 1858). See Andrews 1968, 95-96.

34. British Museum, 1908-6-16-8.

35. Recognition of the influence of the French Academy on the course of neoclassical architecture, particularly in connection with Piranesi's early fantasies, was first shown in Harris 1967, 189 ff., although the extent of Legeay's significance, in particular, is still questionable. For details of other activities of the pensionnaires in connection with festival architecture, see Wunder 1967, 354 ff.

36. Sources for the college plan are discussed in Wilton-Ely 1983a, 295. The preliminary ideas for this design in one of the recently discovered sketchbooks in the Biblioteca Estense at Modena are discussed in Cavicchi and Zamboni 1983, 188-91. For information on the elaborate staircases of Sanfelice in Naples, the author is indebted to Alistair Ward.

37. William Chambers, *Treatise on the Decorative Part of Civil Architecture* (London, 1791), Introduction, p. 10. See also Harris 1970, *passim*.

38. Braham 1980, 83-85. Piranesi's possible influence on Vanvitelli's plan for Caserta is suggested in Wilton-Ely 1979, 91-92. This relationship is more extensively explored in De Seta 1981, 19 ff.

39. The genesis of what is perhaps Piranesi's most ambitious etched fantasy is still uncertain since there is little to rival this immense effect of grandeur in preceding works, either drawn or engraved. See Wilton-Ely, in 1978b, 27; Robison 1986, 33-37.

40. Horace Walpole, *Anecdotes of Painting*, 4th edition (London, 1786), IV, "Advertisement," 398.

41. For Piranesi's impact on Challe and other pensionnaires, see Harris 1967 and Wunder 1968, 22 ff.

42. Chambers's contacts and responses to Piranesi are considered in Harris 1967, *passim*. The French designer Louis-Jean Desprez produced at least three views of Somerset House, including the Yale drawing, ibid., 229 (95), pl. 167.

43. For Adam and Piranesi, see Fleming 1962, *passim*; Stillman 1967, 197 ff.

44. Fleming 1962, 167. The two drawings done for Adam are among the abundant Adam material in the Sir John Soane's Museum, London.

45. Ibid., 166.

46. Stillman 1967.

47. Design for this Piranesian ornamental ruin in a park (Victoria and Albert Museum, 3436-49) is the most finished of several sketches for a garden feature produced for Sir Nathaniel Curzon, whom Robert Adam met shortly after returning from Italy in 1758. Apart from the influence of Piranesi's mode of design in Adam's interiors at Syon House, he was to contribute four etched plates (from Adam's designs, dated 1761) of the entrance hall and anteroom at Syon to *The Works in Architecture of Robert and James Adam*, II, Part IV, pls. 1, 3, 4, and 5), London, 1779. See also Chapter 2, note 24.

48. Adam's fruitful association with Clérisseau is revealed in various letters shortly after they first met in Italy. See Fleming 1962, *passim*. The complex influence of Clérisseau and Piranesi on Adam, especially relating to the Ruin Room at the Trinità dei Monti, Rome (designs in the Hermitage and in the Fitzwilliam Museum, Cambridge) is considered in McCormick and Fleming 1962, 239-243. For the most recent assessment of Clérisseau's relationship with Piranesi see McCormick 1990, *passim*.

49. For a detailed consideration of Piranesi's innovations compared with earlier antiquarian illustrations, see Wilton-Ely 1983b.

50. Robert Mylne's prize-winning design for Blackfriars Bridge, London, was built between 1760 and 1769. Piranesi was to produce an etching (*A view of part of the intended Bridge at Blackfriars, London, in August MDCCLXIIII by Robert Mylne, Architect, engraved by Piranesi at Rome*) after requesting "*una vera copia di quest'opera*" (an exact copy of this work) in a letter to Mylne on November 11, 1760. See Gotch 1951, 182; Wilton-Ely 1978b, 95. Apart from the Venetian's influence on the bridges of Thomas Harrison later in the same century, he also affected the work in France of the Ecole des Ponts et Chaussées, in particular the bridges of the designer Perronet. See Braham 1978, 69.

51. "Se la semplice esteriore osservazione degli avanzi delle antiche magnificenze di Roma è bassata a riformare negli ultimi tempi l'idea del buon gusto dell'Architettura, depravato per l'innanzi dalle rozze e infelici manieri de' Barbari: e se l'applauso delle antiche fabbriche è sempre più cresciuto presso le Nazioni le più culte dell'Europa; si debbono veramente imputare di trascuraggine e di stupidità i nostri Architetti, nell'averne tralasciati la perquiszioni a fondo, colle quali si sarebbe ristabilità la gravità e la maniera la più soda di fabbricare, che (mi sia lecito il dirlo) peranco si desidera negli odierni edifizi." *Antichità Romane*, 1756, I, Preface, 1.

52. Some of Piranesi's predecessors in the imaginative reconstruction of antiquity, such as Ligorio, Kircher, and Montano, are discussed in Wilton-Ely 1978a, 45.

53. Craig 1948.

54. The circumstances leading up to Piranesi's publication of the *Lettere* are investigated in Donati 1950, 321 ff.

55. Likely recipients of the *Lettere* appear to be listed on a sheet inserted in a copy in the James Grote Van Derpool Collection, discussed and reproduced in Parks 1961 (178), 64-65, pl. 15. Names include leading personalities in the Italian art world, such as Anton Raphael Mengs, Sir Horace Mann, and Sir William Hamilton.

56. Translation from Eitner 1971, 106.

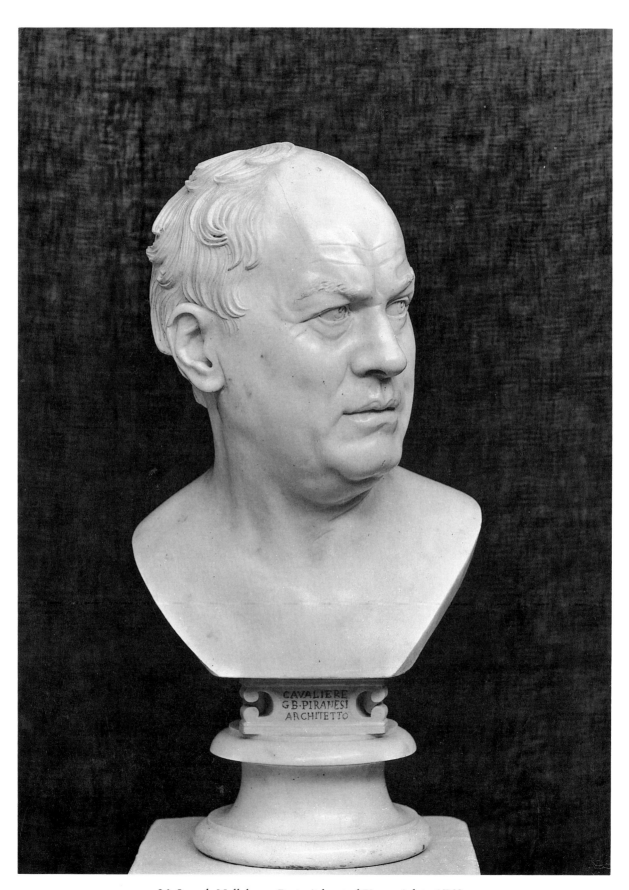

36. Joseph Nollekens. Portrait bust of Piranesi, late 1760s.

2

The Architecture

of

Polemics

A relish for polemic was basic to Piranesi's volatile and irascible character, and Joseph Nollekens's bust of the artist (Fig. 36), made toward the end of the heroic 1760s, superbly captured this.[1] The fierce pride of a Venetian was combined with the vigorous independence of a self-taught, scholarly mind, and Piranesi's last thirty years were punctuated by a series of conflicts and quarrels which produced his intellectual standpoint and gave rise to many of his most original ideas. Images, more than words, were his accustomed weapons, and in the course of these debates he supported his theories with a highly ingenious use of illustration. Apart from the immediate effectiveness of the polemical etchings as satirical gestures, these visually rich and complex compositions were to have a widespread influence on the course of European neoclassical design.

Piranesi's self-appointed mission to reform modern architecture, based on fresh inspiration from antiquity, was in itself hardly original. The significance of his ideas lay in the degree to which he used acts of fantasy, by means of the capriccio, to formulate new concepts and in the way he established a theoretical justification for this procedure (see Fig. 25). His intellectual development was marked by two creative crises, which are reflected in the intensity of his contemporary architectural fantasies, and are notably demonstrated by the two respective editions of the *Carceri* (see Fig. 19). The first crisis, as we have already noted, grew out of his early sense of frustration and disappointment over the moribund Roman architectural scene in the

early 1740s. The second one—of still far greater consequence—was provoked by the early exchanges of the Graeco-Roman controversy as they developed during the 1750s and which came to a head during the following decade.

Certain aspects of Piranesi's illustrations in the *Antichità Romane* show his initial response to the first attacks from the supporters of Greece on the creative reputation and achievements of ancient Rome. These placed an exaggerated emphasis on feats of engineering and building technology, amplified by the visual devices of stage design and tricks of scale (see Fig. 32). In the *Antichità* Piranesi also stressed the fertility of ideas in imperial Roman planning (see Fig. 33), especially where the original remains were sufficiently scant to allow his baroque imagination to take flight. Finally (and this was to prove crucial in the following decade), he drew attention to the abundance and richness of concepts in the ornamental language of the Late Empire (see Fig. 34), especially as found in funerary architecture and design.

A new interest in the achievements of the ancient Greeks, which began to emerge during the middle of the eighteenth century, stemmed from current architectural concerns and swiftly became a live issue rather than a narrow academic quarrel.[2] Claims of primal imagination and artistic originality were to provide the focus of debate, and among the most serious challenges to Piranesi was the *Essai sur l'Architecture* published by the French Jesuit Marc-Antoine Laugier, in 1753.[3] According to this provocative work, the functional principles of nature, as exemplified by the "rustic hut" of primitive man, depicted in its frontispiece (Fig. 37), an architectural equivalent to Rousseau's theories, were epitomized by ancient Greek architecture.

These primitive ideals, it was asserted, had subsequently been corrupted when taken over by the Romans, leading eventually to further debasement in modern times by Borromini and his Italian followers.[4] Laugier's rationalist criterion struck at those baroque principles of fantasy and invention which lay at the center of Piranesi's artistic ideas. As the decade advanced, the Hellenists' claims became more extravagant, although the first specific evidence was not provided until the French architect Julien-David Leroy published his folio on the main monuments of Athens in 1758 (beating the English publication of Stuart and Revett by some four years, despite the fact that they had been among the first to undertake fieldwork in the Aegean).[5] Of far more immediate importance to Piranesi, however, was the arrival in Rome of the German scholar Johann Joachim Winckelmann in 1755, closely following the publication of his seminal essay, *On the Imitation of Greek Works*—a literary expression as emotionally potent as Piranesi's visual rhetoric.[6] Winckelmann, established as librarian to the great collector and connoisseur Cardinal Albani in his villa on the Via Salaria, designed by Marchionni around 1760, became highly influential in Roman circles, and his philhellenic ideals were soon to be reflected in the so-called Greek temples added to the villa (Fig. 38), complementing the celebrated *Parnassus* ceiling

37. The Rustic Hut. Frontispiece to Marc-Antoine
Laugier, *Essai sur l'architecture,* 1753.

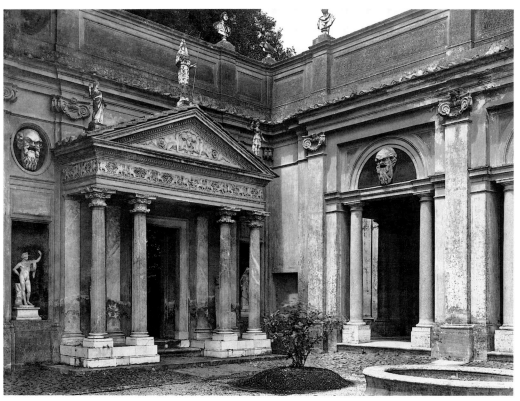

38. Carlo Marchionni. Tempietto Greco, Villa Albani, Rome, ca. 1760.

by Anton Raphael Mengs in the main salon. In contrast, Piranesi's own contribution to the villa's decorative scheme within, referred to later, was to show a far greater vigor in his handling of overtly Roman themes.[7]

Piranesi had begun to draw up an ambitious defense of Rome by the mid-1750s, spurred on by an anonymous essay in praise of Greece by his friend the Scottish painter Allan Ramsay, as well as by Leroy's book. Piranesi's work appeared in 1761 bearing the sonorous title *Della Magnificenza ed Architettura de' Romani* and was dedicated to the recently elected Venetian pope, Clement XIII, who, with other members of the Rezzonico family, was to provide crucial patronage in the 1760s.[8]

This sumptuously presented volume (subsidized by a papal tax-exemption on imported paper) opened with a lengthy and ponderously erudite text in which Piranesi explored the cultural origins of Rome. Denying any significant dependence on the Greeks, he examined the importance of the Etruscans as the Romans' intellectual and artistic mentors, placing a particular emphasis on their early functionalism in hydraulic engineering (exemplified by the Cloaca Maxima, Fig. 39) and road building. He took the opportunity to disprove Laugier's thesis regarding the evolution from wooden to stone architecture and pointed to the Tuscan order as the primitive source of the Roman Doric. However, in marked contrast to this austerely rationalist approach, a large proportion of the plates in *Della Magnificenza* celebrates the decorative fertility of late Roman designers, polemically juxtaposing a series of comparative examples taken from Leroy's engravings and interposing malicious or facetious quotations for good measure (Fig. 40). Piranesi extended the range of examples into modern times citing the continuing originality of Italian designers as represented by cinquecento Mannerism and the seicento Baroque.

Meanwhile, the plates of the *Vedute di Roma* were to reflect these polemical concerns through Piranesi's growing skills in the amplification of scale, lighting, and mood (see Fig. 21). Despite an increasing rhetoric, however, he maintained a remarkable fidelity to details of construction and ornament, supported by extensive and informative captions. Indeed, for all their souvenir role, these plates (which were being rapidly disseminated throughout Europe and were soon to reach America), provided an unprecedented record of historical and topographical information. The *Vedute* also show Piranesi's developing interest in locations outside Rome such as Hadrian's Villa, Tivoli, where he was in the process of completing a site plan begun with the help of Adam, Clérisseau, and others during the 1750s and published posthumously by Piranesi's son Francesco in 1781.[9] His visual ingenuity in documenting extensive and complex remains, such as the baths and the Colosseum, was by the 1770s to result in some of the first aerial views in archaeological illustration (Fig. 41).

While still working on the *Antichità Romane* during the 1750s, Piranesi's architectural inquiries had led him to investigate the hydraulic system of the Roman

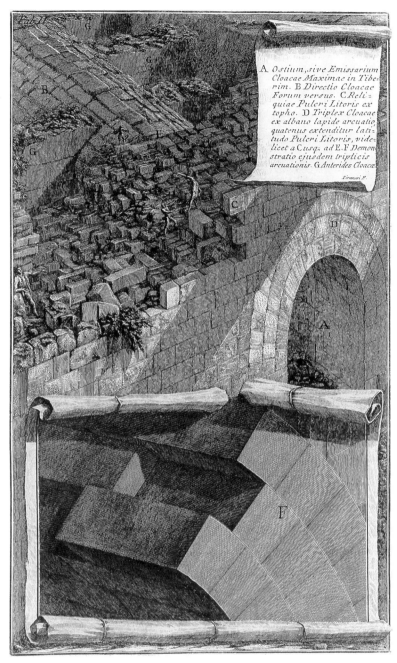

39. View and sectional detail of the Cloaca Maxima.
Della Magnificenza, 1761.

aqueducts in considerable detail. While space had not allowed him to publish all his discoveries and conjectures in the *Antichità,* his new polemical concerns led him to issue in 1761 an extremely thorough analysis of the *mostra* (head fountain) of the Acqua Giulia.[10] From this amorphous heap of ruins on the Esquiline Hill, his powers of imaginative reconstruction, assisted by the ancient treatise on aqueducts by Frontinus, enabled him to produce a particularly elaborate celebration of Roman technology.[11]

After a long gestation extending back into the previous, crucial decade, Piranesi issued in 1762 the finest and most influential of all his polemical-archaeological works, *Il Campo Marzio dell'Antica Roma.* Significantly, this work was dedicated to Adam—as a fellow architect and designer, rather than to the pope or a princely

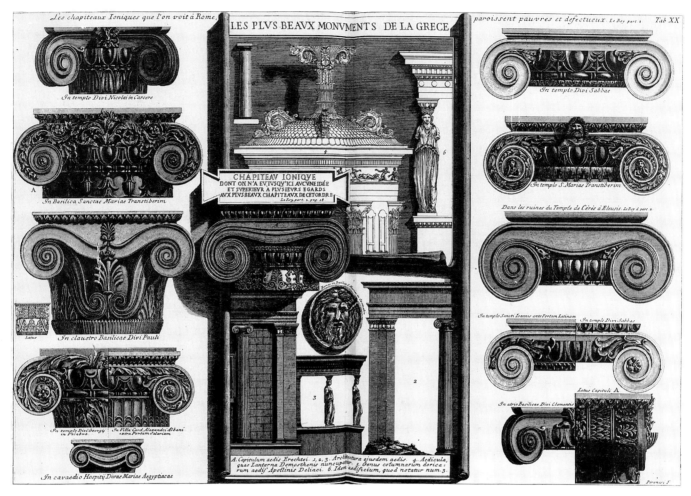

40. Roman Ionic capitals compared with the Greek. *Della Magnificenza,* 1761.

patron—and set out to demonstrate the Romans' originality in urban design.[12] In opposition to Winckelmann's thesis (later elaborated in the *History of Ancient Art*) that the complexity of late antiquity reflected a decline in taste, Piranesi charted the evolution of the monumental environment created in the Campus Martius with an extremely learned text and a variety of specialized illustrations. By means of a concerted sequence of maps, he traced the detailed process of evolution from primitive beginnings among the marshlands flanking the Tiber and outside the Severan Walls. In doing so, his reconstructive activities were supported by a sound scholarly method, appropriate to the Enlightenment and its concern with the phenomena of historical change. Applying his imagination to the evidence provided by the fragments of the Severan Marble Plan and his topographical investigations on the site, he isolated the remains of temples, mausolea, stadia, theaters, and baths from the accretions of a medieval townscape. However, since the creative genius of Rome as a model to modern designers was to be the main function of this treatise, he gave full vent to his own imaginative license in a vast map—the *Ichnographia* (Fig. 42)—the

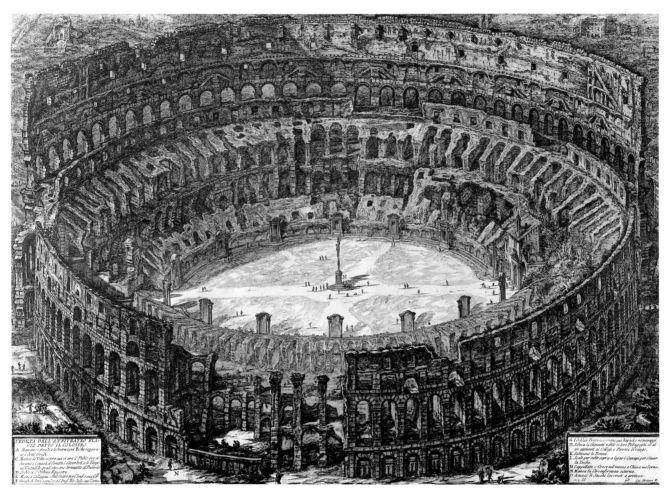

41. Colosseum from the air. *Vedute di Roma,* ca. 1775.

climax to this urban flowering. This vast capriccio, consisting of six contiguous plates and purporting to show Rome under the last emperors, is itself portrayed as a colossal fragment of a visionary Marble Plan, implying the unlimited fertility of the Roman genius.[13] As it happened, Piranesi had begun this particular part of the book in 1757 at the instigation of Robert Adam, and to symbolize this relationship he depicted the two architects as an artistic diumvirate on a medallion within the inscribed plaque.

Like the earlier planning fantasies of the college plan of 1750 (see Fig. 23) and the *Nymphaeum of Nero* of 1756 (see Fig. 33), the *Ichnographia* is the product of a brilliant conflation of varied forms drawn from the imperial baths, the Palantine complex, Hadrian's Villa, and the more tendentious reconstructions of Ligorio and Montano, to mention only a few. However, unlike the Palladian starting point of the college plan and the Borrominian character of the *Nymphaeum of Nero,* the morphology of Piranesi's latest planning exercise came remarkably close to current developments in European neoclassical architecture in which plans were generated by com-

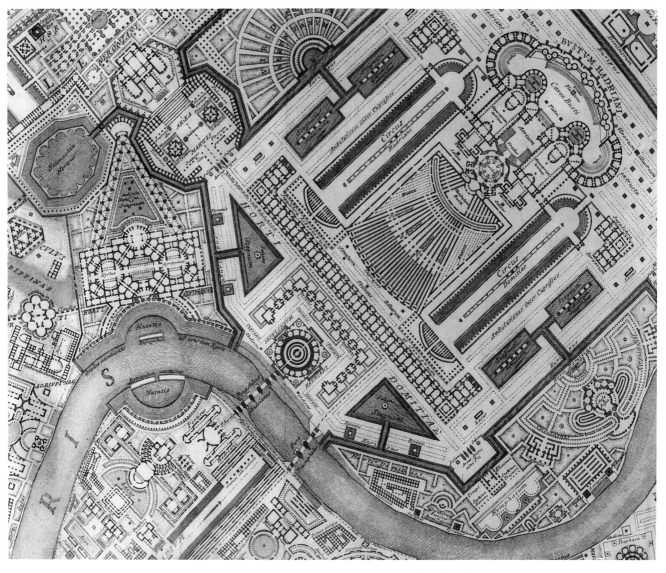

42. Large fantasy plan of the Campus Martius or *Ichnographia* (detail). *Il Campo Marzio*, 1762.

bining distinct geometric forms, derived from antiquity, into multiple patterns. At this time, however, no other European designer had pushed this process to such extremes of ingenuity, and the *Ichnographia* was to provide a repertoire of concepts to stimulate the imagination of several generations of architects, including Adam himself, Neufforge, Boullée, Ledoux, Valadier, and Soane.[14] Specific borrowings apart, however, the importance of Piranesi's urban fantasy lay in its demonstration of an imaginative synthesis, liberated from the increasing restrictions (as Piranesi saw them) of the rabid functionalists and avant-garde theorists, exemplified by Laugier and the philhellenic school of designers.

As Piranesi's preoccupation with establishing a new basis for design began to overtake his concern with the scholarly and pedestrian exchanges in the Graeco-Roman controversy, his sources of inspiration began to broaden substantially, and we can already detect in the aerial perspectives (Fig. 43), reconstructing portions of the

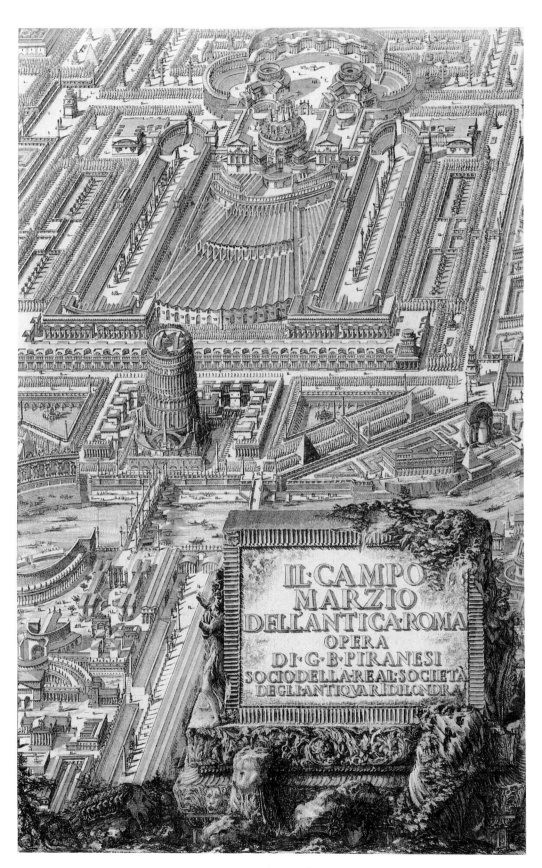

43. Aerial reconstruction of part of the Campus Martius
including Hadrian's Mausoleum. *Campo Marzio.*

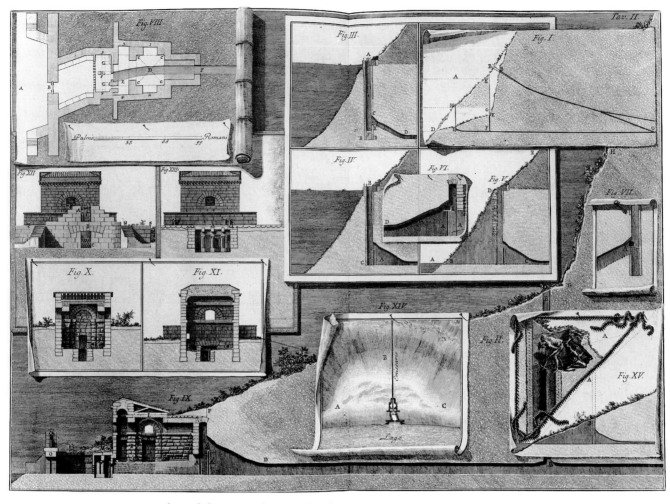

44. Technical diagrams showing the drainage outlet, or *emissarium*, of Lake Albano and its supposed construction, *Emissario del Lago Albano*, 1762.

Ichnographia, the signs of Greek as well as Egyptian motifs. For example, Greek caryatids are used in Piranesi's fanciful reconstruction in aerial perspective of the precinct relating to the Pantheon in the final plate of the *Campo Marzio*.

During the early 1760s, Piranesi began to extend his researches in the field outside Rome as he continued to gather fuel for his polemical defense. He was to issue folios devoted to the Etruscan city of Cori and to a variety of antiquities in the area surrounding the pope's favorite residence at Castel Gandolfo.[15] His most ambitious work at this time was devoted to the design and construction of the *emissarium* (drainage outlet) to Lake Albano, carried out by the Romans, according to Livy, in 358 B.C. In this volume, *Descrizione e Disegno del Emissario del Lago Albano*, published in 1762, his Venetian training as well as his painstaking investigations of the site resulted in a remarkable suite of technical diagrams (Fig. 44) appearing in sharp contrast to the inflated rhetoric of the accompanying *vedute* (Fig. 45) with their reverberations of Salvator Rosa. If the cyclopean blocks of masonry and superhuman scale of the structure recall the *Carceri*, this is not without point, for in the midst of the creative tensions of these years Piranesi issued the definitive version of these penal fantasies, heavily reworked and explicitly referring to his current preoccupations (Fig. 46).

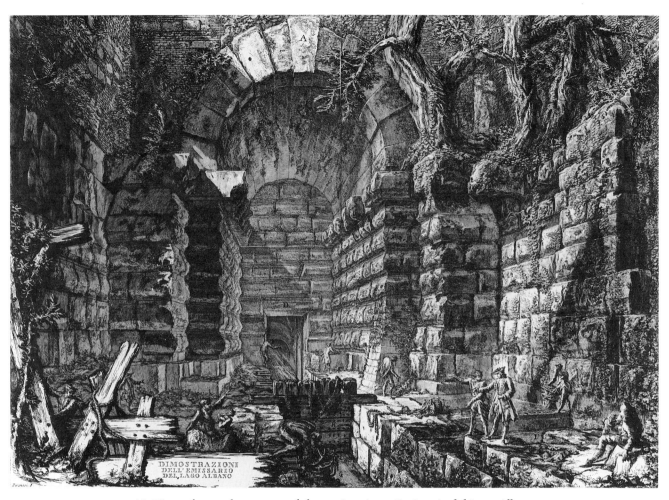

45. View of tunnel entrance of the *emissarium. Emissario del Lago Albano.*

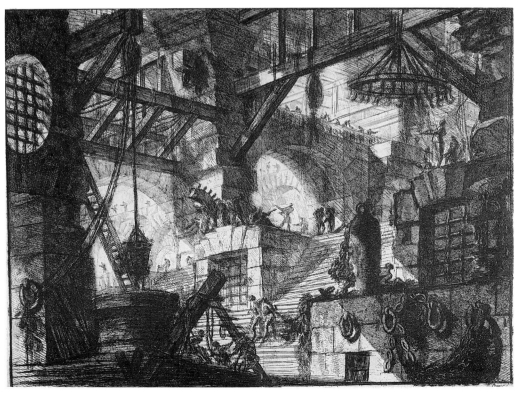

46. Prison interior: "The well." *Carceri,* 1761 edition, pl. XIII.

While the original fourteen plates of the *Carceri* seem to have been largely overlooked on their first appearance, which was virtually anonymous, in 1749, their impact was to prove immediate on a new generation of designers, artists, and writers.[16] Although mercifully few contemporary prisons show a direct influence from the gruesome symbolism of the *Carceri*, apart from George Dance's Newgate Prison in London (begun in 1769, Fig. 47), the formal manipulation of almost abstract form devoid of ornamental distractions in these plates paralleled, for more thoughtful and receptive European designers, the abundance of ideas offered by the *Ichnographia*.[17]

Signs of Piranesi's continual revision of certain of the *Carceri* plates in subsequent years suggest that they served as a formal experiment for his architectural thoughts. These images, especially the two added in the early 1760s (Fig. 48), indicate Piranesi's attempt to escape the limitations of the Vitruvian classical grammar by an almost mannerist flouting of the conventions of classical architectural design. This is also seen in a series of small architectural fantasies added to the *Opere Varie* at this time, introducing violent juxtapositions of classical elements and showing an unexpected interest in the expressive potential of Greek Doric (Fig. 49). The three small fantasies in question each indicate a specific familiarity with recently published Greek orders, not only the conventional Doric of the Parthenon, but more idiosyn-

47. George Dance the Younger. The Debtor's Door,
Newgate Prison, London, 1769-78.

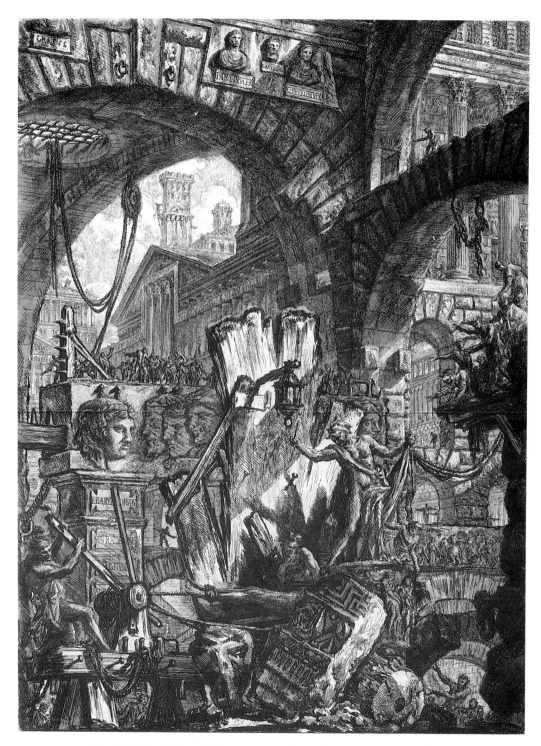

48. Additional plate, "The man on the rack." *Carceri,* 1761 edition.

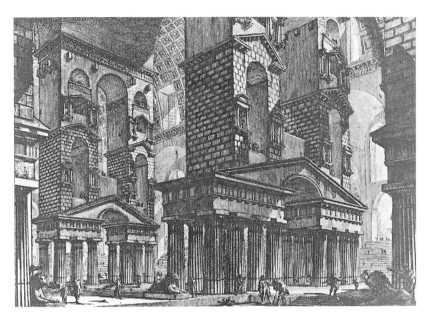

49. Fantasy composition featuring the remains of ancient baths
with Greek Doric columns. *Opere Varie,* after 1760.

cratic versions, such as from the Temple of Apollo at Delos. His surviving fantasy drawings of this period (such as the one at Bologna, Fig. 50), when compared to the earlier capricci of the 1740s and 1750s where anti-Vitruvian forms are tentatively introduced, show the same new imaginative range and aggressive violation of Vitruvian conventions.[18]

If Piranesi's artistic development toward a new and liberating system of eclectic design had so far outdistanced his theoretical position, his involvement in the Graeco-Roman debate had begun to force him to abandon his rationalist defense of Rome (as represented by the text of *Della Magnificenza*) in favor of creative license and formal diversity. When, therefore, the French critic Pierre-Jean Mariette attacked the ideas of *Della Magnificenza* in 1764 with a review in the *Gazette Littéraire*, Piranesi was ready to respond with an apologia of his artistic beliefs in a three-part publication issued in 1765.[19] In the first part, *Osservazioni sopra la lettre de M. Mariette,* he set out to refute the Frenchman's statements sentence by sentence, largely along the lines of his earlier defense of the Etruscans as sole originators of the Roman achievement. The title page (Fig. 51), although prominently featuring the Tuscan order, stresses the issue of artistic originality above the mere wrangling over sources and dates. Two contrasting insets on the left of the plate juxtapose the hand of Mariette, the armchair critic, with the tools of the practicing designer whose discipline brings him far closer to the creative spirit of antiquity.

Since Mariette's criticisms of Piranesi reflected the growing influence of Winckelmann's views in their praise of "la belle et noble simplicité" of the Greeks, the third part of Piranesi's publication, which claims to consider the evolution of the fine arts in Europe since antiquity, is largely confined to stressing the complexity of

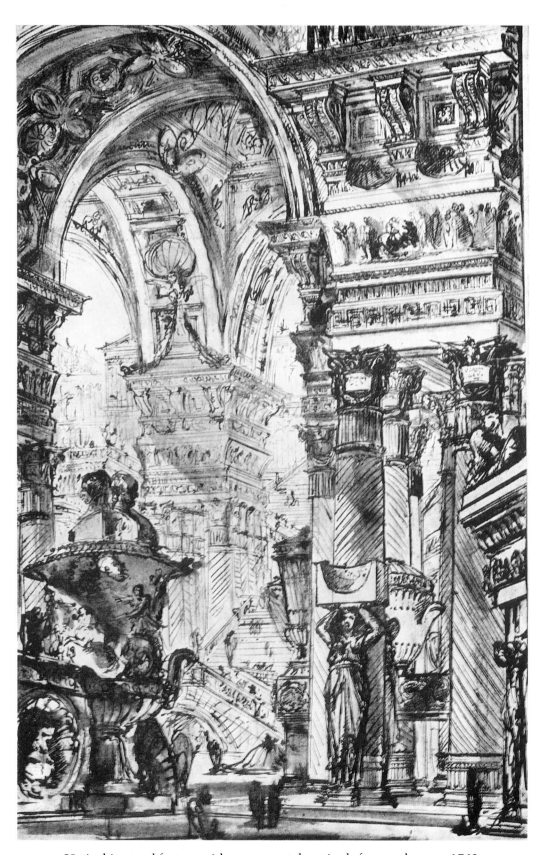

50. Architectural fantasy with monumental portico before a palace, ca. 1763.

51. Title page of *Osservazioni sopra la lettre
de M. Mariette,* 1765 (detail).

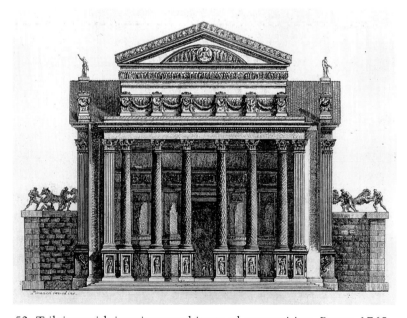

52. Tailpiece with imaginary architectural composition. *Parere,* 1765.

Etruscan tomb decoration at Chiusi and Corneto. However, it was the central part of the publication, entitled *Parere su l'Architettura* (*Opinions on Architecture*), which was to prove of crucial importance in outlining a theoretical justification of Piranesi's newfound philosophy of design. It consists of a debate between two architects— Protopiro, a rigoristic follower of Laugier and his puritan aesthetic, and Didascolo, spokesman for Piranesi in favor of the freedom of the imagination and the need for richness and variety in architectural composition. The discussion is short and decisive, for Piranesi had no doubts that artistic license was necessary for a healthy state of design and essential for the development of new ideas.

The text of the *Parere* was originally illustrated by a few vignettes featuring novel examples of anti-Vitruvian composition (Fig. 52), as anticipated by the architectural fantasies discussed earlier. However, Piranesi's continuing experiments in formal ingenuity, evident in surviving sketches in London (Fig. 53), Berlin, and Bayonne, indicated that he had begun to create far bolder and more challenging *invenzioni*.[20] An aggressive eclecticism is now amplified by monumental forms derived from Egyptian sources and boldly integrated with Greek and Etruscan elements. These inquiries resulted in a set of additional plates to the *Parere*, where inscriptions underlined their polemical intent. One such quotation from Ovid states, "Nature renews herself constantly: to create the new out of the old is, therefore, also proper to man"; another drawn from Sallust asserts, "They despise my novelty, I their timidity" (Fig. 54).[21]

The influence of Piranesi's new approach to design, as propounded in the *Parere*, had already begun to take effect, if on a more restrained level, in the early works of the Adam brothers. In the *Parere*, Didascolo had referred to James Adam's invention of a British order (Fig. 55), which Robert's brother had proudly shown to Piranesi on his visit to Rome in 1762, as exemplifying the imaginative application of antiquity to modern needs.[22] However, it was to be in Robert's initial activities as a designer in England that the more far-reaching evidence of Piranesi's inspiration was to be found. This is particularly evident at Syon House where Robert Adam's ingenious remodeling of the Duke of Northumberland's sixteenth-century seat outside London reflects in plan, but even more in its decorative scheme, the imaginative fruits of Piranesi's instruction in the 1750s.[23] (Indeed, Piranesi was flattered to be asked to etch four plates of the Syon interiors for the Adams's folio, *The Works in Architecture*, published during the 1770s, Fig. 56.[24])

By the time the reconstruction of Syon House was under way in the mid-1760s, Piranesi was in a position himself to apply his innovative ideas to a series of practical commissions in architecture and the decorative arts through the enlightened patronage of Clement XIII and the Rezzonico family. In addition to preparing designs at the pope's request for a monumental tribune to S. Giovanni in Laterano, he was to reconstruct the priory church of the Knights of Malta for Cardinal Giovambattista

53. Study for imaginary architectural composition in the
style of plates added to the *Parere* after 1767.

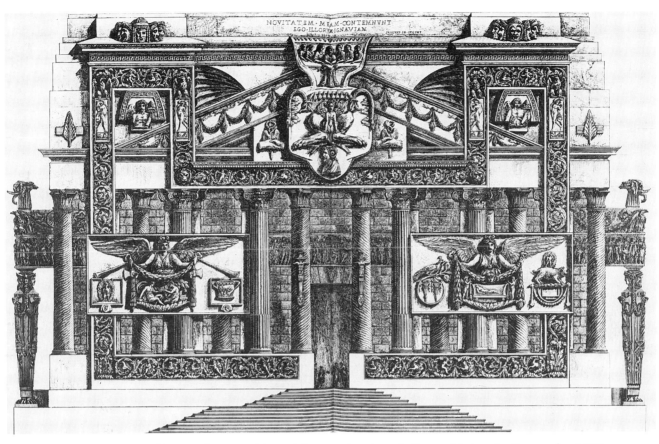

54. Imaginary architectural composition with quotation from Sallust, added to the *Parere* after 1767.

55. James Adam. Design of a lion and unicorn capital
for a British order, 1762.

56. Piranesi after Robert Adam. Longitudinal section of entrance hall,
Syon House, Middlesex. *The Works in Architecture*, II, 1779.

Rezzonico, prior of the order. He also carried out decorative schemes, complete with furniture, for the pope at Castel Gandolfo, as well as for Cardinal Rezzonico at the Quirinal Palace, and for Senator Abbondio Rezzonico in Palazzo Senatorio on the Capitoline Hill. These opportunities apart, he was to make lucrative contacts with visiting tourists, especially various members of the English nobility, and began to open up a profitable market in ornamental chimneypieces and restored antiquities, also determined by his novel system of composition.

By the close of the 1760s Piranesi was in a situation to review his achievements in the application of his innovative system over a wide field of design. Thus in 1769 (sadly the year in which his major patron Clement XIII died), he issued his final polemical and theoretical work, entitled *Diverse Maniere d'adornare i Cammini ed ogni altra parte degli Edifizi desunte dall' Architettura Egizia, Etrusca, e Greca* (or to give its title in Piranesi's English, *Divers Manners of ornamenting chimneys and all other parts of houses, taken from the Egyptian, Tuscan and Grecian Architecture*). This impressive folio, dedicated to his leading patron, Cardinal Giovambattista Rezzonico, consisted of an extensive theoretical text in three languages—Italian, English, and French—addressed to an international audience of patrons and artists. Moreover, it was illustrated by a sequence of etchings of his own designs.[25]

The theoretical text, *An Apologetical Essay in defence of the Egyptian and Tuscan Architecture*, actually offers a far broader basis for discussion than its title

suggests. Taking artistic originality as his theme, Piranesi examines the importance of nature as a varied source of inspiration. Pointing to the distorted view of Egyptian art which had resulted from the survival of its monumental forms, he indicates the variety which this civilization had derived from observed nature, evident in small-scale works such as scarabs, intaglio seals, and reliefs. During his discussion concerning the necessity of judging the monumental forms of ancient Egypt within their architectural context, he advances a remarkable defense of stylization, citing the sphinx capitals in the collections of the Borghese family and of Robert Adam (represented in the Morgan Library collection by two red chalk studies for the etching previously illustrated in *Della Magnificenza,* Fig. 57):

> Let the two winged sphinxes which are upon them [i.e. the capitals] be observed, and let the majestic feathers of their wings be considered, which besides being extended horizontally, and disposed like the reeds of the shepherd's pipe, are likewise turned up, and bent contrary to nature, to make an agreeable contrast with the Ionic volutes of these two capitals which are twisted downwards.[26]

He also mentions that the two Egyptian lions of the four ornamental animals on the main fountain of the Acqua Felice (Fig. 58) demonstrate the same mastery of abstraction from nature:

> I have in view, among other works of theirs [i.e. the Egyptians], the two Lions or Leopards which serve to adorn the fountain of the Felician aqueduct in Rome, together with two others studiously copied, both as to action and

57. Study of antique capital with confronted
sphinxes from Villa Borghese.

58. Detail from the view of the main fountain of the Acqua Felice
showing the Egyptian lions. *Vedute di Roma,* ca. 1760.

design from nature, that is, worked after the Grecian manner. What majesty
in the Egyptian ones, what gravity and wisdom, what union and modification
of parts! How artfully are those parts set of which are agreeable to architec-
ture, while those are suppressed which are not advantageous to it! Those
other lions on the contrary, which are exactly copied from nature, and to
which the artist capriciously gave what attitude he pleased, what have they
to do there? They only serve to diminish the great effect which the Egyptian
ones gave to the architecture of that fountain; which, however, is not one of
the most elegant.[27]

Extending this argument to the Etruscans (or Tuscans), he conducts his defense less
on the historical grounds of *Della Magnificenza,* which had appeared some eight
years earlier, than on some remarkable passages of formal analysis. He praises their
powers of abstraction, especially with respect to the so-called Etruscan vases in such
collections as that of Sir William Hamilton, and includes two charts of shells
selected from the Gualtieri collection in Florence to suggest a possible source of for-
mal inspiration (Fig. 59).[28] Although he cannot resist returning to his support of
Etruscan originality with a particularly tendentious chart of inventions ascribed to
this people (Fig. 60), his main conclusion relates to the need to abandon such narrow

59. Comparative diagram showing "Etruscan" vases and shell forms. *Diverse Maniere*, 1769.

partisan arguments supporting a single culture in favor of a broad-ranging synthesis of motifs from many civilizations, as characterized by the very development of antique art itself.

In the plates which follow the *Essay*, Piranesi includes a number of works executed during the 1760s according to these principles. While pride of place goes to the furniture designed for Cardinal Rezzonico in his Quirinal apartment (see Fig. 116) and to the monumental clock produced for the rooms in the Palazzo Senatorio belonging to the cardinal's brother Abbondio (see Fig. 122), the major proportion of the etched designs are devoted, as the folio's title indicates, to the application of this eclectic system to the chimneypiece as an essentially modern requirement. The initial designs, which had already been executed for the Earl of Exeter (see Fig. 123) and

60. Chart of inventions attributed by Piranesi to the Etruscans. *Diverse Maniere,* 1769.

the banker John Hope (see Fig. 124), skillfully incorporated antique fragments and are relatively restrained. Those which follow, however, are increasingly extravagant in form and are clearly, like the architectural compositions added to the *Parere*, exaggerated for polemical effect (Fig. 61). Similar to the planning fantasy of the *Ichnographia* in the *Campo Marzio*, these strange compositions were intended to offer a range of ideas, both to stimulate invention as well as to provide specific motifs for individual productions. As Piranesi explains:

> The Roman and Tuscan were at first one and the same, the Romans learned architecture from the Tuscans, and made use of no other for many ages; they afterwards adopted the Grecian, not on account that the Tuscan was deficient either in parts, ornaments, or beauty; but because novelty and merit rendered agreeable certain elegances and graces peculiar to the Greeks, as each nation has its own; the Tuscan and Grecian were mixed together, the graces and beauties of the one became common to the other, and the Romans found means to unite them both in one and the same work. This is what I likewise have pretended to do in these chimneys, which are not after the Egyptian

61. Design for chimneypiece, with flanking chairs, involving Etruscan motifs. *Diverse Maniere.*

manner, to unite the Tuscan, or what is the same, the Roman with the Grecian, and to make the beautiful and elegant of both united subservient to the execution of my design. The connoisseurs will easily distinguish what belongs to the Greeks, and what to the Tuscans.[29]

Notable among these plates is a sequence of chimneypieces in the Egyptian taste (see Fig. 141) which were to have a powerful impact later in the century. By the time the *Diverse Maniere* appeared, however, many of Piranesi's readers would have been able to judge the success of his approach from the painted interiors of the Caffè degli Inglesi on the Piazza di Spagna—the only plates in the book to suggest a complete decorative scheme (see Figs. 143 and 144).

The *Diverse Maniere,* representing as it does Piranesi's considered defense of his innovative system of design, falls at the close of an extremely productive decade in his long-awaited career of practicing architect and designer. While its theoretical *Essay* and supporting illustrations represent the flowering of a strange and complex imagination, they also underline the crucial importance of discerning patronage at this point in the story. In the following chapters, we shall be considering the detailed workings of Piranesi's innovative system in his two major architectural commissions for the Rezzonicos, Clement XIII and his cardinal nephew, and the evidence justifying the following credo which concludes the *Diverse Maniere*:

Must the Genius of our artists be so basely enslaved to the Grecian manners, as not to dare to take what is beautiful elsewhere, if it be not of Grecian origin? But let us at last shake off this shameful yoak [sic], and if the Egyptians, and Tuscans present to us, in their monuments, beauty, grace and elegance, let us borrow from their stock, not servilely copying from others, for this would reduce architecture and the noble arts [to] a pitiful mechanism, and would deserve blame instead of praise from the public, who seek for novelty, and who would not form the most advantageous idea of an artist, as was perhaps the opinion some years ago, for a good design, if it was only a copy of some ancient work. No, an artist, who would do himself honour, and acquire a name, must not content himself with copying faithfully the ancients, but studying their works he ought to shew himself of an inventive, and, I had almost said, of a creating Genius; And by prudently combining the Grecian, the Tuscan, and the Egyptian together, he ought to open himself a road to the finding out of new ornaments and new manners. The human understanding is not so short and limited, as to be unable to add new graces, and embellishments to the works of architecture, if to an attentive and profound study of nature one would likewise join that of the ancient monuments.[30]

Notes

1. Wilton-Ely 1976b. The young British sculptor Joseph Nollekens (1737-1823) was involved in the restoration of classical antiquities in order to earn a livelihood while studying in Rome (1760-70), and he may have worked for Piranesi in this capacity. Although Piranesi was elected to the Accademia di San Luca in 1761, the bust was probably executed toward the end of the sculptor's stay in Rome, and shows the sitter near the age of fifty.

2. For a discussion of the broader issues of the controversy, see Crook 1972, Wiebenson 1969, and Rykwert 1980, *passim.*

3. Herrmann 1962, 191-93. For a complete English translation of the *Essai* see Laugier [1753] 1977.

4. Borromini was to be one of the principal targets of the neoclassical theorists. See Blunt 1979, 218 ff. Piranesi, on the other hand, pays tribute to this seventeenth-century architect in several of his publications, and borrowed ideas for his own designs from this source. For Piranesi's attitude toward Borromini, see essays by Wilton-Ely and Connors 1992, *passim.* See also Chapter 1, note 18.

5. For Leroy, see Braham 1980, 64-66, 79, and Rykwert 1980, 378, 379-80, 411-12.

6. For a discussion of Winckelmann's writings and selected passages in translation, see Irwin 1972. See also Praz 1972, 40 ff.

7. Winckelmann and the Albani Circle are considered in Lewis 1961. For Villa Albani and its interiors, see Rykwert 1980, 342-55, and Chapter 5, note 35.

8. Piranesi's role in the ensuing Graeco-Roman controversy is considered in Wilton-Ely 1978c; Wilton-Ely 1991.

9. *Pianta delle fabbriche esistenti nella Villa Adriana* (Rome, 1781). See MacDonald and Pinto 1994.

10. *Le Rovine del Castello dell' Acqua Giulia* (Rome, 1761).

11. Frontinus, *De aquis urbis Romae.* Piranesi also took advantage of extensive researches by his contemporary Giovanni Polenti, who had edited this Roman text.

12. For a full discussion of the importance and approach of *Il Campo Marzio*, see Wilton-Ely 1978c, 538-41.

13. The significance of the *Ichnographia* within Piranesi's concept of the architectural fantasy as a creative stimulus is examined in Wilton-Ely 1983a.

14. For the influence of the *Ichnographia* on contemporary European architects, see ibid., 303. Some specific borrowings by Ledoux from Piranesi's *Ichnographia* are examined in Reutersvärd 1971, 10 ff. Its impact on Soane is discussed in McCarthy 1991.

15. *Antichità di Cora* (Rome, 1764); *Antichità di Albano e di Castelgandolfo* (Rome, 1764).

16. For further discussion of the later states of the *Carceri* and their impact on writers as well as designers and artists, see Wilton-Ely 1978a, 85-91, 125-26. See also Praz 1975, 14-17, and Robison 1986, *passim.*

17. For Piranesi's influence on George Dance the Younger, see Stroud 1971, *passim.* Various scholars have differed in their assessment of Piranesi's influence on Newgate Prison, but none can deny the pervasive impression of the *Carceri* upon penal design in the late eighteenth century.

18. The Bologna fantasy drawing (Biblioteca Civica, 7/1190) may have once been owned by the Romantic stage designer Palagio Palagi (1775-1860).

19. In correspondence with Monsignor Giovanni Bottari, one of Piranesi's early patrons, Mariette claimed that the letter was published without his knowledge. See Wittkower [1938-39] 1975, 235 ff.

20. While two Berlin drawings (Kunstbibliothek, 135 and 136/3940) and two in an English private collection are clearly studies for the plates added to the *Parere* around 1767, a third in Berlin (134/3940) and one in London (British Museum, 1908-6-16-44) appear to be rejected compositions for that publication. The sheet of studies in Bayonne appears to contain preliminary thoughts in this line of inquiry. The context of these *Parere* drawings is examined in Wilton-Ely 1991.

21. "Rerumque novatrix Ex aliis alias reddit natura figuras" (Ovid, *Metamorphoses* XV); "Novitatem meam contemnunt, ego illorum ignaviam" (Sallust, *in Iugurtha*). Another quotation is taken from Terence's *Eunuch*: "Aequum est vos cognoscere atque ignoscere quae veteres factitarunt si faciunt novi" (It is reasonable to know yourself, and not to search into what the ancients have made if the moderns can make it); and for satirical effect, a quotation from Leroy's publication on Greek architecture is set on a highly original facade: "Pour ne pas faire de cet art sublime un vil métier où l'on ne ferait que copier sans choix" (One must not restrict choice if one is not to reduce this sublime art to a mean trade.)

22. In letters to his brother Robert, James Adam described the reception of his original designs in Rome. Fleming 1962, 305-7.

23. Stillman 1966, passim.

24. The four plates etched by Piranesi in Rome from Robert Adam's designs of 1761 were published in *The Works in Architecture of Robert and James Adam,* II, pt. IV, 1779; pl. I, *Section of one Side of the Hall at Sion;* pl. III, *Ceiling of the Hall;* pl. IV, *Two Sections of the Anti-room* [sic]; and pl. V, *Ionic Order of the Anti-room* [sic], *with the rest of the Detail of that Room.* In the preface to Part IV of this volume, the Adam brothers referred to Piranesi's plates as "the largest he has ever attempted in regular architecture" and stated that "we owe [it] to that friendship we contracted with him during our long residence at Rome, and which he has since taken every occasion to testify in the most handsome manner."

25. More preparatory designs for the plates of this publication survive than of any other single work by Piranesi, the greatest concentration being in the Pierpont Morgan Library, New York, and the Kunstbibliothek, Berlin. The nature of these and their role in the book are discussed in Rieder 1973. See also the relevant catalogues: Stampfle 1978 and Fischer 1975.

26. *Diverse Maniere,* 12. The sphinx capital, reproduced in *Della Magnificenza,* pl. XIII (for which the Morgan chalk drawings are probably studies), was to inspire the original capitals on the facade of S. Maria del Priorato of 1765-66 (see Fig. 97 in this book). For these drawings see Stampfle 1978, xxiii, nos. 19 and 20.

27. *Diverse Maniere,* 14. The original Egyptian lions have been subsequently transferred to the Vatican Museum and replaced by replicas.

28. Sir William Hamilton's first collection of classical antiquities and vases was published with illustrations by d'Hancarville in Naples in 1766-67 before its eventual sale to the British Museum in 1772. Piranesi was in correspondence with Hamilton over certain trial proof plates of chimneypiece designs prior to their publication in the *Diverse Maniere.* A letter from Piranesi in Rome to Hamilton (British Museum, Add. MS 42069, f. 50) on 16 October 1763 is referred to in Croft-Murray 1962, 46, and the translation of a later reply in French from Hamilton in Naples to Piranesi (now in the Morgan Library, MA 321) is quoted in full in Parks 1961, 36.

29. *Diverse Maniere,* 15.

30. Ibid., 33.

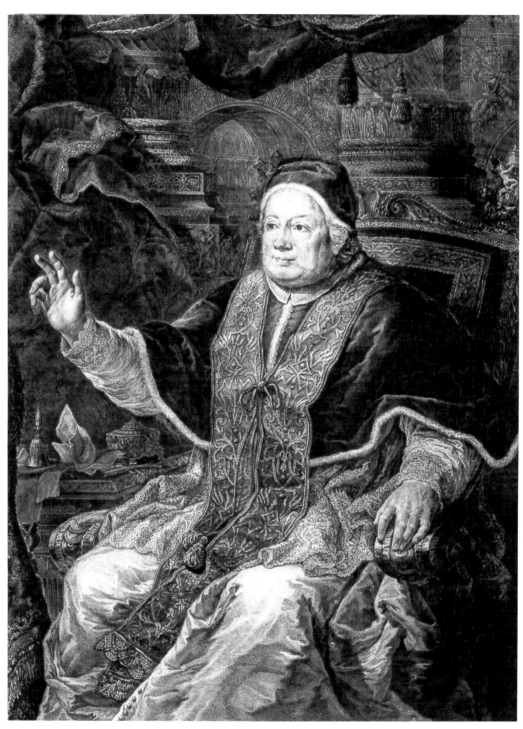

62. Piranesi with Domenico Cunego. Portrait of Clement XIII.
Della Magnificenza, 1761.

3

The Tribune

for

S. Giovanni

in Laterano

The early 1760s marked a climactic point in Piranesi's career, and certain tensions and frustrations were to be reflected in the disturbing images of the refashioned *Carceri* (see Fig. 48). In some respects, worldly success had come swiftly to him; he was the leading topographical engraver in Rome and in 1761 had transferred his prosperous business from the Corso to a more impressive establishment in the Palazzo Tomati, Via Sistina. Here, close to the top of the Spanish Steps and the English quarter of Rome, he began to attract a growing clientele of foreign patrons.[1] His extensive contribution to Roman archaeology through the *Antichità Romane* had been given international recognition with an Honorary Fellowship of the Society of Antiquaries of London, followed by election to the Accademia di San Luca, where his fiery personality was swift to provoke controversy over the Balestra Monument.[2]

Artistically, the involved exchanges of the Graeco-Roman debate had forced Piranesi to reconsider his initial position, expressed in *Della Magnificenza ed Architettura de'Romani* in 1761, of ambivalent support for rational, functional engineering achievements (see Fig. 39) on the one hand, yet concentration on the rich, idiosyncratic vocabulary of late imperial decoration (see Fig. 40), on the other. Already by 1762 in the *Campo Marzio* treatise, he was advocating the need for an

unfettered language of design, drawing freely from a wide range of visual sources (see Fig. 42). Justifying these ideas in the dedication to his fellow architect Robert Adam, as a kindred spirit, he wrote:

> I am rather afraid that some parts of the Campus which I describe should seem figments of my imagination and not based on any evidence: certainly if anyone compares them with the architectural theory of the ancients he will see that they differ greatly from it and are actually closer to the usage of our own times. But before anyone accuses me of falsehood, he should, I beg, examine the ancient [marble] plan of the city . . . he should examine the villas of Latium and that of Hadrian at Tivoli, the baths, the tombs and other ruins, especially those beyond the Porta Capena, and he will find that the ancients transgressed the strict rules of architecture just as much as the moderns. Perhaps it is inevitable and a general rule that the arts on reaching a peak should then decline, or perhaps it is part of man's nature to demand some license in creative expression as in other things, but we should not be surprised to see that ancient architects have done the very things which we sometimes criticize in buildings of our own times.[3]

Piranesi's lifelong aspirations as a trained architect were still largely unfulfilled, apart from the outlet his etched fantasies provided and the increasing impact his imagination had upon other designers such as the Adam brothers, George Dance, Robert Mylne, and many other visiting professionals. He badly needed opportunities to practice and to develop his ideas under discerning patronage. Almost by providence, this was to occur with the support of the new Venetian pope, Clement XIII, and his family, who gave Piranesi, among other things, two key architectural commissions in which his artistic vision could be given the maximum scope.

The pontificate of Clement XIII, extending from 1758 to 1769, marked a new phase of artistic patronage in Rome after the relative lull under Benedict XIV.[4] The new pontiff, while not an unduly astute politician, had a particularly developed sense of cultural responsibilities, and the discernment not only to support Piranesi substantially but also to recognize the great importance of the artist's rival, Winckelmann. Clement appointed the German scholar Prefect of Antiquities and gave him considerable control over the development of the Vatican collections which were to form the nucleus of the celebrated Museo Pio-Clementino. Despite the pope's support of the apostle of Greek austerity, however, his personal taste for the opulence of imperial Rome is alluded to by Piranesi both in his dedication and prefatory portrait of Clement XIII (Fig. 62) in *Della Magnificenza.*[5] Prominent among the new pope's schemes for Rome was his intention to enhance the premier church of the Eternal City, S. Giovanni in Laterano. While Borromini's program of modernizing the

Constantinian basilica, between 1646 and 1649, had gone no further than the interior of the nave and aisles (Fig. 63), early in the following century, between 1733 and 1736, Alessandro Galilei had added the great east front (Fig. 64, liturgically the west front since, like St. Peter's, the Lateran is oriented in reverse direction to customary usage).[6] The time was long overdue to complete this program at the western end, containing the presbytery, with appropriate splendor.

According to a letter from Charles-Joseph Natoire, director of the French Academy in Rome, to the Marquis de Marigny in September 1763, it appears that the pope first commissioned Piranesi to design a new high altar for the Lateran.[7] Before long, however, this idea soon developed into a series of elaborate schemes for remodeling the entire west end of the basilica. Until relatively recently, evidence concerning Piranesi's intentions for the projected tribune, which was sadly destined to remain only a project, was provided by a significant group of preparatory drawings and sketches in the Morgan Library. This evidence was first published by Felice Stampfle in 1948 and later, in 1968, formed the basis for a major article by Manfred Fischer.[8] However, dramatic new light was provided by the discovery of an incomplete set of twenty-three highly finished drawings for Piranesi's Lateran scheme. This set was acquired by the Avery Library in the autumn of 1971 and exhibited the following year in honor of the late Rudolf Wittkower, who had done so much to pioneer

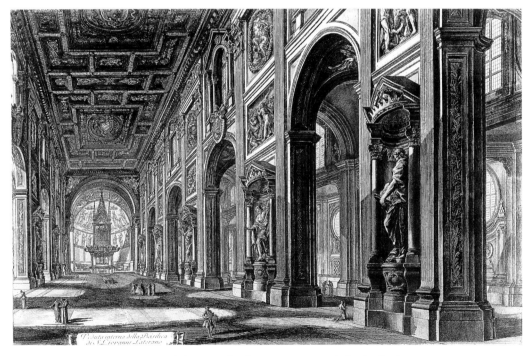

63. View of the nave looking west toward the high altar.
Vedute di Roma, ca. 1770.

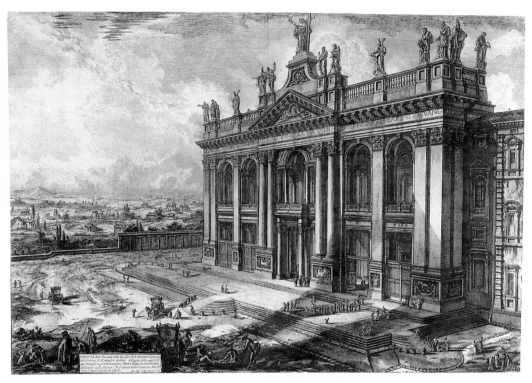

64. View of the east front of S. Giovanni in Laterano.
Vedute di Roma, mid-1770s.

studies on Piranesi as an architect and designer.[9] These extremely fine drawings, indicating five distinct but interrelated solutions to the projected tribune, appear to have been drawn up by Piranesi (with considerable studio assistance in parts) during 1764. They were subsequently adapted, by means of added embellishments, for presentation to Cardinal Giovambattista Rezzonico (dedicatee of the *Diverse Maniere*) in 1767, after the commission had been abandoned. Indeed, it is quite possible that Clement XIII's bestowal of the knighthood of the *Sperone d'Oro* (Golden Spur) on Piranesi in 1767 was intended to console the architect for this major disappointment in his career.[10]

Borromini's scheme for modernizing the Lateran nave under Innocent X clearly provided a specific source of inspiration for Piranesi's approach, especially in the challenge of applying a highly original modern system of design to the venerable structure. The solution of the seicento master was to encase each pair of consecutive columns of the original nave inside a broad pillar, framed by a colossal order of pilasters, and featuring an *aedicule* (tabernacle niche) of colored marble for statuary in front of each pillar (see Fig. 63). The brilliant manipulation of color and textures was further enhanced by the effects of two complex interlocking rhythms of articulation running through the nave bays.

Apart from this major opportunity to demonstrate his new architectural language, Piranesi was virtually unique among the designers of his time in his complete

accord with the ideas and spirit of Borromini—a master whose reputation was increasingly in decline as the austere tastes of Laugier and Winckelmann gradually prevailed in Rome. Already in Piranesi's early career we find conscious tributes to Borromini in the plates of his first publication, the *Prima Parte di Architetture e Prospettive* of 1743 (see Fig. 9). Later, the architect was to give particular emphasis to Borromini's stimulating *fantasia* in the text of his polemical book, *Parere su l'Architettura*, issued in 1765 while he was working on the Lateran commission.[11]

In the debate of the *Parere*, Didascolo had pointed out that if the radical Protopiro's functionalist philosophy was right, not only Borromini and Bernini were to blame for heedlessly applying ornament to structure, but also the multitude of designers who created the architectural riches of classical antiquity. (It might be added, in support of Piranesi's defense of originality in the *Parere*, that Borromini himself had asserted in his *Opus Architectonicum*, "I would never have given myself to that profession of architecture with the idea of being merely a copyist."[12])

Among the five versions drawn up by Piranesi in the Avery designs, two schemes shown in the opening drawings (as apparently ordered and numbered by Piranesi himself, with certain discrepancies) present a relatively modest solution involving an apsidal presbytery with an *exedra* (forechoir) flanked by recesses for the choir itself (Fig. 65). This, however, did not affect the existing transept as reconstructed by Giacomo della Porta at the end of the sixteenth century, which featured on its southern wall the fresco of the *Ascension* by the Cavaliere d'Arpino. In this particular solution, the pontifical altar (traditionally sited to the east of the high altar) appears to have remained in its existing position in the transept.

One of these two initial schemes, indicated by Avery Drawings 4 and 5, is represented in the Morgan Library by a vigorous sectional elevation toward the south which reveals Piranesi's keen sensitivity for the rhythms and ornamental vocabulary of Borromini (Fig. 66).[13] In a detailed study, also in the Morgan Library, we see Piranesi's preparatory definition of a Borrominian *aedicule* for this particular scheme.[14] In the other scheme, shown in the opening sheets of the Avery set, Drawings 1 to 3, Piranesi develops and enriches the walls and vault of the presbytery with additional reliefs and further oculi.[15] Another fine preparatory study for the sectional elevation of this design to the south, in the Morgan Library (Fig. 67), indicates Piranesi's earliest idea for developing the tribune with an ambulatory surrounding the presbytery.[16]

Given such an unparalleled opportunity for ornamental display, however, Piranesi was to produce a far more ambitious solution for the tribune—both more visually arresting and a fitting climax to the end of Borromini's dynamic and polychromatic nave. The earliest hints of this concept may be traced back to the experimental decade of the 1740s when, as we have seen, various exploratory ideas on the large columnar interior, focused on a screened apse, were to result in the etching of

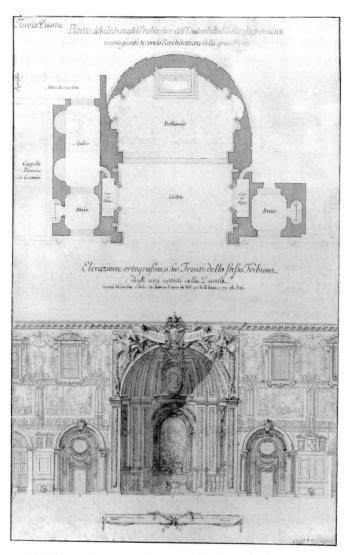

65. Plan and section of proposed tribune looking west.
Presentation drawing (Tavola 4).

the *Entrance to an ancient temple* (see Fig. 5) in the *Prima Parte*.[17] One of the preparatory studies for this particular plate, also in the Morgan Library (see Fig. 4), shows that Palladio's scenic treatment of the east end of Il Redentore in Venice was one of Piranesi's principal sources of inspiration.[18]

The third scheme (as we continue to follow Piranesi's sequence in the Avery set) introduces a major change of plan in Drawing 7 (Fig. 68), involving a monumental columnar screened ambulatory, with the pontifical altar placed in the transept, as shown by the plan of preceding Drawing 6.[19] Although perhaps a question of like minds arriving at a similar solution, it is particularly interesting to find among Borromini's unrealized designs for the sanctuary of S. Carlo al Corso (now in the Albertina, Vienna) a strikingly similar solution.[20] This resemblance is confirmed by the following comment of the early eighteenth-century architect Giuseppe Antonio Bianchi, who had seen Borromini's original designs for the complete transformation of the Lateran, then in the possession of the master's heirs. He wrote:

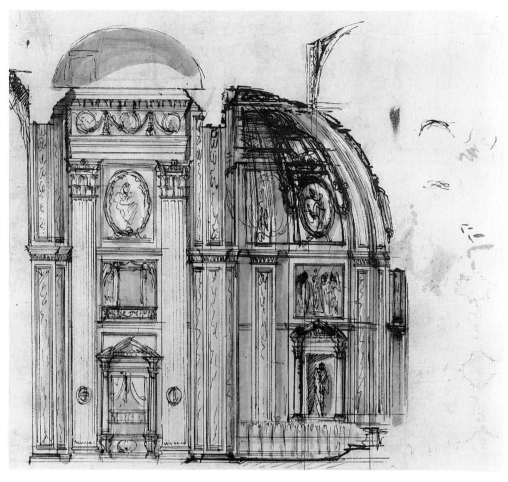

66. Preliminary sectional study for the tribune for Tavola 5
showing south wall of sanctuary.

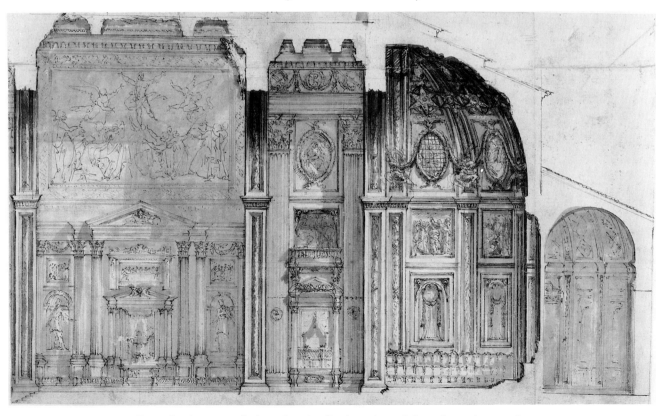

67. Preliminary study for a longitudinal section of the tribune for Tavola 3
showing the south wall of the sanctuary and transept.

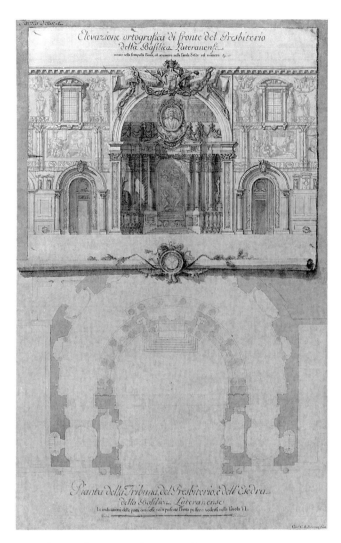

68. Plan and section of proposed tribune for ambitious
third scheme looking west toward the sanctuary (Tavola 7).

The idea of the Cavaliere Borromini was not only to make it [the Lateran]
vaulted, but to create a half-dome at the altar end, and to construct the trib-
une and nave around [i.e. an ambulatory] as in S. Carlo al Corso, but in better
form, as can be seen in his sketches that are still preserved by the Borromini
family.[21]

The elevational treatment of this, Piranesi's ideal solution, is shown in a large and
outstandingly beautiful preparatory drawing in the Morgan Library, added on to a stu-
dio rendering of the entire elevation of the Lateran nave (Fig. 69). [22] Once again the
seminal idea for this design may be seen in the mid-1740s when Piranesi's obsession
with a domed temple containing a vast, freestanding, and curved columnar screen
was resolved in the etched fantasy *Temple of Vesta* (see Fig. 6), also in the *Prima
Parte.*[23] The Morgan Library sectional design is definitively rendered with an
exquisite use of washes in Avery Drawing 8 (Fig. 70).[24] Here we see the subtle manip-
ulation of light introduced from a concealed clerestory over the nave roof, highlight-
ing the screen with an almost theatrical intensity. Again, Piranesi draws on the

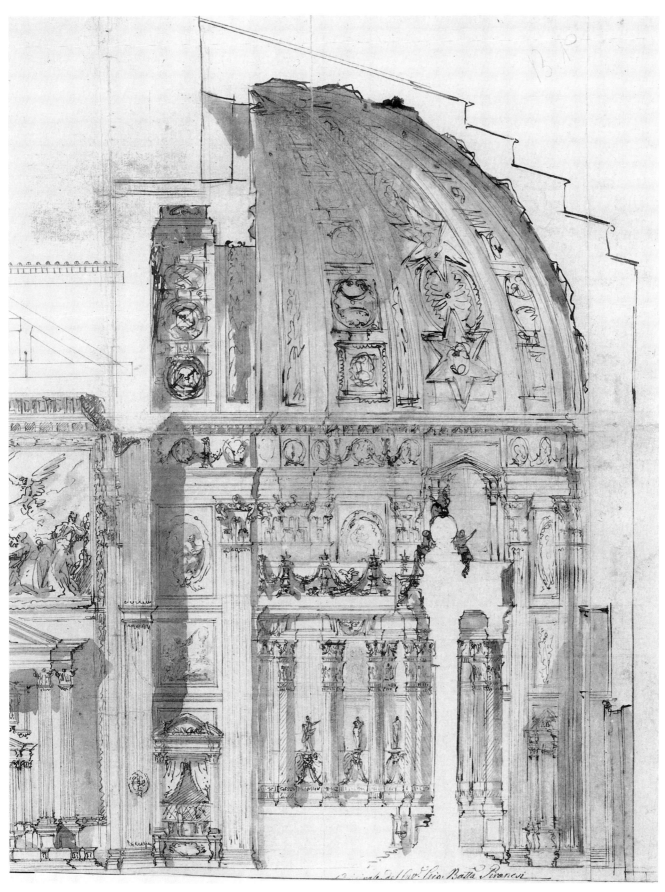

69. Preliminary sectional study (detail) for Tavola 8 of third scheme showing longitudinal section with south wall of sanctuary and part of transept.

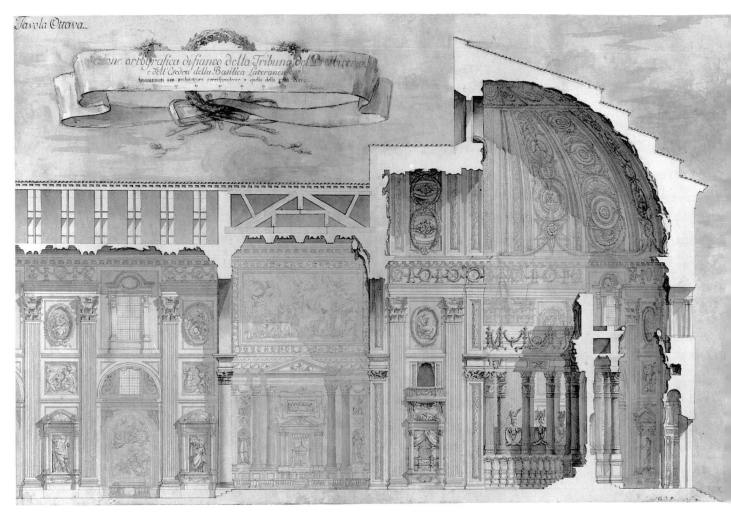

70. Longitudinal section of the third scheme showing south wall of
sanctuary with transept and beginning of nave (Tavola 8).

scenic tradition of Venetian church design, initiated by Palladio and given spectacu-
lar expression by Longhena in S. Maria della Salute—a building of equal importance
to that of Il Redentore in Piranesi's formative years.[25]

Despite the scenic and highly ornate character of the third scheme, it is particu-
larly remarkable how close Piranesi's emphasis on columnar forms in this scheme
comes to the avant-garde ideas of contemporary French neoclassical designers—as for
example, in Jacques-Germain Soufflot's design for Sainte Geneviève (later, the
Panthéon) in Paris.[26] However, while both designers share certain eclectic methods of
composition (in Soufflot's case, an ingenious conflation of Roman thermal planning
and Gothic structure), the comparison also underlines the sharp divergence in their
use of ornament. Indeed, Soufflot's reaction to the Baroque, largely influenced by the
current theories of Laugier in Paris, is palely reflected in contemporary Italian archi-
tecture in the works of Luigi Vanvitelli (a sharp critic of Piranesi by this time), and
can be seen in his Neapolitan church, Santissima Annunziata.[27]

In marked contrast, Piranesi's predilection for extreme richness in ornament—far closer to north Italian designers such as Juvarra or Guarini than to any contemporary source—is emphasized by a group of four specialized decorative studies among the Avery drawings amplifying the third scheme. Drawing 10 (Fig. 71) defines the elevational treatment of the tribune as seen from the rear wall of the ambulatory looking east toward the nave, and is faintly anticipated by a rapid sketch in the recently discovered Modena sketchbook of the 1740s tracing its origins to the *Temple of Vesta* fantasy (see Fig. 6).[28]

A far more detailed study in Drawing 25 (Fig. 72) features the central portico of the rear elevation of the columnar screen and comes remarkably close to the contemporary vignette at the end of the *Parere su l'Architettura* (see Fig. 52), which illustrates this theoretical definition of Piranesi's adventurous eclecticism—a composition displaying a neomannerist richness of surface decoration and anti-Vitruvian language.[29]

Turning, as it were, 180 degrees, Piranesi then provides a study in Drawing 9 (Fig. 73) for the rear elevation of the tribune apse looking toward the west where Borromini's bay system is extended around the enclosing wall.[30] The central panel of the apsidal vault is featured in an extremely powerful study in Drawing 19 (Fig. 74), featuring the Rezzonico eagle, which is closely modeled on the celebrated aquiline relief of SS. Apostoli.[31]

With this sumptuous third scheme providing an ideal solution for a suitable finale to Borromini's nave, Piranesi appears to have then explored the possibility of bringing the papal altar with baldacchino from its existing position in the transept into the forechoir, as shown in the plan with Drawings 11 and 12 (Figs. 75 and 76).[32] In the latter, the baldacchino with its explicit use of Borrominian motifs—winged seraphs, palms, and swags—inescapably recalls the fluency and exuberance of Piranesi's early Venetian designs, uniquely represented in the Morgan Library (color plate 1), and underlines his heroic resistance to the developing restraints of Winckelmann's Rome (Fig. 77).

The Avery set also contains a group of separate designs for the papal altar, several incorporating a reliquary containing the heads of St. Peter and St. Paul (discovered at the time of Urban V in 1368, and a major possession of the Lateran). Three of these studies, largely rendered in a somewhat mechanical manner by a studio assistant (but with evidence of brilliant interventions by Piranesi), pursue this Borrominian idiom to a point where they are actually inscribed "*inventato su lo stile* [or *sul gusto*] *del Boromino* [sic]" (Fig. 78, Drawing 23).[33] However, a fourth study for the altar and baldacchino (Drawing 20, Fig. 79), unmistakably in Piranesi's own hand, represents a major break from the seicento fluency of the entire set of Avery drawings.[34] This design, carried out in a vigorous disjunctive mode of composition, is extremely similar to the bizarre plates of architectural designs added around 1767 to the *Parere su*

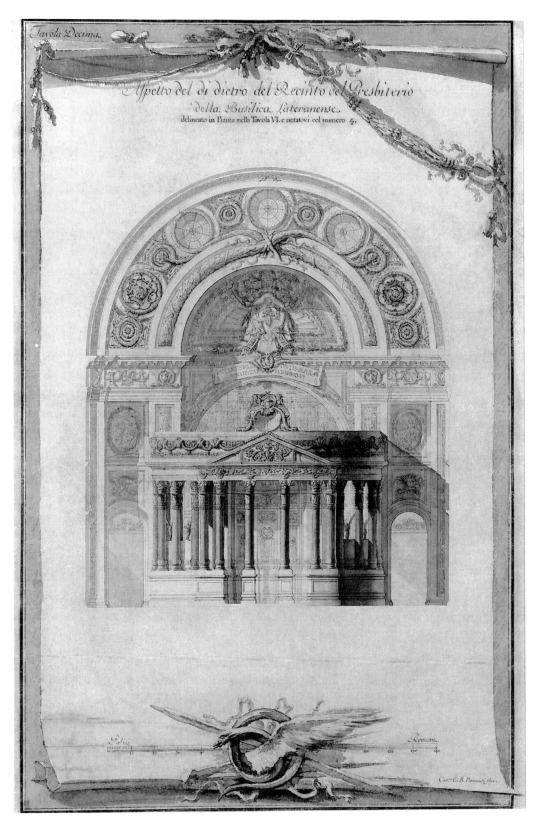

Aspetto del di dietro del Recinto del Presbiterio
della Basilica Lateranense.
delineato in Pianta nella Tavola VI. e notatovi col numero 4.

71. Elevation of the third scheme looking east, showing the colonnade
separating the ambulatory from the presbytery (Tavola 10).

72. Detailed design for the colonnade separating the ambulatory
from the presbytery in third scheme (Tavola 25).

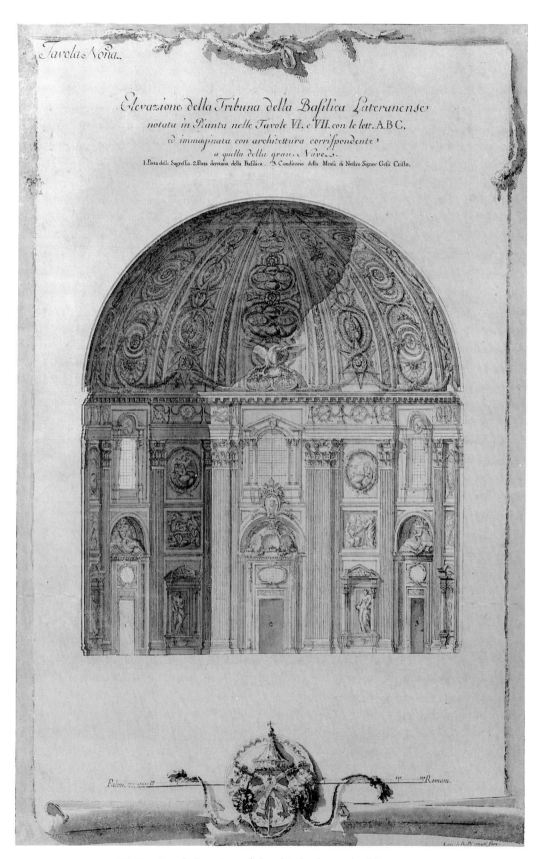

73. Sectional elevation of the third scheme looking west
toward the apse wall (Tavola 9).

74. Detailed design for coffering in apse of third scheme
(Tavola 19), corresponding to Tavola 9.

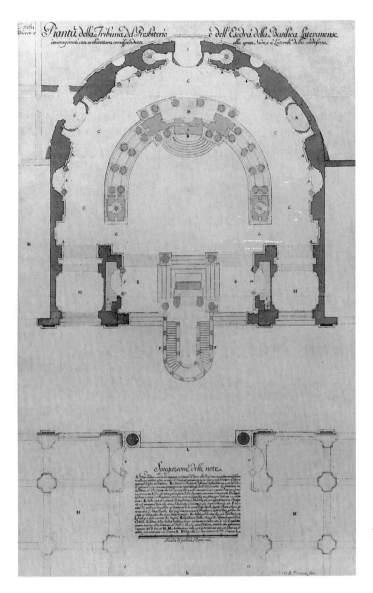

75. Alternative plan for the third scheme
showing papal altar incorporated within
the sanctuary (Tavola 11).

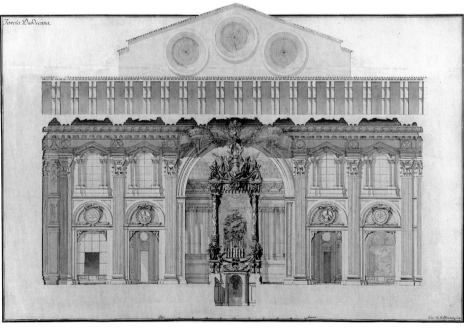

76. Transverse section showing papal altar with baldacchino
set within the sanctuary arch (Tavola 12).

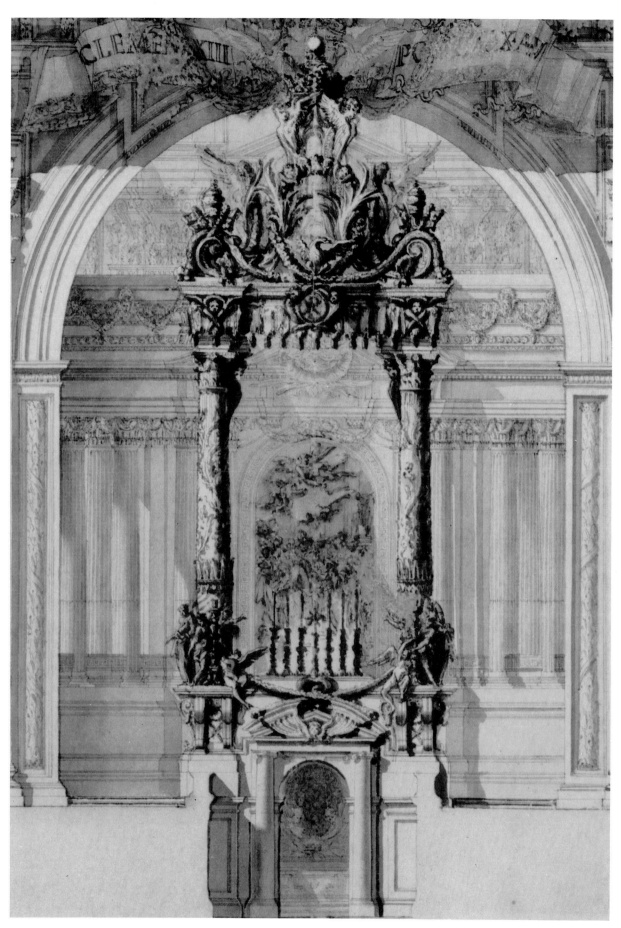

77. Detail of Tavola 12 showing Piranesi's treatment
of the papal altar and baldacchino.

l'Architettura (see Fig. 54).[35] Moreover, thc spccific use of banded columnar reliefs and running fretwork, together with a new solemnity of manner, are reminiscent of the marked change in Piranesi's mode of composition represented by a capriccio drawing in Bologna (see Fig. 50).[36] Here, Piranesi transcends the close imitation of Borromini's forms in favor of a bolder and more personal system of design, which is also evident in the more extreme compositions among the plates of the *Diverse Maniere*, published at the end of the decade.

Since, however, prudence had to be combined with the products of fantasy if this commission for the tribune was to be adopted, Piranesi appears to have decided to unite the extreme richness of the third scheme with the greater practicality of his initial proposals. This apparent compromise resulted in two final schemes, represented by five successive drawings of the Avery set, in which the concept of a columnar apse with an ambulatory (the latter now raised above the sanctuary floor) is implied without the extensive structure required by the ideal scheme.[37] In the penultimate scheme Drawings 14, 15, and 16, the composition focuses on a large altarpiece set against a closed apse and flanked by exceptionally elaborate candelabra with support-

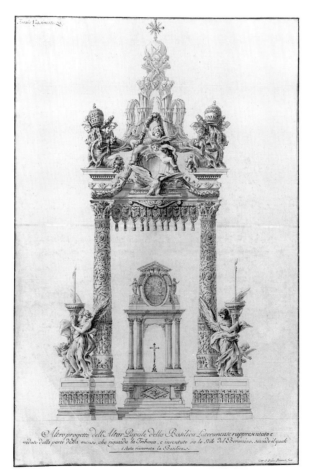

78. Alternative design for papal altar with baldacchino,
flanked by angels bearing candelabra,
executed in a studio hand (Tavola 23).

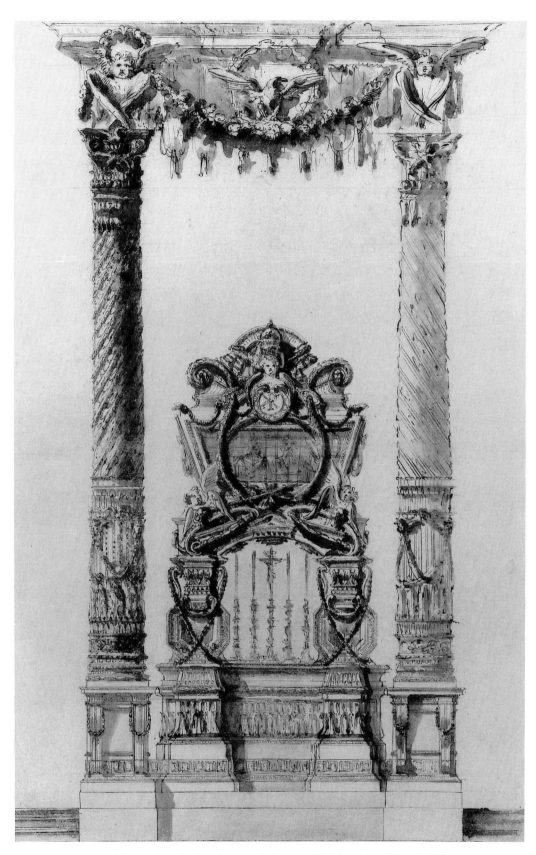

79. Alternative design for papal altar and baldacchino (Tavola 20).

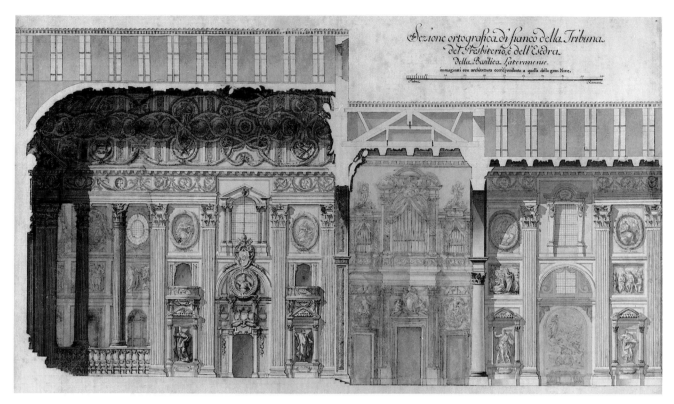

80. Longitudinal section of tribune showing north wall of sanctuary
with transept and beginning of nave (Tavola 18).

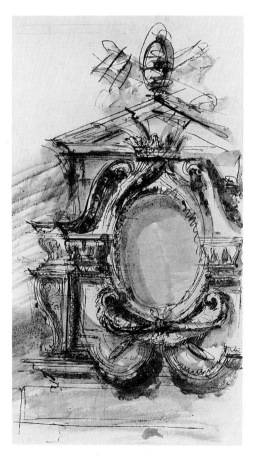

81. Study for a papal monument.

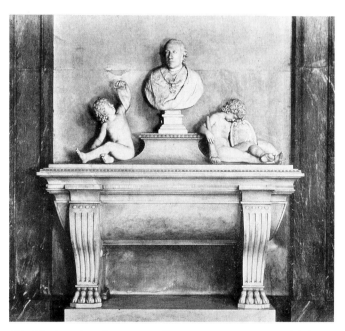

82. Christopher Hewetson. Funerary monument with bust
of Cardinal Giovambattista Rezzonico (d. 1783).

ing figures.[38] In what is perhaps the finest of all the Avery designs, Drawing 15 (color plate 2), Piranesi presents this monumental tableau with all the resources of his scenic ability and Venetian taste for emotive lighting. As before, the architect is anxious to involve the papal altar and baldacchino within this sumptuous composition, and, in order to achieve this, in the final and fifth scheme (Drawings 17 and 18, Fig. 80), he extends the presbytery by a further group of Borrominesque bays in order to provide a linking theme with the powerful rhythmic system of the nave.[39]

In addition to this abundance of information relating to Piranesi's approach to the greatest challenge of his career, as provided by the Morgan and Avery drawings, there also survive a few sheets of decorative studies related to the Lateran commission—principally, studies for papal monuments as represented by a handsome sketch in the Morgan Library (Fig. 81).[40] While an effective comparison with contemporary religious architecture in Rome is difficult, evidence of other contemporary solutions for monuments and tombs may place Piranesi's designs within a certain perspective. In considering the simple, classicizing nature of the funerary monument executed by the British sculptor Christopher Hewetson in 1783 for Piranesi's chief patron and nephew of the pope, Cardinal Giovambattista Rezzonico in S. Nicola in Carcere (Fig. 82), the question arises whether the Lateran scheme was abandoned in 1767 for reasons of taste as much as finance.[41] As already mentioned, the pope (whose own monument was carried out by Canova far later in even stricter neoclassical austerity) had been swift to recognize the significance of Winckelmann's scholarship, while promoting the extremely diverse genius of Piranesi in more private and personal commissions. What was still largely acceptable in Rome during the early 1760s was to appear markedly old-fashioned by the close of the decade. And, perhaps, in final analysis it should be added that the brilliance of Piranesi's visionary Lateran survives more effectively in the virtuosity of his pen and wash drawings than in the reality of an executed building.

Since the cross-fertilization of ideas is already familiar in the work of Piranesi, it should come as no surprise to find the concepts for the Lateran tribune represented again, but on a far more modest scale, in the execution of his other architectural commission of these years. In Piranesi's reconstruction of the priory church of the Order of Malta, S. Maria del Priorato, his innovative system of composition created one of the minor masterpieces of eighteenth-century church design.

Notes

1. Piranesi's plates from that date were inscribed: "Presso l'Autore a Strada Felice nel Palazzo Tomati vicino alla Trinità de'monti." The title "Cavaliere" was added to his name on plates from 1767 after Clement XIII conferred on him the order of the *Sperone d'Oro* in 1766.

2. Piranesi was admitted as an Honorary Fellow of the Society of Antiquaries of London on April 7, 1757 (Robert Adam was elected a Fellow in 1761, and Johann Joachim Winckelmann an Honorary Fellow in 1760). In 1761 he was elected to the Accademia di San Luca and from 1772 onward was deeply involved in a contro-

versy over the proposed monument to the architect Balestra in Santi Luca e Martino. See Bertelli 1976a, 117-20.

3. "Sebbene ciò di che io piuttosto tener debbo, si è; che non sembrino inventate a capriccio, più che prese dal vero, alcune cose di questa delineazione del Campo; le

quali se taluno confronta coll'antica maniera di architettare, comprenderà, che molto da essa si discostano, e s'avvincinano all'usanza de' nostri tempi. Ma chiunque egli sia, prima di condannare alcuno d'impostura, osservi di grazia l'antica pianta di Roma . . . osservi le antiche ville del Lazio, quella d'Adriano in Tivoli, le terme, i sepolcri, e gli altri edifizi di Roma, che rimangono in ispezie poi fuori di Porta Capena: non ritroverà inventate più cose dai moderni, che dagli antichi contra le più rigide leggi dell'architettura. O derivi pertanto dalla natura e condizione delle arti, che quando sono giunte al sommo, vanno a poco a poco in decadenza e in rovina, o così porti l'indole degli uomini, che nelle professioni ancora reputansi lecita qualsisia cosa; non è da maravigliarsi, se troviamo eziandio dagli architetti antichi usate quelle cose, che nelle fabbriche nostrali talvolta biasimiamo." *Il Campo Marzio dell' Antica Roma,* 1762. (English translation quoted from Scott 1975, 166-67.)

4. For an assessment of Clement XIII and members of the Rezzonico family as patrons, see Pastor 1950, vol. 36, 176 ff.; see also Clark 1965, 30-31, on Clement's nephew Cardinal Giovambattista Rezzonico.

5. The portrait of Clement XIII in the front of *Della Magnificenza,* etched by Piranesi with the help of Domenico Cunego, pays tribute to the pope's taste for lavish ornament by including in the background the sumptuous bases of a column in the Baptistry of Constantine, illustrated in plate IX of that work— a monument which was to inspire Piranesi's designs for the tribune of the nearby Lateran.

6. The seventeenth- and early eighteenth-century work at the Lateran is described in Wittkower 1973, 212-13, 382-83. The twelve Apostles in the tabernacles of Borromini's nave were added under Clement XI between 1700 and 1715.

7. Published in Montaiglon and Guiffrey 1901, vol. 2, 489, no. 5696.

8. Stampfle 1978; Fischer 1968 a and b.

9. The twenty-three presentation drawings were initially published in 1972, see Nyberg 1972, and subsequently reissued in a catalogue of larger format, see Nyberg and Mitchell 1975. The drawings were later included, together with Lateran designs from the Morgan Library, in the 1992 Rome exhibition, see Wilton-Ely and Connors 1992.

10. Clement XIII conferred the *Sperone d'Oro* on Piranesi during a visit to the recently completed S. Maria Aventina in 1766. From 1767 onward, Piranesi added "Cavaliere" to his signature on plates.

11. In the *Prima Parte* Piranesi uses the plan and roof of Borromini's S. Ivo della Sapienza as an ingredient in the *Mausoleo Antico* (Fig. 9), and its spiral cupola appears twice in the *Prospetto d'un regio Cortile* (reproduced in Robison 1986, 86).

12. Borromini, *Opus Architectonicum* (Rome, 1725), preface.

13. Nyberg and Mitchell 1975, 284: no. 4 *(Tavola Quarta), Plan and View of sanctuary from the transept;* no. 5 *(Tavola Quinta), Longitudinal section showing south wall of sanctuary with transept and beginning of nave;* Stampfle 1978, xxv (no. 57).

14. Stampfle 1978, xxv, no. 58.

15. Nyberg and Mitchell 1975, 283-84, no. 1 *(Tavola P'ma [Prima]), Plan of sanctuary;* no. 2 *(Tavola Sec'da [Seconda]), Cross section showing west wall of transept and view into sanctuary;* no. 3 *(Tavola Terza), Longitudinal section showing south wall of sanctuary with transept and beginning of nave.*

16. Stampfle 1978, xxv, no. 56.

17. The evolution of this concept of the columnar interior with screened apse is traced in Wilton-Ely 1978b, 21-22.

18. Stampfle 1978, xxxii, no. A2.

19. Nyberg and Mitchell 1975, 284-85, no. 6 *(Tavola Sesta) Plan of sanctuary with screen of columns and ambulatory;* no. 7 *(Tavola settima) Plan and view of sanctuary from the transept.*

20. Albertina (159). See Portoghesi 1967, 160, fig. cxxvii.

21 Quoted in ibid.

22. Stampfle 1978, xii, xxv, no. 55, *Longitudinal section through length of nave looking toward the south wall, with proposed scheme for alteration of west end.* In this large drawing, unfolding to a length of almost five feet, some two-thirds is given over to a mechanical transcription of Borromini's wall system, probably by an assistant, but the proposed changes at the west (liturgically the east) end are indicated in an extremely free manner, with extensive use of washes, by Piranesi himself.

23. Preliminary ideas for the composition, finally resolved in the etched plate *Temple of Vesta* in the *Prima Parte,* are found on one of the pages in the recently discovered notebooks at Modena. See Cavicchi and Zamboni 1983, 205-6, fig. 102, and in a more developed design in the British Museum (1908-6-16-22) fig. 103.

24. Nyberg and Mitchell 1975, 285-86, no. 8 *(Tavola Ottava), Longitudinal section showing south wall of sanctuary with transept and beginning of nave.*

25. This scenographic tradition in Venetian church design is examined in Wittkower [1957] 1975, 126 ff.

26. Braham 1980, 73 ff.

27. See Wilton-Ely 1979, 95-96. Vanvitelli, highly dismissive of Piranesi, wrote to his brother, "if they were to get Piranesi to carry out some building, one could see what would come out of a madman's head, without any sound basis. Nor should a lunatic complete the tribune at S. Giovanni Laterano, even though Borromini, who restored the church, was not particularly level-headed, and if it is to be Panini, it would be a *quid simile* to Piranesi." (Pane 1973, 12, 42, no. 15. See also De Seta 1983, 103 ff.)

28. Nyberg and Mitchell 1975, 286-87, no. 10 *(Tavola Decima), Elevation looking from the east, showing the colonnade separating the ambulatory from the presbytery.* For the Modena drawings related to the Temple of Vesta plate, see note 23.

29. Ibid., 291, no. 25 *(Tavola Vigesimaquinta), Design for colonnade separating the ambulatory from the presbytery with alternate version of attic to left.* Dorothea Nyberg points out the stylistic similarities with the vignette in *Parere su l'Architettura*, 291.

30. Nyberg and Mitchell 1975, 286, no. 9 *(Tavola Nona), Cross section showing rear of apse facing west.*

31. Ibid., 290, no. 19 *(Tavola Decimanona), Panel of vaulting coffers, corresponding to drawing 9.* The aquiline relief of SS. Apostoli refers to the Rezzonico coat of arms, which features a double-headed eagle at the center. Piranesi used this classical motif on a number of occasions, notably the title page of *Della Magnificenza* (dedicated to Clement XIII) and years later on the title page to Volume II of the *Vasi, Candelabri, Cippi, Sarcophagi.*

32. Ibid., 287-88, no. 11 *(Tavola Undecima), Plan of sanctuary with screen of columns and ambulatory;* no. 12 *(Tavola Duodecima), Cross section showing projected west wall of transept with baldacchino placed inside sanctuary arch.* No. 12, almost entirely in the hand of an assistant except for the baldacchino itself, is the only cross section of the transept by Piranesi showing his intention to remodel the western wall in a Borrominian manner, in contrast to nos. 2, 4, and 7, which retain the existing design.

33. Ibid., 291, no. 21 *(Tavola Vigesimaprima), Plan and Elevation of papal altar and baldacchino,* according to the inscription "inventato sul gusto del Boromino, secondo il quale è stata rinnovata la Basilica"; no. 22 *(Tavola Vigesimaseconda) Papal altar and baldacchino, flanked by elaborate candelabra;* no. 23 *(Tavola Vigesimaterza) Papal altar and baldacchino flanked by elaborate candelabra,* according to the inscription "inventato su lo stile del Boromino." All three drawings appear to be by the same hand, and the character, as well as the handling of the ornament, is rather dry and over-elaborate.

34. Ibid., 290, no. 20 *(Tavola Vigesima), Papal altar and baldacchino.*

35. The drawing, clearly by Piranesi throughout, shows a similar technique to surviving preparatory studies for these additional plates to the *Parere.* See Chapter 2, note 20.

36. See Chapter 2, note 18. Drawing No. 20 has the same banded column reliefs, running fretwork, and columns with spiral fluting and idiosyncratic capitals involving swags and figurative ornament as found in the Bologna composition.

37. Nyberg and Mitchell 1975, 288-90, no. 14 *(Tavola Decimaquarta), Plan of sanctuary with ambulatory;* no. 15 *(Tavola Decimaquinta), Cross section through the choir, corresponding to no. 14;* no. 16 *(Tavola Decimasesta), Longitudinal section showing south wall of sanctuary with transept and beginning of nave;* no. 17 *(Tavola Decimasettima), Plan of sanctuary;* and no. 18 *(Tavola Decimaottava), Longitudinal section showing north wall of sanctuary with transept and beginning of nave.* While nos. 14, 15, and 16 are related, the remaining two, 17 and 18, appear to belong to a final solution involving an extension of the choir by two bays. (See note 39).

38. The composition of an altar flanked by candelabra comes close to a vigorous sketch design in the Morgan Library (Stampfle 1978, p. xv, no. A5) attributed by Manfred Fischer to the Lateran scheme (Fischer 1968, 208) but is almost certainly an early idea for the altar of S. Maria del Priorato (see Fig. 102).

39. Ibid. 289-90, no. 17 *(Tavola Decimasettima), Plan of sanctuary* no. 18 *(Tavola Decimaottava),* and *Longitudinal section showing north wall of sanctuary with transept and beginning of nave* (Fig. 80). These remaining two drawings appear to belong to a solution similar to that represented by nos. 14, 15, and 16. The choir is now extended by two further bays to the west, and the ambulatory passage behind the main altar wall rejected. In the apse the large columns have been set against a blind wall on top of a continuous pedestal with niches set into the wall in each intercolumniation.

40. Stampfle 1978, xxx, no. 110. The verso of this sheet (repr. ibid., 97) has a fragment of the ground plan of the Lateran tribune represented by no. 4 *(Tavola Quarta).* This sheet was originally contiguous with no. 58 in the same collection, which has a study for a bay related to no. 5 *(Tavola Quinta),* and on its verso an earlier study for the tabernacle frame for that bay with the geometric structure outlined. Other possible sketches or studies for ornamental features or monuments to be incorporated in the Lateran scheme include a design for an ornamental frame and cartouche in the Morgan Library with a fragmentary study for the title page of *Le Antichità d'Albano e di Castelgandolfo* (1764) on its verso (ibid., xxvii, no. 71), and a sketch for a papal cartouche in the same collection (ibid., xxx, no. 111).

41. See Hodgkinson 1958, 42 ff.

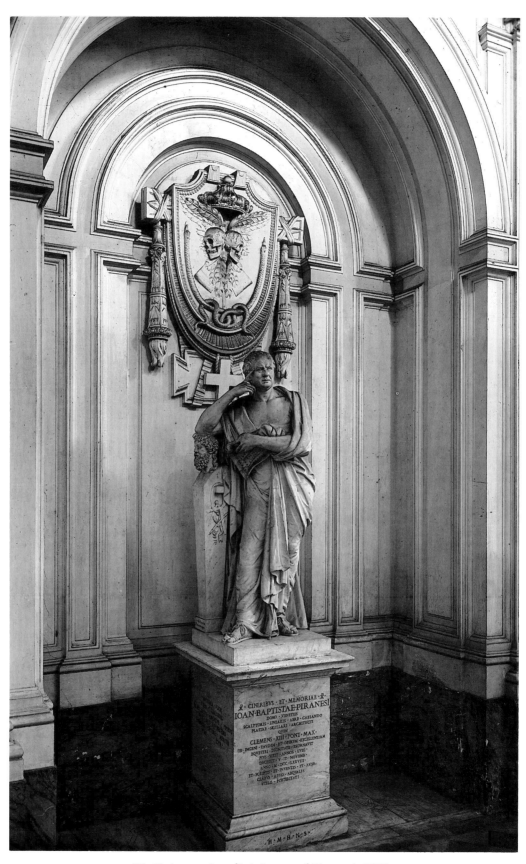

83. Guiseppe Angelini. Statue of Piranesi, 1779.

4

The Remodeling

of

S. Maria del Priorato

When he died on November 9, 1778, Piranesi was laid to rest in his only executed work of architecture, the priory church of the Knights of Malta on the Aventine. His body had been transferred from his local church, S. Andrea delle Fratte, at the direction of his leading patron Cardinal Giovambattista Rezzonico, grand prior of the order. A year later Piranesi's family replaced the artist's self-designed monument— an imposing marble candelabrum (Fig. 84)—with Angelini's statue of him (Fig. 83), dressed *all'antica* with architect's instruments and a plan of the Temple of Neptune at Paestum, which he had recently surveyed and etched.[1] However, Angelini's frozen image, reflecting the neoclassical restraint of the times, scarcely does justice to the dynamic spirit of Piranesi, who had refused to be inactive even in his last hours of life. In the terms of Christopher Wren's epitaph in St. Paul's Cathedral, *si monumentum requiris, circumspice,* it is the skillfully reconstructed church and buildings of S. Maria del Priorato that remain the most eloquent testimony to Piranesi's ideals and achievements as architect and designer. It is particularly rewarding to examine this building and its related structures in some detail, since they demonstrate the architect's creative use of fantasy combined with a complex system of symbolism—both derived from classical antiquity for contemporary use.[2]

Piranesi's remodeling of S. Maria del Priorato between 1764 and 1766 occurred at a critical moment in his career when he was formulating his new system of design, as advocated in his polemical publication of 1765, *Parere su l'Architettura* (see Fig. 52). Indeed, his approach to the Aventine commission and, in particular, the handling

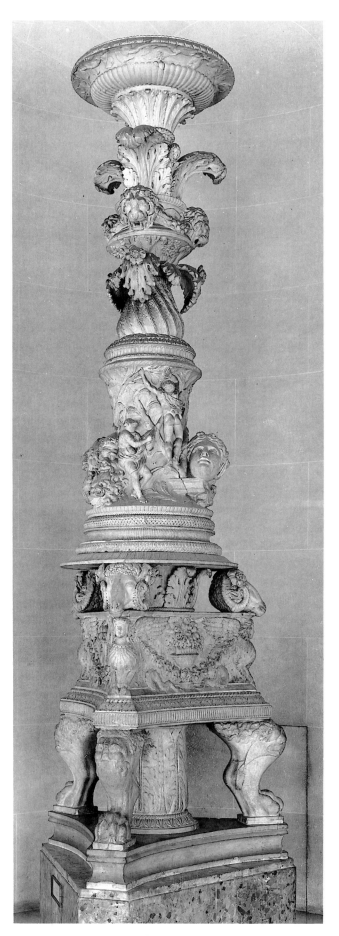

84. Piranesi's funerary candelabrum.

of the decorative scheme may be seen as a trial run for these innovative ideas. The debate in the *Parere* between two architects—the functionalist Protopiro and the imaginative Didascolo—represented Piranesi's reaction against the austere, restrictive theories launched a decade earlier in Laugier's *Essai sur l'Architecture*. Piranesi, opposing what he considered to be the sterile monotony of Laugier's approach (which, if pushed to its logical conclusion, he claimed, would have resulted in a tabula rasa), provided in the additional illustrations of the *Parere* a series of bizarre designs composed from an exceptionally wide range of sources—Greek, as well as Etruscan, Roman, and even Egyptian (see Fig. 54).[3] In these compositions, polemically exaggerated to stress the liberating advantages of this imaginative attitude toward antiquity, Piranesi sought to emulate the Roman fertility of invention (and, by implication, that of their Etruscan predecessors) as well as the decorative richness of the Late Empire.

Similar to the contemporary project for the Lateran tribune, the Aventine commission originated from Rezzonico patronage, this time from Clement XIII's cardinal nephew Giovambattista.[4] In 1769, Piranesi dedicated his definitive testament of design, the *Diverse Maniere,* to the cardinal as the model patron for his experimental work —the very kind of patron whom Piranesi had found so notably lacking when he first arrived in Rome some twenty years earlier. Piranesi was to receive other forms of practical encouragement from the cardinal, who also commissioned an interior scheme with elaborate furnishings for his Quirinal apartments (see Fig. 116).[5] It was also to him that Piranesi presented the specially embellished designs for the Lateran tribune after the project had been abandoned in 1767.[6] Moreover, it is probably through this same patron's recommendation that Piranesi received the knighthood of the *Sperone d'Oro;* the investiture taking place in the completed priory church when the pope visited it in October 1766.[7]

The priory of the Knights of Malta had first been established on the Aventine toward the end of the fourteenth century.[8] At that time, the order had left its earlier headquarters in a former monastery of Basilian monks in the Forum of Augustus to occupy the remains of a Benedictine convent, S. Maria de Aventina, at the southern end of the hill overlooking the Tiber. It was not until 1566 that the dilapidated church was rebuilt by the prior, Cardinal Bonelli, and the adjoining buildings were enlarged to become the Villa di Malta (Fig. 85). During the next century, embellishments by Prior Benedetto Pamphili were to include an arcaded upper story to the villa and a Kaffeehaus in the grounds. He was probably also responsible for laying out what is still one of the loveliest gardens in Rome, featuring an avenue of laurel framing a celebrated vista of St. Peter's dome.

By the eighteenth century the priory buildings were badly in need of a thorough renovation, and Piranesi's activities there are documented in an exceptionally detailed statement in an account book, now in the Avery Library.[9] This was compiled

85. Modern plan of priory buildings and garden with
Piranesi's entrance screen and piazza.

from the daily work sheets of the *capromastro muratore* (foreman) Giuseppe
Pelosini, and covers the period from November 2, 1764, to October 31, 1766, its 384
quarto pages with 762 specified entries detailing every aspect from basic structural
repairs to the minutest detail of the lavish ornamental scheme. The book was pre-
sumably submitted to the prior at the completion of the work, after Piranesi had
endorsed the total amount of 10.947.29½ scudi on April 10, 1767.

While the precarious structure of the church's foundations and vault received
immediate attention, Piranesi's impressive approach must be considered first for this
was clearly intended to announce the specific character of the priory church and the
iconographic themes of its decorative program. Up until this time, the unprepossess-
ing extension of the ancient road *Vicus Armilustri* (the modern Via di S. Sabina) had

given access to the priory. An abundance of vineyards, orchards, and gardens lay to the south, providing an arcadian setting for the ceremonial piazza which Piranesi was to create by widening the extension of the *Vicus Armilustri* into a rectangular space outside the priory walls (now the Piazzale de' Cavalieri di Malta, see Fig. 85).

To the north of this piazza, against the garden wall of the priory and on the axis of the laurel avenue, the architect placed an entrance screen with a pair of rectangular blind niches to either side, topped with a small pediment with urns and ball finials (Fig. 87). Along the opposite northern wall of the piazza he set a group of three *stelae* (commemorative pillars) bearing decorative reliefs, the outer ones flanked by obelisks (Fig. 89). The entire composition was ornamented with additional urns and finials and on the shorter end wall to the east of the piazza, he placed another *stela* between obelisks with an inscribed tablet recording the circumstances of the commission.[10] Today, the growth of cypresses and the later buildings of S. Anselmo have dwarfed a composition which, in Piranesi's time, set against distant views of the Roman campagna, would have evoked a mood of martial solemnity (Fig. 88).

Among some nine surviving drawings by Piranesi for the Aventine commission is a preparatory design for the entrance screen, now in the Kunstbibliothek, Berlin (Fig. 86).[11] This design shows the basic form of the executed building as derived from a Palladian source, the decorative treatment being still relatively conventional at this stage.[12] On the same sheet there are a number of random sketches for decorative motifs which can be connected with various plates (published some four years later) among the chimneypiece designs of the *Diverse Maniere,* indicating the development of the architect's new mode of composition (see Fig. 61).[13] By the time the decorative reliefs of the entrance screen were executed, however, they were to possess a fluency of expression and thematic complexity far beyond the summary indications found in the Berlin design.

The iconography of the Order of Malta, both naval as well as military, was readily available on funerary monuments and in its publications.[14] Predictably, Piranesi sought Roman equivalents from the reliefs on various triumphal arches and on the base of Trajan's Column. More specifically, however, he appears to have drawn inspiration from a group of six ceremonial reliefs in S. Lorenzo fuori le Mura (now in the Capitoline Museum).[15] One of these also provided motifs for the lintel on a chimneypiece design in the *Diverse Maniere* (see Fig. 128).[16] On this relief, to one side of a candelabrum, appear in order an *aplustre* (the fan-like terminal of a warship's stern), an anchor, a *cheniscus* (the swan's head terminal ornament of a ship's prow), a steering paddle, the prow of a warship with triple-sword ram, and a *bucranium* (an ox skull ornament).[17] The Capitoline version of the warship appears on the keystone of the Aventine screen and had previously appeared in an ornamental letter of the *Antichità Romane*, while the other prow on the keystone had appeared in the title page to the treatise *Della Magnificenza ed Architettura de' Romani*.[18] The flanking

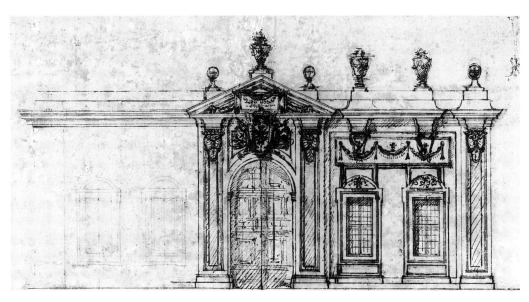

86. Preliminary design for screen (detail).

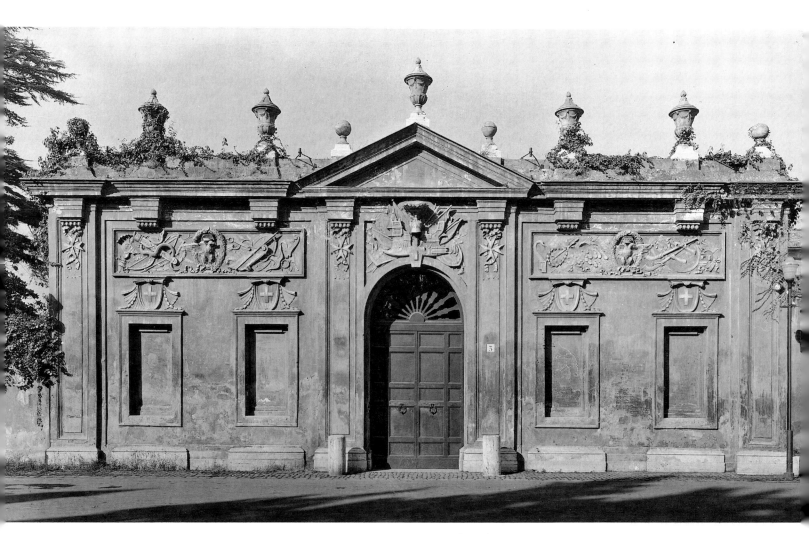

87. Entrance screen to the priory.

88. Giuseppe Vasi. Etched view of the Aventine (detail) looking toward
the Pyramid of Cestius and S. Paolo fuori le Mura from the Tiber with
Piranesi's newly completed church to the left, 1771.

89. Piazzale de' Cavalieri di Malta looking southwest.

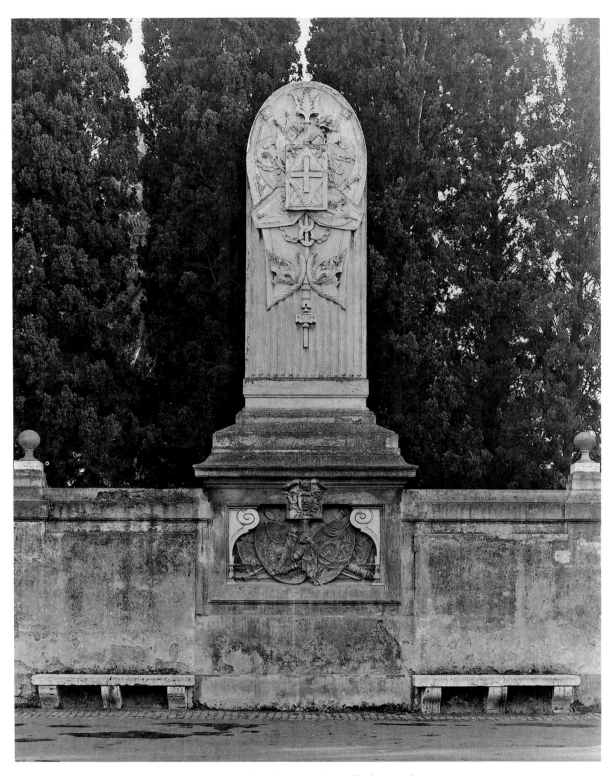

90. Central *stela* on south wall of piazzale.

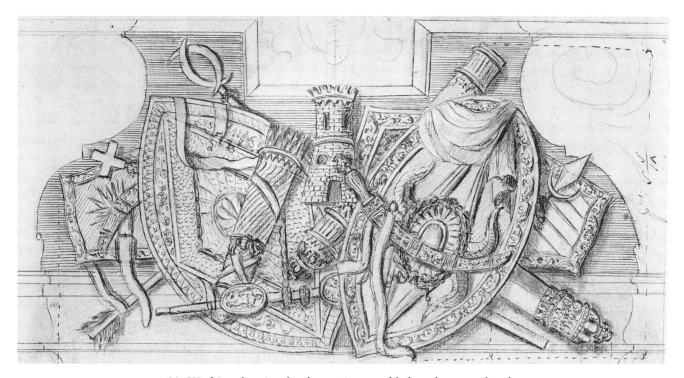

91. Working drawing for decorative panel below the central *stela*,
with trophies and Rezzonico insignia.

reliefs extend this iconography to the family emblems of the Rezzonico family. Apart from the embattled tower of their coat of arms, even the twin-headed eagle within a wreath of oak leaves is derived from antique precedent—the celebrated aquiline relief, originally in Trajan's Forum but later removed to the porch of SS. Apostoli, which had also inspired certain decorative features in Piranesi's Lateran tribune (see Fig. 74), as mentioned earlier.[19]

Most of these motifs also appear on the reliefs of the central *stela* across the piazza where they are arranged in a more monumental and arcane composition (Fig. 90). A remarkably fine working drawing for the lower of the two reliefs, now in the Morgan Library (Fig. 91), shows the care with which Piranesi's images were rendered, and it is extremely likely that specific elements, such as the (missing) head of Medusa, were also closely controlled by similarly detailed studies.[20]

It is the reliefs on the two flanking *stelae* (Fig. 92), virtually identical in their compositions and represented in the Morgan Library by a working drawing for the righthand one (Fig. 93), that provide a group of symbols connected with a completely new theme.[21] A fresh layer of iconography can now be seen to operate, stemming from Piranesi's continuing controversial claims for the Etruscan origins of Italic culture. In his *Apologetical Essay in Defence of the Egyptian and Tuscan Architecture*, which prefaced the plates of the *Diverse Maniere* in 1769, he was to return to a discussion of Etruscan originality introduced eight years before in *Della Magnificenza.* By way of illustration, he supplied a chart (see Fig. 60) in which he tells us "it will

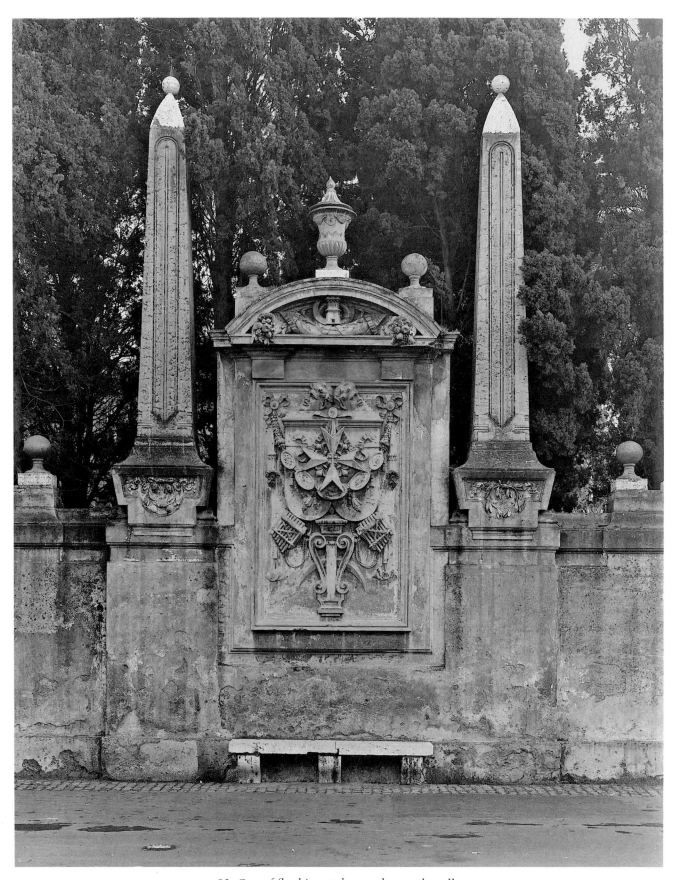

92. One of flanking *stelae* on the south wall.

93. Working drawing for the decorative relief of the righthand *stela*,
with Maltese, Rezzonico, and Etruscan symbols.

appear that we are indebted to the Tuscans [Etruscans] for a variety of inventions useful in human life, as sacred, military, civil, politic, public, and private." From the 114 items in this controversial anthology there appear over twenty motifs from the Aventine buildings, many of them having no direct connection with Rezzonico heraldry or even the Order of Malta—for example, the lyre, cameo, cornucopia, serpent, bird's wing, and shepherd's pipes.[22]

Although these motifs appear at random on the chimneypieces and certain pieces of furniture of the *Diverse Maniere* (see Fig. 61), on the piazza reliefs they possess considerable historical resonance, for Piranesi was well aware of the special place the Aventine enjoyed in the earliest history of Rome.[23] Among the Seven Hills, it alone was set outside the *Poemerium* (sacred area) bounded by the Severan city walls, mainly due to the hill's association with foreign (that is, non-Roman) cults and later with colonies of traders, particularly those from Etruria. By the mid-fourth century a substantial number of foreign cults had been established on the Aventine, many originating with the Etruscans. While it is unwise to place too much weight on the fact, it is nevertheless interesting to note that the symbols associated with a number of these deities appear on the piazza reliefs. To take but one example, the shrine of the Bona Dea was believed to be on the site of the priory itself, and the serpent sacred to this goddess of healing appears prominently on various reliefs in the piazza (see Fig. 86) and throughout the priory church (see Figs. 97 and 106), also providing a symbol of the order's medical functions.[24]

In dedicating the *Diverse Maniere* to Cardinal Rezzonico in 1769, Piranesi recalled various works of architecture undertaken for his patron's family. Because of the abandoning of the Lateran project, he laid particular emphasis on the Aventine church, which had been "rinovato, anziché ristorato" (renewed rather than merely restored). Bearing in mind the modest form of the original sixteenth-century church, this was no overstatement.

The church, erected in the sixteenth century at the southwestern angle of the hill, was a simple rectangular structure consisting of a nave of four bays with rudimentary transepts and a shallow apse at the east end. Its only external decoration was the pedimented west front, articulated by pairs of pilasters at the outer edge to either side of a pedimented doorway with a circular window above (Fig. 94).[25] Since the ground fell away steeply in two directions, the most prominent view of the facade was obtained below from the bank of the Tiber and the ancient *Via Marmorata* (see Fig. 88). Therefore, in order to give this modest facade a degree of pomp, Piranesi added an attic story (later destroyed by French artillery during the Risorgimento but shown in a drawing in the Soane Museum, originally owned by Robert Adam, Fig. 95), while the existing elements were transformed by applying finely balanced incrustations of stucco ornament over its entire surface (frontispiece).[26] Here, Piranesi's debts to the delicate ornamental fantasies of cinquecento

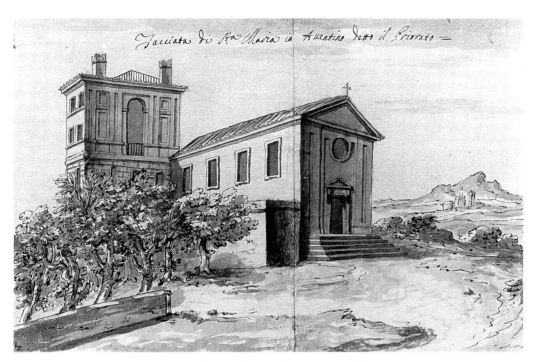

94. Seventeenth-century drawing by unknown artist of S. Maria del Priorato
showing the building before renovation by Piranesi.

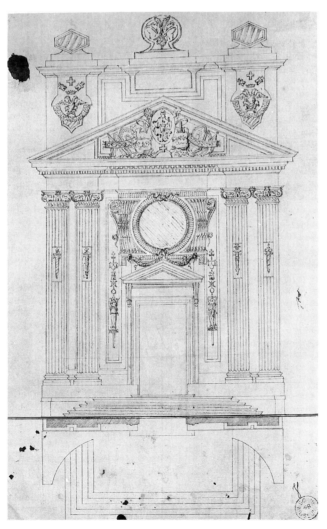

95. Late eighteenth-century elevation of
Piranesi's façade by unidentified hand.

Mannerists, particularly Pirro Ligorio, can be observed, and, under strong light, the general effect of the resulting composition assumes the graphic precision of one of Piranesi's own etched plates.[27] The strange mode of the facade's composition, with its brittle disjunction of form and collage-like assembly of highly diverse motifs, is an explicit demonstration of the theories set out and illustrated in the contemporary *Parere su l'Architettura* (see Fig. 54).

On this facade, military, Rezzonico, and Etruscan motifs from the piazza are repeated, intricately combining the designer's archaeological and aesthetic preoccupations. The Rezzonico tower is ingeniously set within the Ionic capitals with their confronted sphinxes, closely following the antique versions at Villa Borghese and in Robert Adam's collection (see Fig. 57).[28] Even the fret serving as a frieze has topical relevance deriving from Etruscan tomb decorations at Chiusi, as illustrated in the *Parere*.[29] Although little evidence survives for the evolution of Piranesi's facade design, two preliminary studies exist for the ceremonial swords on the pilasters. An example in the Morgan Library (Fig. 96) is virtually identical to the far lefthand sword as executed, while the other, in the British Museum, is a rejected variant for one of the righthand ones.[30]

A completely new feature, however, is introduced at the center of the facade (Fig. 97) later to be highlighted within the church—a reeded sarcophagus with circular wreathed panel (skillfully incorporating the existing cinquecento window), accompanied by flanking console brackets entwined with serpents—a motif which appears on two of the chimneypiece designs in the *Diverse Maniere*.[31] The sarcophagus denotes the funerary nature of the priory church, for it contained tombs of the order's illustrious dead and their martial achievements are symbolized by the antique standards flanking the entrance with the initials F E R T (*Fortitudo eius Rhodum tenuit*), referring to the knights' heroic defense of Rhodes.

Inside the church, the brittle flatness of the facade reliefs is exchanged for an impressive sense of space in which the cool white interior (Fig. 98) culminates in the intensified drama of the high altar (Fig. 99). Rudolf Wittkower has shown how Piranesi, working within the restrictions of the sixteenth-century structure, introduced various scenographic devices of Venetian church design, as already worked out in certain of his early architectural fantasies (see Fig. 4).[32] Undoubtedly this particularly un-Roman tradition in liturgical planning also derives from the most elaborate of Piranesi's schemes for the Lateran tribune. There he had set a highly sculptural altar against an apsidal screen of columns, all of which were amplified by the sensuous effects of concealed lighting (see Fig. 68).

The Aventine altar, which is the key feature of this impressive vista, understandably exercised Piranesi's greatest imaginative powers both in terms of its thematic and visual impact. The extreme originality of his final solution can be seen by comparing it with an alternative design for the same altar (now in the Cooper-Hewitt

Museum, Fig. 100) which is probably by Carlo Marchionni, architect of the Villa Albani.[33] Related to this far more conventional design, but in a much more vigorous and incisive hand, is a separate study for the tomb inserted below the *mensa*, with the cardinal's coat of arms and the Rezzonico eagle.[34] As frequently seen already, certain of Piranesi's more original ideas can be traced back to the experimental fantasies of the 1740s. The concept of a monument involving a giant globe with supporting figures (while traceable iconographically to sources such as Ripa's *Iconologia*) appears prominently in several of the early capricci (see Fig. 13) and, in Piranesi's case, seems to derive from Girolamo Campagna's large bronze sculptural group behind the high altar of S. Giorgio Maggiore in Venice.[35] In a private collection in New York, there is a sketch by Piranesi for a similar composition involving Faith, with heraldic references to the Rezzonicos, which may relate to an early idea for the Aventine altar (Fig. 101).[36] It is clearer, however, that at a certain point in the evolution of his Aventine

96. Study for sword and scabbard with Maltese
and Rezzonico insignia ornamenting the outer
pilasters of the church facade.

98. Interior of the nave looking east.

97. Detail of the church facade.

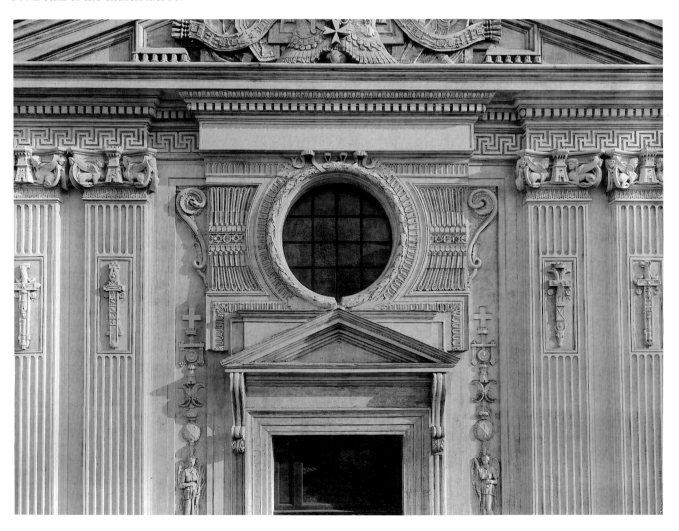

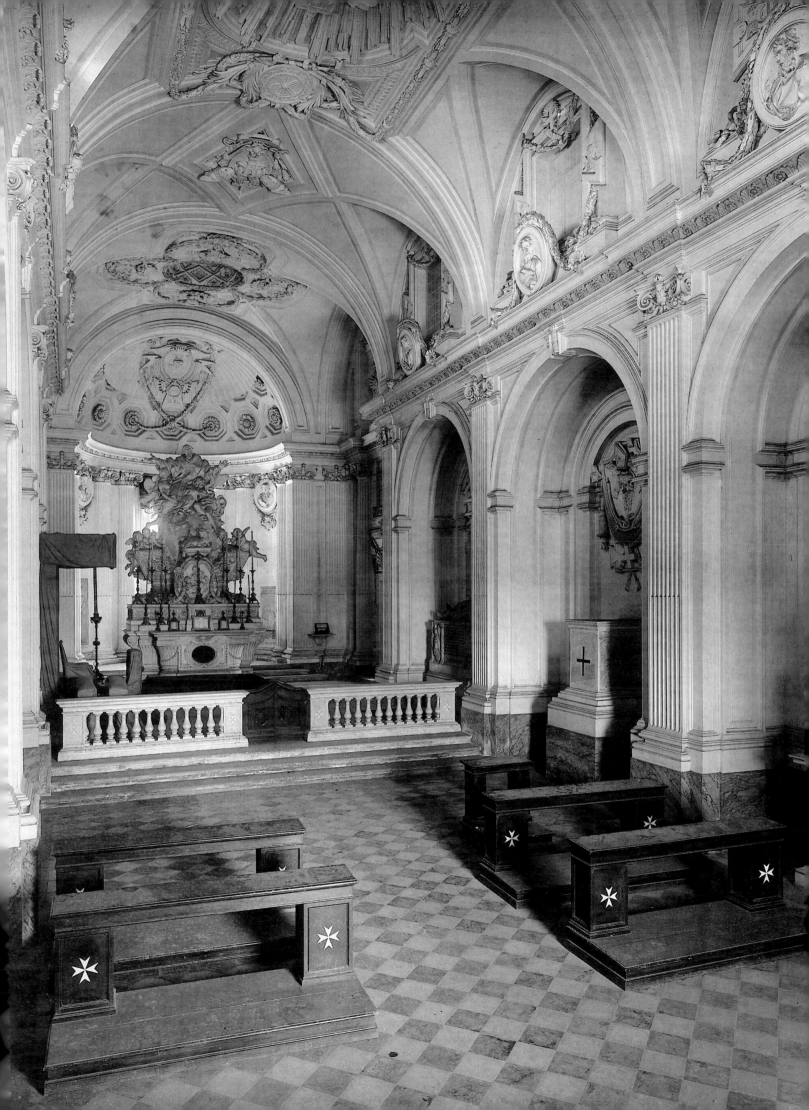

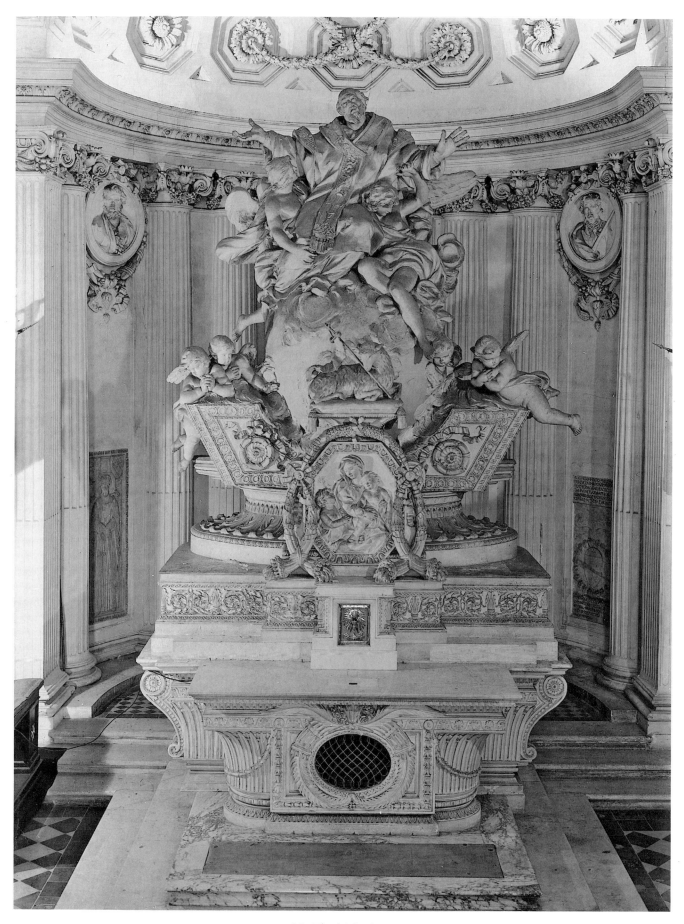

99. The high altar.

100. Carlo Marchionni. Projected design for high altar
of S. Maria del Priorato.

101. Attributed to Piranesi. Preparatory sketch
for figure group of an altar.

design Piranesi, inspired by one of his most complex altar projects for the Lateran
(color plate 3), devised a composition involving flanking candelabra and an alterna-
tive solution to the figural group. This is represented by a small but extremely vigor-
ous sketch in the Morgan Library (Fig. 102).[37] While the candelabra were subse-
quently discarded, probably because of the restricted area available in the Aventine
church, Piranesi introduced the basic idea from which the final solution evolved—a
sarcophagus with wreathed lunette serving as *mensa*, behind which a relief of the
Madonna supports a dynamic tableau featuring *The Apotheosis of St. Basil of
Cappadocia.* The choice of St. Basil was determined by the nature of the previous
altarpiece, attributed to Andrea Sacchi, depicting St. Basil presenting a dove to the
Madonna and Child—a theme recalling the dedication of the original priory church
in the Forum of Augustus.[38]

The definitive form of the altar emerges in a drawing in Berlin (Fig. 103) where an
even greater complexity is introduced to the structure.[39] This now consists of two
precisely defined sarcophagi—the rear one supporting a third out of which (conveyed
by a series of swiftly registered chalk strokes) the saint is borne heavenward by
angels and putti.

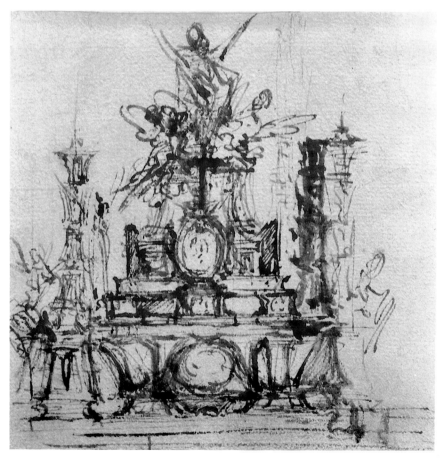

102. Preliminary compositional sketch for
high altar, flanked by candelabra.

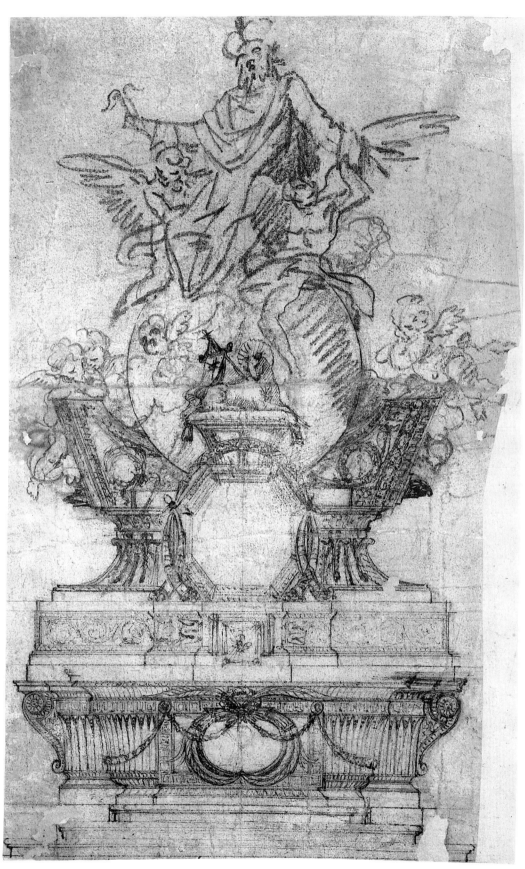

103. Preparatory study for the high altar.

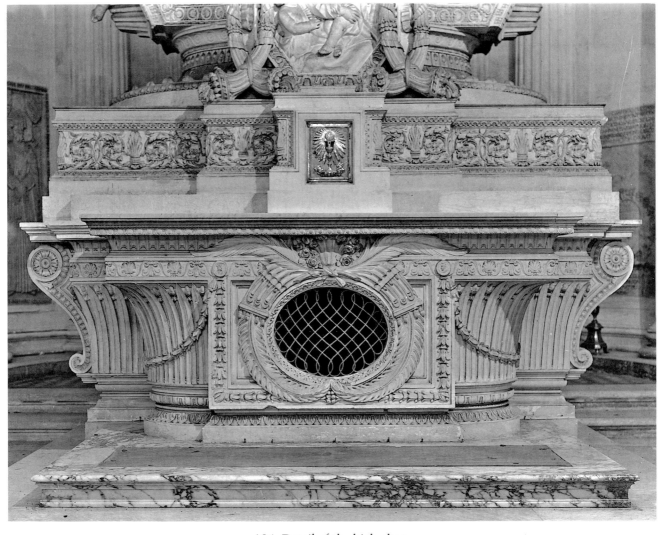

104. Detail of the high altar.

The final solution, represented in the Morgan Library by a highly finished design for the lower part of the altar (color plate 3), is extremely close to the work carried out in gypsum and stucco by the sculptor Tommaso Righi (see Fig. 99).[40] The absence of detail in the upper portion of the drawing involving the figural group may be because this part of the design was left to Righi, for the executed figures are extremely close to those in his Balestra Monument in SS. Martino e Luca.[41] In what might otherwise be considered a three-dimensional capriccio if not for its liturgical decorum, Piranesi blends a considerable variety of decorative sources which appear in various preceding archaeological publications and later tabulated in his "Etruscan" chart of the *Diverse Maniere.* A minor but significant alteration here is the application of a triple ram of swords to each end of the upper sarcophagus of the altar, transforming a funerary object into a maritime image (Fig. 104).

The formal ambivalence of the altar's structure is equally striking. In certain respects, the process of its generation is anticipated in the strange monuments in the fantasy frontispieces of the *Antichità Romane* some ten years earlier, particularly the frontispiece to Volume III (see Fig. 35). On the other hand, the basic formal composition of the altar strikingly resembles the geometric astringency of neoclassical designers like Ledoux in the next decade (Fig. 105).[42]

Something of the stylistic and thematic complexity of the altar is extended to the decoration of the apse and transepts, particularly in the idiosyncratic Ionic capitals

105. Modern compositional diagram of the high altar.

inspired by ancient Roman sources, as indicated in the plates of *Della Magnificenza.*
For instance, the capitals of the half-columns incorporating the Rezzonico eagle (Fig.
106) relate to antique exemplars at Villa Casali and Villa Giustiniani, and the ser-
pents coiled around their volutes refer to the altar, where a scarcely perceptible band
of undulating snakes animates the frame that encloses the *Madonna and Child with
St. John* (see Fig. 99).[43] From the altar, the saint's gesture directs the eye upward to a
small lantern set in the vault above, lit by an oblique light source to indicate the
dove traced on its roof. Around the oculus of this lantern a four-lobed molding
encloses eight exquisitely rendered scenes in relief from the *Life of the Baptist* (Fig.
107), patron of both the grand prior and the order.[44]

To compensate for the restricted space of the church's ceiling, as the design of the
altar does for the presbytery space below, Piranesi introduced a system of vaulting
which in its diagonal rhythms and use of oblique light recalls Borromini's complexity
at the Propoganda Fidei. Further west on this vault there occurs a large relief panel
(Fig. 108) whose composition closely follows the handsome preparatory drawing in
the Morgan Library (Fig. 109).[45] This design celebrates the Order of Malta within the
conventional framework of baroque ceiling composition but with a new archaeologi-

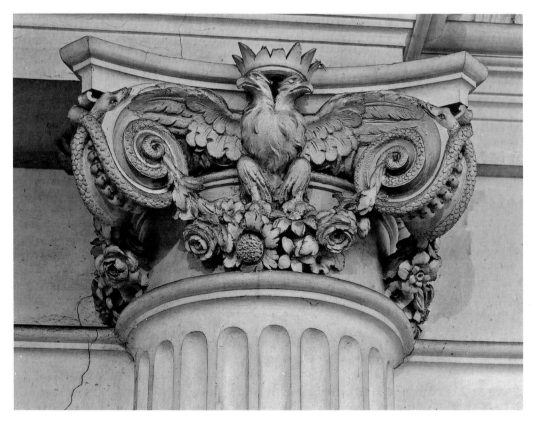

106. Detail of column capital with serpents and Rezzonico eagle.

107. Detail of sanctuary vault with reliefs depicting the Life of the Baptist surrounding the oculus.

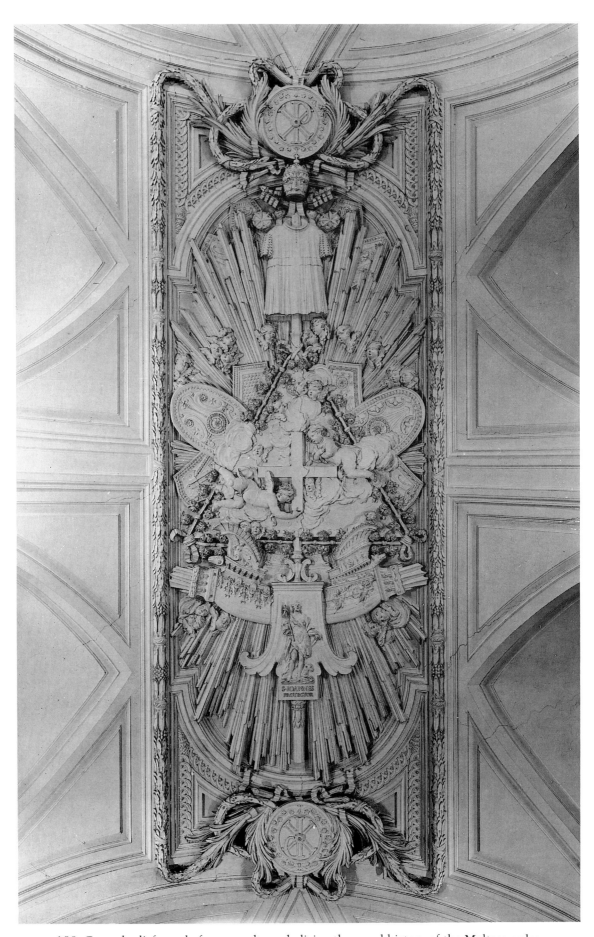

108. Central relief panel of nave vault symbolizing the naval history of the Maltese order.

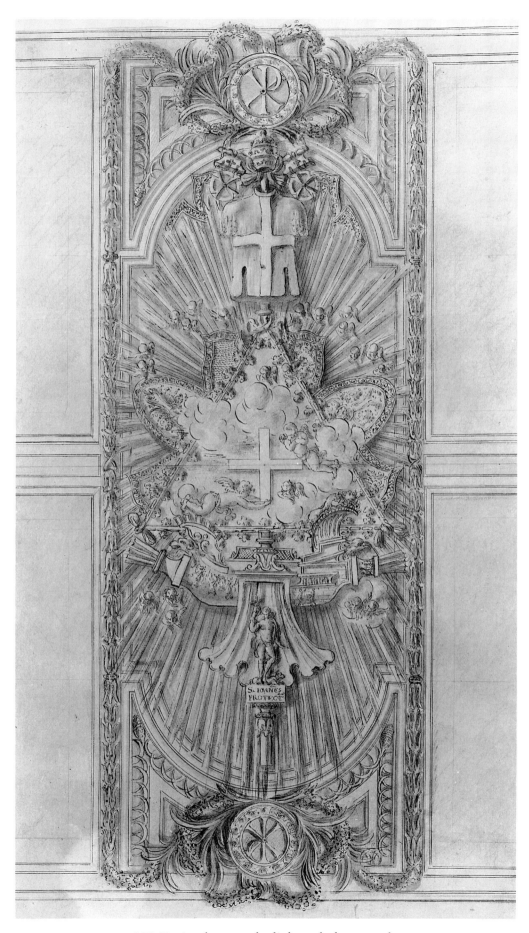

109. Design for central relief panel of nave vault.

cal precision, determined in its minutest detail by the architect's directions as recorded in the Avery account book.[46] Beyond the traditional iconography—the cross depicted within a floral triangle representing the Trinity, accompanied by the papal tiara and surcoat of the order—a predominantly maritime theme is emphasized. Providing the axis for the entire panel is a large rudder bearing an image of the Baptist on its blade (Fig. 110). Furthermore, this is supported at its lower end by warship prows juxtaposed with the triple ram swords, both introduced on the entrance screen in the piazza (see Fig. 86) and repeated on the altar below (see Fig. 104).

Maritime symbols are equally prominent in the decoration of the transept where substantial reliefs over the sacristy entrance and the door opposite contain crossed anchors and *aplustres* flanking a ritual candelabrum. The particular emphasis given to naval imagery throughout the Aventine scheme can be explained by the historic significance of successive leaders of the Italian division of the Knights of Malta. Among the commanders of the eight divisions of the order, the bailiff of the Italian knights was responsible as Grand Admiral for naval operations. Since in the defense of Rhodes, and later of Malta, naval prowess was paramount for survival, Piranesi paid specific tribute to an outstanding protagonist of the Order of Malta within the church.

During the restoration of the sixteenth-century priory in 1617 by Cardinal Aldobrandini, four medieval tombs from the order's earlier headquarters on the Aventine were reinstalled in the nave bays.[47] Piranesi, consciously following the example of Borromini at the Lateran (Fig. 111), used considerable ingenuity to incorporate these medieval monuments into his scheme of modernization.[48] He devised a sequence of elaborate plaques or cartouches for six of the eight bays, three of them combining the heraldic achievements of the dead, who are represented below with appropriate weapons and attributes. In the westernmost bay, immediately inside the entrance on the north, had been placed the tomb of Frà Sergio Seripando, the distinguished admiral who died in Rome during an embassy from Rhodes in 1465. Above the monument Piranesi set an elaborate trophy depicting prows with triple swords and twin *aplustres* (Fig. 112), as befitting one who, according to the late medieval epitaph, had brought terror into the hearts of the enemy.[49]

Rudolf Wittkower, referring to the Aventine commission, considered that "S. Maria del Priorato was a test case of Piranesi's theory that a vital style displaying an immense variety could arise from a meaningful digestion of the architectural styles of the past."[50] For Piranesi as an architect, that style's vitality was further enriched by the potency of its association with the imagery of classical antiquity. With a masterly skill and coherence sustained from piazza to high altar, Piranesi had provided the Knights of Malta with an appropriately dignified setting for their ceremonies and a lasting memorial to their eventful history.

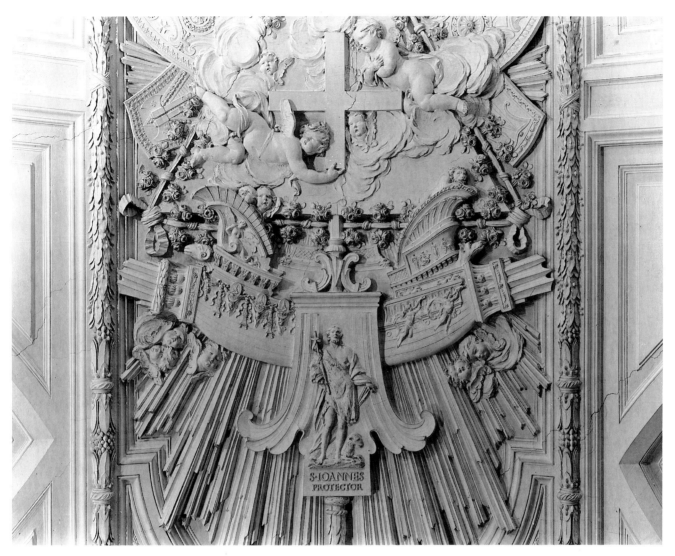

110. Detail of relief panel of nave vault.

The significance of Piranesi's iconographic scheme may go even further in the Piazzale de' Cavalieri di Malta. The total conception and specific location of this monumental forecourt may be seen as an arcane reference to a piece of early Roman history on the Aventine. In past years, a number of attempts have been made to suggest possible sources of inspiration for the arrangement of the *stelae* along the southern and western walls of the piazza. Werner Körte in 1933 drew attention to Piranesi's visionary reconstruction of roads lined with tombs and monuments—for example, his Via Appia fantasy in the *Antichità Romane* (see Fig. 34)—and to the artist's plate (also in the *Antichità*) showing the cinerary urns set on the garden wall of Villa Corsini.[51] It is hard to believe, however, that so coherent an arrangement as Piranesi's ceremonial forecourt evolved from such casual ideas.

111. Francesco Borromini. Compositional capriccio
of the tomb of Pope Sergius IV (d. 1012) at the Lateran
incorporating medieval fragments, after 1655.

112. Detail of the tomb of Admiral Frà Sergio Seripando
(d. 1465) showing Piranesi's ornamental reliefs
involving naval symbols.

A far more sophisticated source of inspiration may be the Capitoline reliefs discussed at the beginning of this chapter. A page in the Uffizi sketchbook of Francesco da Sangallo records a portion of the particular relief quoted by Piranesi on the entrance screen. This is placed next to a drawing of a densely packed relief of military and naval trophies, some of them identical to the Capitoline reliefs. That drawing has been shown to represent a section of the two large ornamental pillars brought from S. Sabina on the Aventine to the Uffizi collection in 1588, still to be seen there in the Sala del Ingresso. The scholar Jan Crous, during his researches on the early history of the Aventine Hill, established that these and several other missing ornamental pillars recorded in other sketchbooks had almost certainly once formed the decoration of the sacred enclosure on the Aventine connected in Roman antiquity with the rite of the *Armilustrium*.[52]

According to Varro and Livy, the *Armilustrium* was a ceremony of great age which took place annually on the Aventine on October 19 when the priests of Mars ritually purified the weapons and equipment of the Roman army, deposited there at the close of the summer campaign.[53] Armed with helmets, cuirasses, and *ancilia* (ceremonial curved shields linked with the destiny of Rome), these priests performed their liturgy to the sound of trumpets—all of these objects being prominently featured on the reliefs of Piranesi's piazza.[54] While the precise site of the *Armilustrium* enclosure is still uncertain, excavations recorded in 1764 when Piranesi began work on the Aventine buildings revealed the original surface of the ancient *Vicus Armilustri* leading to his piazza.[55] While associating the *Armilustrium* with this region of the Aventine around the priory of the Knights of Malta was common by the mid-eighteenth century, it is strange that no reference to this matter occurs throughout Piranesi's own antiquarian works.[56]

Nevertheless, it is singularly appropriate that by the middle of the eighteenth century, when the heroic phase in the history of the Knights of Malta in the Mediterranean was well over, the arms and equipment of the order were deposited ceremonially on the Aventine in true Roman fashion by a designer so closely attuned to the past (see Fig. 87). Valerio Mariani, writing about the Piazzale de' Cavalieri di Malta in 1938, called it "an architectonic-decorative commemoration, solemn and exquisitely refined, of this warrior order at the moment of its withdrawal to meditate on the past."[57] With these words he may have come closer than he realized to identifying the unifying theme of Piranesi's complex layers of imagery on the Aventine.

Notes

1. For the circumstances behind the replacement of the marble candelabrum by Angelini's statue, see Wilton-Ely 1976b, 593-95.

2. For previous studies of the design and construction of Piranesi's Aventine buildings, see Körte 1933, 16 ff.; Wittkower [1961] 1975; Wilton-Ely, 1976a; Pressouyre 1978; Alfieri 1979; Rykwert 1980, 380 ff.; Tafuri 1978.

3. In the *Parere* debate Didascolo, speaking for Piranesi, suggests that the rejection of all forms of ornament in building would result in a tabula rasa: "Se la parete, questa non ha bisogno d'architravi; se le colonne, o i pilastri, la parete

che vi fa ella? Via sceglicte, Signor Pro-
topiro, che cosa volete abbattere? Le
pareti, o i pilastri? Non rispondete? E io
distruggerò tutto. Mettete da parte, Edi-
fizi senza pareti, senza colonne, senza
pilastri, senza fregi, senza cornici, senza
volte, senza tetti il piazza, piazza, cam-
pagna rasa." *Osservazioni . . . Parere su
l'Architettura* (11).

4. For Cardinal Giovambattista Rezzonico
as a patron, see Chapter 3, note 4.

5. In the dedicatory preface to the *Diverse
Maniere* (1769), Piranesi refers to himself
as the cardinal's architect ("suo archi-
tetto") and refers to the various commis-
sions undertaken for the Rezzonicos,
such as the Lateran tribune, the interiors
designed for the cardinal at the Quirinal
and for his brother Senator Abbondio at
Palazzo Senatorio, as well as the Aventine
works.

6. On the first sheet *(Tavola Prima)* of the
Lateran designs the inscription states:
"presentati dal medesimo Cav.^re nell
'anno 1767, a S. E. Monsignor D. Giovam-
batista [sic] Rezzonico Nipote e Maggior-
domo della Santità Sua." See Nyberg and
Mitchell 1975, 19.

7. A detailed account of Piranesi's investi-
ture at the church is given in *Diario Ordi-
nario Di Roma*, October 15, 1766. He was
unable to use the title "Cavaliere," until
the issue of the relevant papal brief on
January 16, 1767.

8. A history of the church and site (origi-
nally known as S. Maria Aventina) is pro-
vided in Montini 1959.

9. The account book is discussed in some
detail in Wittkower 1975. It is the inten-
tion of the present author to publish a
transcript of this unique document. A
contemporary account of Piranesi's Aven-
tine work in progress is given in *Diario
Ordinario Di Roma*, no. 7497, July 20,
1765.

10. The inscription on the western stela
is as follows: *Joannes Baptista/ Rezzon-
ico/ SS. Domini Nostri/ Clementis PP.
XIII/ Fratris Filius ac Magnus Prior
ut Loci Maiestatem Augeret/ Aream
Hanc Laxandam Curavit/ A.P.C.N./
MDCCLXV.*

11. Fischer 1975, 169-70, no. 859 verso.

12. The form taken by the Berlin design
of Piranesi's screen resembles the neo-
Palladian facade of the Villa Algarotti,
Carpenedo di Mestre, designed by
Francesco Algarotti, repr. in Brusatin
1969, fig. 85.

13. Motifs on the Berlin sheet are con-
nected with the following designs in the
Diverse Maniere: Plate XI, Plate XXIII,
and Plate XL (Focillon 1918, nos. 871,
883, and 901 respectively, and Wilton-Ely,
1993, nos. 823, 832, and 845 respectively).
For F. 883/W-E. 832 see Fig. 61 in this
book.

14. Motifs in the iconography of the
Knights of Malta are reproduced in the
illustration of the Lapidary in Scicluna
1955.

15. The Capitoline reliefs are fully illus-
trated and discussed in Jones 1912, 258 ff.,
nos. 99, 100, 102, 104, 105, and 107, pls.
61-62. The original function and location
of these six fragments are uncertain, but
some of them are believed to have been
at S. Lorenzo fuori le Mura before being
recorded in the Palazzo dei Conservatori
in the mid-sixteenth century.

16. Ibid., 258-59, no. 99. The chimney-
piece design is the lower one in pl.
XXXVIII (Focillon 1918, no. 898; Wilton-
Ely 1993, no. 842) of the *Diverse Maniere*
and reproduced in Fig. 128 of this book.

17. *Aplustres* feature in another furniture
design (pl. XII, lower chimneypiece, Focil-
lon 1918, no. 872; Wilton-Ely, ibid. no.
824) and virtually the entire repertoire of
the Aventine military and naval symbols
appear on furniture in plate LXIV (Focil-
lon 1918, no. 924; Wilton-Ely, ibid. no.
879) (Fig. 122). This includes an elaborate
clock for another nephew of Clement
XIII, Senator Abbondio Rezzonico. Robert
Adam was to anticipate Piranesi's sym-
bolism (including the warship prow with
triple swords) on his Admiralty screen,
London, in 1760. (See *The Works in
Architecture of Robert and James Adam*,
London, 1822, vol. 3, pl. XII).

18. *Antichità Romane*, 4.

19. See Chapter 3, note 31.

20. Stampfle 1978, xi, xxv, no. 54.

21. Ibid., xi, xxv, no. 53.

22. *Diverse Maniere*, 31. Apart from this
reference to the Etruscan chart in the
text, Piranesi provides a detailed list or
key to this anthology on the preceding
two pages of the folio. Among the most
prominent items on the Aventine reliefs
which appear in the chart (Fig. 60), as
numbered by him, are the lyre (52), cameo
(62), cornucopia (77), serpent (84), bird's
wing (89), and shepherd's pipes (94).

23. The early history of the Aventine is
covered in Lugari 1896; Merlin 1906;
Boethius and Ward-Perkins 1970.

24. Merlin 1906, 107-8, no. 1.

25. Early drawings of S. Maria del Priorato
include those by (1) anonymous,
Albertina, Vienna (Rome, no. 576), repr.
in Fischer 1968, 223, fig. 16 [Fig. 94 in this
book]; (2) Poelenburgh, Uffizi, Florence
(no. 798), before 1637; (3) Wittel, Heine-
man Collection, Lugano, repr. Zwollo
1973, fig. 250, before 1736. See other
illustrations in Alfieri 1979, figs. 4-7.

26. This drawing in the Sir John Soane's
Museum, London, presumably acquired
by Adam because of his friendship with
Piranesi, is discussed in Stillman 1967,
200.

27. Piranesi was to pay tribute to the dec-
orative invention of mannerist designs,
such as Ligorio's exquisite casino of Pius
V in the Vatican or Peruzzi's Palazzo Mas-
simi alle Colonne in his *Apologetical
Essay* (or *Ragionamento*) in the *Diverse
Maniere*, 3.

28. The sphinx capitals, based on antique
examples illustrated in *Della Magnifi-
cenza*, p. xiii (see Chapter 2, note 26) are
discussed in the *Diverse Maniere, Essay*,
12, as outstanding examples of the styl-
ization of natural forms inspired by Egyp-
tian art. (See the quotation in Chapter 2
of this book.)

29. The Greek fret providing the frieze on
the church facade is based on a particular
Etruscan version found in a tomb near
Chiusi, as illustrated at the center of
pl. III in the illustrations at the end of
the preface *Della Introduzione e del
Progresso delle Belle Arti in Europa
ne'Tempi Antichi*, the final element of
the three-part publication which includes
the *Parere*.

30. For the New York drawing, see Stampfle 1978, XXV, no. 52, and for that in London (1908-6-16) see Wilton-Ely 1976a, 220, fig. 14. See also Thomas 1954, 51.

31. Focillon 1918, nos. 900, 913; Wilton-Ely 1993, nos. 844, 855. Serpents provide a variety of decorative motifs in many of the *Diverse Maniere* designs.

32. See Chapter 3, note 25.

33. One of an important group of designs by Marchionni in the Cooper-Hewitt Museum, New York (Nr. 1938-88-3497), a number of them being for Villa Albani. See Rykwert 1980, 345 ff., where some are reproduced. See also Chapter 5, note 35.

34. Cooper-Hewitt Museum, New York (1938.88.4193). This design and another version (1938.88.4192) are discussed and reproduced in Tafuri 1978, figs. 471-72. Because of the Rezzonico emblem and cardinal's hat in 1938.88.4193, the drawings may possibly relate to an early project for the high altar of the Aventine church.

35. This motif of a monumental globe with supporting figures features prominently in the fantasy drawing, formerly owned by the Société des Architectes Diplomés par le Gouvernement, Paris, and now in the Musée du Louvre (see Chapter 1, note 28), as well as in that of the British Museum (1908-6-16-11). See Wilton-Ely 1978b, 18, 26 (nos. 22, 42c), fig. 17; Robison 1986, 33-34, figs. 37-39.

36. The New York drawing clearly relates to a group of three rapidly executed compositional sketches on a similar theme in the Kunstbibliothek, Berlin, which Heinrich Brauer (1961, 474 ff.) considered as preliminary studies for Piranesi's Aventine altar. See also following note.

37. Stampfle 1978, xi, xxxii, no. A-5. Manfred Fischer (see Fischer 1968a, 211, fig. 4, and Chapter 3, note 8) attributed this particular drawing to the Aventine commission prior to the discovery of the Avery presentation drawings for the Lateran. These latter show certain figural groups flanking the high altar or papal altar, respectively, in the form of angelic figures with monumental candelabra (Drawings nos. 15, 22, and 23), close in character to the Morgan sketch discussed above. These resemblances underline the close interrelationship in Piranesi's mind between the two contemporaneous projects.

38. For the altarpiece by Andrea Sacchi, formerly in the Sacristy and now in Villa di Malta, see Montini 1959, fig. 19.

39. Brauer 1961; Fischer 1975, 169, no. 858.

40. Stampfle 1978, xi, xxiv-xxv, no. 51.

41. For the Balestra monument of Righi, see Chapter 3, note 2. Piranesi was capable, however, of sketching his ideas in terms of conventional putti. See the small composition on a preparatory drawing for the Lateran in the Morgan Library (Stampfle 1978, no. 58).

42. Significantly it has been left to our own century to isolate this neoclassical aspect by means of a specially lit photograph of the rear of the altar, first published in Portoghesi 1980, and by a similar one in Alfieri 1979, fig. 17. The diagram in Fig. 105 in this book was first published in Pediconi 1956, fig. 3.

43. Piranesi may have learned to update this Roman conception of a figurative capital from Borromini's use of the Pamphili dove used in the order decorating the facade of the family palace in Piazza Navona. He was also clearly inspired by an ancient capital involving two eagles supporting a swag, illustrated in *Della Magnificenza*, pl. XVII inscribed "In villa Dnorum de Casalibus."

44. For a compositional sketch in pen and brown ink of the Baptist preaching, attributed by the present author to Piranesi and probably connected with this vault decoration, see Den Broeder 1991, 142-43, repr.

45. Stampfle, 1978, xi, xxiv, no. 50.

46. Wittkower [1961] 1975, p. 250. The roses which profusely decorate the symbol of the Trinity may allude to the tradition that the island of Rhodes, from which the order originated, derived its name from the Greek word for rose. (I am indebted to Louise Rice for this observation.)

47. Bottarelli and Monterisi 1940, I, 210.

48. See Wittkower 1973, 212; Blunt 1979, 146-54.

49. Bottarelli and Monterisi 1940, I, 210; according to Seripando's inscription "quem tremuit Maurus et tremuere Phryges."

50. Wittkower [1961] 1975, 258.

51. Körte 1933, 20-22; *Antichità Romane*, II, second frontispiece and pl. LVII.

52. Crous 1933, 1 ff.

53. Varro, *De Lingua Latina*, V 153; VI 22, Livy, XXVII, 374; see also Merlin 1906, 65-67, 104-5.

54. When the celebrated musicologist Dr. Charles Burney was gathering material for his *History of Music* in 1770, he received specialized advice on ancient Roman instruments from Piranesi. See Burney [1770] 1969, 132, 155, 204, 205, and 211.

55. *Diario Ordinario Di Roma*, no. 7496, July 19, 1765. Among other pieces of evidence, an inscribed stone found near S. Sabina confirmed the nearby location of this ceremonial area, see *Corpus Inscriptionem Latinorum*, VI, 31069.

56. The association of the Armilustrium with the region of the Aventine around the priory was common knowledge by the mid-eighteenth century, as indicated by the text to Giuseppe Vasi's view of the Aventine in his *Magnificenza di Roma*. For further discussion of this problem, see Caetani-Lovatelli 1897, 178 ff.

57. Mariani 1938, 21, as quoted by Praz 1972, 93.

113. Pietro Labruzzi. Portrait of Piranesi, ca. 1778.

5

The Decorative Designer

This discussion has concentrated on the importance of Piranesi's unfettered imagination in his approach to design. As his spokesman the architect Didascolo put it in the debate of the *Parere su l'Architettura*, "Quella pazza libertà di lavorare a capriccio" (That wild freedom to create through flights of fantasy).[1] This baroque principle, which was to come under direct attack during the 1750s through the Graeco-Roman controversy, is vividly symbolized in the self-portrait etched at the outset of that decade by Piranesi's friend Felice Polanzani (see Fig. 1). Embodying Piranesi's visionary interpretation of the past, this plate was first used as a frontispiece to the *Opere Varie* in 1750 and, significantly, was reused for the *Antichità Romane* in 1756. This fruitful dialogue between past and present is also emphasized in Pietro Labruzzi's oil portrait of Piranesi (now in the Museo di Roma, Fig. 113) executed shortly after the architect's death in 1778.[2] Here Piranesi is shown with a characteristically rhetorical gesture, holding a preparatory study for the frontispiece to his last publication, devoted to the Temples at Paestum, while in the right foreground the base of the large candelabrum (now in the Louvre, see Fig. 84) is prominently displayed. This marble capriccio—ingeniously composed of miscellaneous ornamental antique fragments—was used as his funerary monument at S. Maria del Priorato until the work was replaced, as mentioned earlier, by Angelini's classicizing statue (see Fig. 83).[3]

Piranesi's etched architectural fantasies and their related studies provided him with a means for formal experiment over the course of almost thirty years of design. The inquiries of the early 1740s, represented by the plates of Piranesi's first publication, the *Prima Parte di Architetture e Prospettive,* show his first attempts—within the Palladian system of his Venetian training—to enlarge the formal repertoire of modern design. In so doing, he not only drew inspiration from an unprecedented range of classical sources but also from the recent experiments of high baroque

designers, notably Borromini (see Fig. 9). A dramatic transformation in his draughts-manship, graphic techniques, and imaginative grasp—especially during his later Venetian years and while under the influence of Tiepolo and the stage designs of Juvarra (see Fig. 12)—is revealed in the first state of the *Carceri* in the mid-1740s (see Fig. 19). This particular phase was to reach its climax at the end of that decade with the etched fantasies of the *Opere Varie* of 1750, and was supremely expressed in the *Magnificent Port* (see Fig. 25). There Piranesi's increasing revolt against the limita-tions of Vitruvian classicism was expressed in a completely personal idiom—striking in both the breadth of composition and command of highly original detail. As a result of extensive archaeological researches during this period, culminating in the publica-tion of the *Antichità Romane* in 1756, a wealth of new material had fueled Piranesi's imagination. Indeed, the stated intention of this publication as a stimulus to modern architects is consciously emphasized by the elaborate fantasy compositions forming the frontispieces to the four volumes (see Figs. 34 and 35). By the 1760s, the vigorous exchanges of the Graeco-Roman controversy had impelled Piranesi to formulate a far more radical system of composition (see Fig. 52)—singular in its catholicity of sources and richness of form—in marked reaction to the growing austerity of taste preached by Laugier, Winckelmann, and the supporters of Greece. Some of this will-fully idiosyncratic style is introduced in the two plates added to the refashioned *Carceri d'invenzione* (see Fig. 48). By the middle of the 1760s, Piranesi's stylistic innovations were not only given theoretical support in the *Parere* but also put into practice throughout the remodeled buildings of S. Maria del Priorato (see frontis-piece). Moreover, as the decade advanced, a new boldness in formal complexity and sculptural power, which left behind the last traces of rococo delicacy, appeared in the bizarre architectural compositions added after 1767 to the *Parere* (see Fig. 54) and in related preparatory studies, now in London (see Fig. 53) and Berlin. This final phase in Piranesi's stylistic experiments can be seen not only in certain chimneypiece designs etched in the *Diverse Maniere d'adornare i Cammini* of 1769 (see Fig. 61), but also in one of the Avery presentation designs for the pontifical altar of the pro-jected Lateran tribune (see Fig. 79). In these later works we find an ungainly yet arresting style, remarkable for the violent disjunction of diverse elements and pos-sessing effects of brooding monumentality.

The circumstances of Piranesi's debut as a decorative designer of interiors and related furnishings still remain uncertain. However, his recorded activity in various Venetian palaces during the mid-1740s is supported by the unique group of studies in the Morgan Library.[4] While the majority represent sketches for wall panels and *bois-eries* (see Fig. 11), the verso of one of these sheets has an incomplete pen study for what appears to be an elaborate gilt pier table, characteristic of the current rococo taste. This shows the same highly sinuous, asymmetrical structure found in the con-temporary designs for a pulpit (Fig. 115) and for the festival gondola (color plate 1),

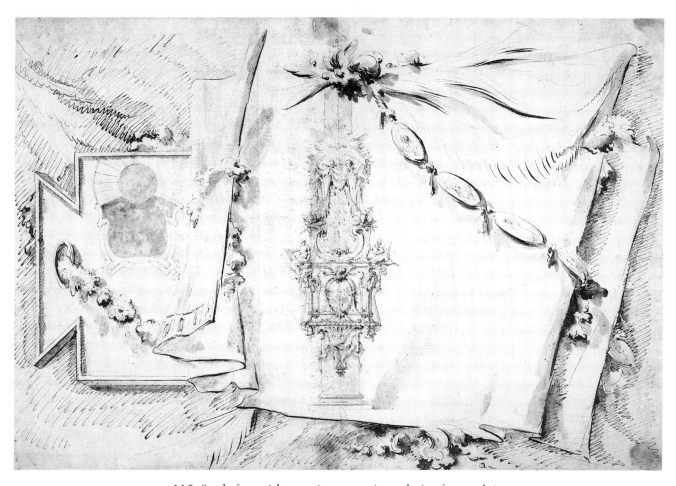

115. Study for a title page incorporating a design for a pulpit.

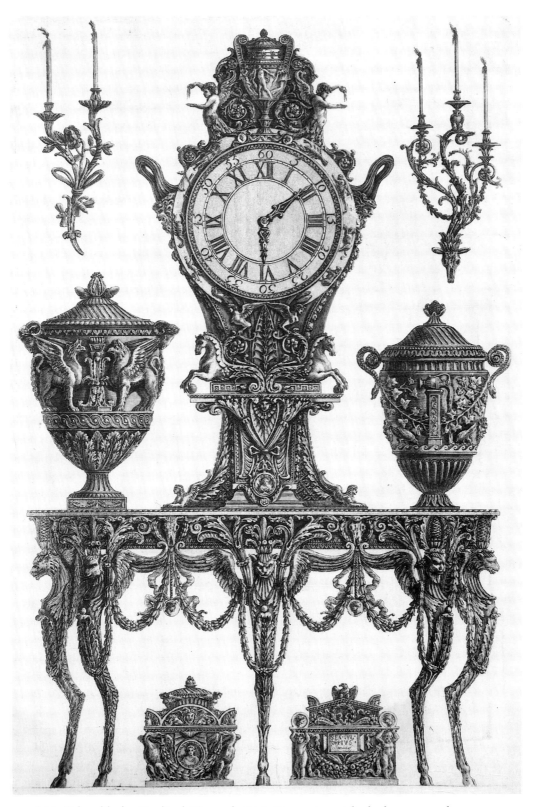

116. Side table for Cardinal Giovambattista Rezzonico with clock, urns, and sconces
(related to a design in Fig. 120). *Diverse Maniere,* 1769.

both in the Morgan Library.[5] More significant in terms of Piranesi's later development in furniture design is the recurrence of this rococo expression in his earliest surviving furniture executed nearly two decades later: the twin pier tables produced for Cardinal Giovambattista Rezzonico's Quirinal apartments (later published in the *Diverse Maniere*, Fig. 116), which came to light during the 1960s and are now in Minneapolis (color plate 5) and Amsterdam respectively.[6] These magnificent pieces not only confirm the accuracy of the *Diverse Maniere* as a source of information, but emphasize Piranesi's obdurate resistance to neoclassical restraint as seen in the Louis Seize style and the contemporary furniture of Robert Adam's mature designs. While the general structure of Piranesi's tables remains conservative, as a preparatory study in London (Fig. 114) emphasizes (we should not discount the personal tastes of his Venetian patron in this respect), the ornamental concepts and detail are far more original. These reflect the influence of antique bronze furniture then being uncovered at Herculaneum and Pompeii, notably the elaborate bronze tripod from the Temple of Isis (Fig. 117).[7] This decorative originality also occurs in Piranesi's approach to mirror frames and in his designs for commodes in the *Diverse Maniere*, which are explored in certain pen sketches in the Gahlin collection in London.[8] However, the three Morgan designs for mirror frames (color plate 4), which are rendered with an exceptional degree of finish in brown ink, india ink wash, and pencil, do in fact suggest a development away from the delicately asymmetrical to the heavier, more geometric, and regular forms of avant-garde neoclassical taste.[9]

Apart from the Rezzonico works, we can be fairly certain that several other decorative designs published in the *Diverse Maniere* were executed during the 1760s—for example, the carriage work of coaches and sedan chairs. According to a letter of January 1768, the Earl of Carlisle refers to his intention of having a coach made from a Piranesi design, and it has been noted that a vehicle, based on a design etched in the *Diverse Maniere* (a preparatory study is in the Morgan Library, Fig. 118), can be seen crossing the foreground in the *veduta* of St. Peter's (Fig. 119), which was issued between 1771 and 1773.[10] Again a stylistic development is suggested by comparing the sober form of this coach with the far more exotic one appearing in the earlier *veduta* of the same subject, produced around 1750.[11]

Piranesi's imagination was less inhibited by traditional furniture forms when it was applied toward the design of clocks and smaller objects. In the prefatory *Essay* outlining his philosophy of design in the *Diverse Maniere*, he stressed the importance of nature and antiquity as complementary sources of inspiration and demonstrated this fruitful relationship in the vignettes and diagrams of that work. This process of abstraction from natural forms found in antiquity is graphically demonstrated by the red chalk studies (now in the Morgan Library, Fig. 120) for the two sconces appearing in the etching of the Rezzonico table (see Fig. 116).[12] Another brief sketch

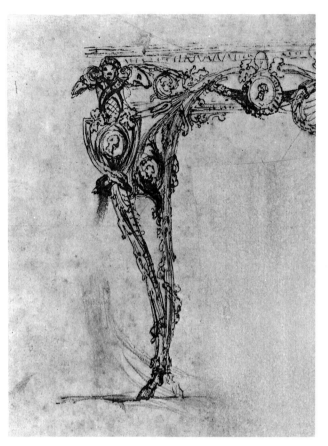

114. Sketch design for part of a table.

117. Bronze tripod from the Temple of Isis, Pompeii. *Vasi*, 1778.

118. Design for a coach.

119. Detail of coach from view of Piazza di S. Pietro. *Vedute di Roma*, ca. 1771-73.

120. Design for sconces.

in the Morgan collection shows the initial concept for a table clock taking the form of a pineapple (Fig. 121), which also appears in another plate featuring the extravagant timepiece for Abbondio Rezzonico's rooms in the Palazzo Senatorio (Fig. 122).[13] In this etching, the sources from antiquity are again explicit, for the elaborate pier table, in particular, owes many of its nautical motifs to the same Capitoline reliefs then being used for the Aventine decorations.[14]

In the *Diverse Maniere,* however, the larger proportion of Piranesi's activities as a designer is devoted to the chimneypiece. In the *Essay,* Piranesi states his wish to demonstrate the application of his novel system of design to the chimneypiece—a uniquely modern requirement also possessing a strong architectural character. In addition to the sixty etched designs for chimneypieces, an even greater number of preparatory studies have so far come to light, many neither etched nor related to executed works. The majority is today concentrated in the collections of the Morgan Library and the Kunstbibliothek, Berlin.[15]

121. Design for a clock in the
form of a pineapple.

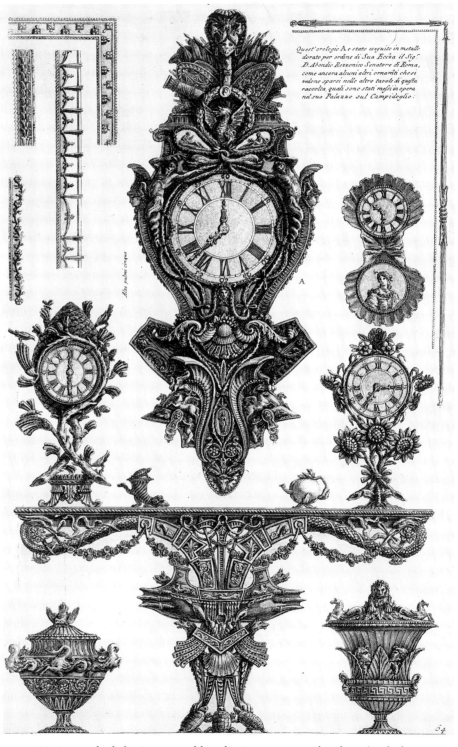

122. Large clock for Senator Abbondio Rezzonico with others (including
the pineapple design of Fig. 121) and urns. *Diverse Maniere,* 1769.

Clearly, the chimneypiece was of considerable importance to Piranesi during the 1760s as a focus for experimental design. Indeed, it appears that he had circulated certain of these designs in trial proof before their publication in 1769. Sir William Hamilton, in a letter written from Naples in 1767 (now in the Morgan Library), acknowledges receipt of certain chimneypiece plates, adding, "I am delighted that you have done this work for it will be very useful in my country where we make much use of fireplaces."[16] As if to stress his new recognition by leading connoisseurs, the opening plates of the *Diverse Maniere* illustrate two works already executed— one of them for the Earl of Exeter at Burghley House in England (Fig. 123) and the other for the merchant banker John Hope of Amsterdam (Fig. 124), now in the Rijksmuseum (Fig. 125).[17] These chimneypiece examples relate to Piranesi's growing activity as a restorer of classical antiquities in which he imaginatively incorporated various antique fragments. By this time, in fact, the production of ornamental chimneypieces was a thriving trade in Rome, and Piranesi was quick to put his inventive skills to commercial advantage.

As Piranesi is anxious to point out in the plate's caption, the Exeter work (color plate 7), in particular, exploits the polychromatic effects of rosso antico and white statuary marble, embellished with gilt metal decorations.[18] Other similar compilations, too late to be included in his book, were made up in Piranesi's studio at Palazzo Tomati and exported to foreign clients visiting Rome on the grand tour. For instance, one of a pair (Fig. 126) acquired around 1769 to 1770 by Piranesi's enthusiastic patrons Edward Walter and his wife, Harriet, and later transferred to Gorhambury House, St. Albans, is connected with a sequence of exploratory studies in the Morgan Library.[19]

The grand tour generated the manufacture of another chimneypiece commissioned in Rome in 1774 by the young George Grenville, nephew and heir to Lord Temple of Stowe. It remained in the great Buckinghamshire mansion until 1922 when it was sold; eventually it was installed in the Banco de Santander, in northern Spain.[20]

While it is clear that Piranesi improvised these compositions according to the availability of materials excavated at Hadrian's Villa, Tivoli, and other sites rich in fragments, it is equally likely that his acute business sense prompted him to vary the size and character of these chimneypieces to suit his clients' existing interiors. This is borne out by comparing the more ambitious of the two Gorhambury pieces (in the drawing room there, see Fig. 126) with the extremely delicate composition, involving cameos on amethyst and rosso antico reliefs, installed at Wedderburn Castle, Scotland (Fig. 127). This was acquired by Patrick Home for 371 scudi after a visit to Piranesi's showrooms in 1774.[21]

Another category of chimneypiece design featured in the *Diverse Maniere*, however, while equally representative of Piranesi's eclectic mode of design, displays a

123. Chimneypiece design for the 9th Earl of Exeter
(see plate 7). *Diverse Maniere,* 1769.

124. Chimneypiece design for John Hope. *Diverse Maniere.*

125. Chimneypiece for John Hope (detail).

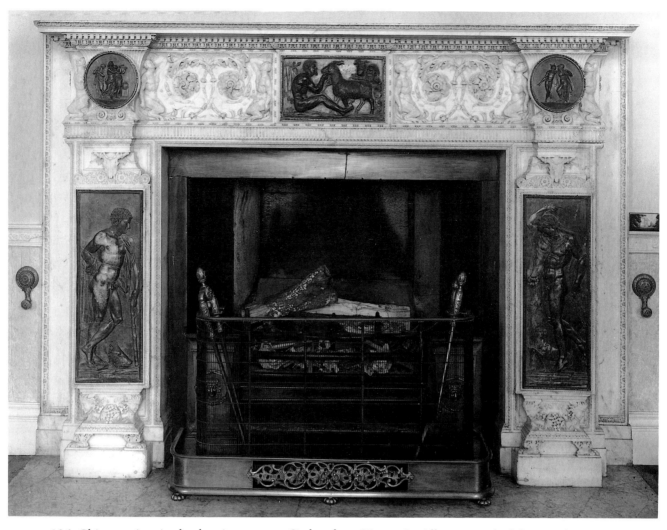

126. Chimneypiece in the drawing room at Gorhambury House, St. Albans, Hertfordshire, early 1770s.

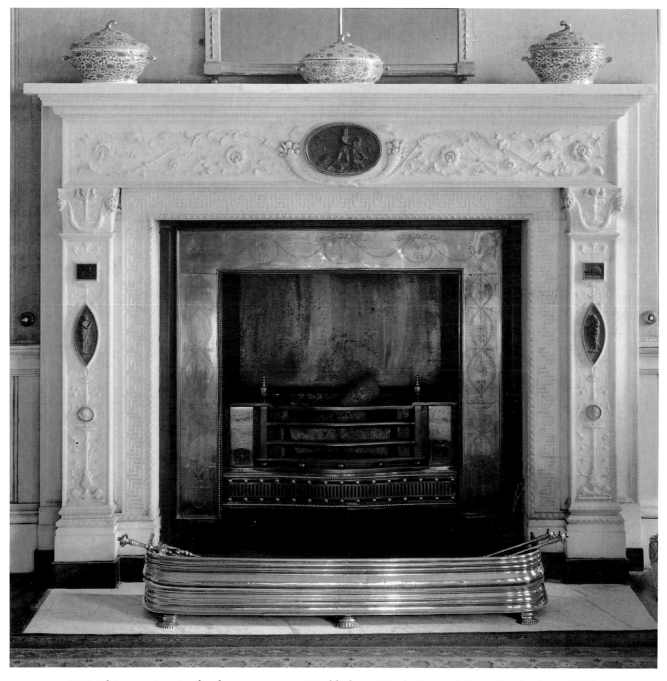

127. Chimneypiece in the drawing room at Wedderburn Castle, Berwickshire, Scotland, ca. 1774.

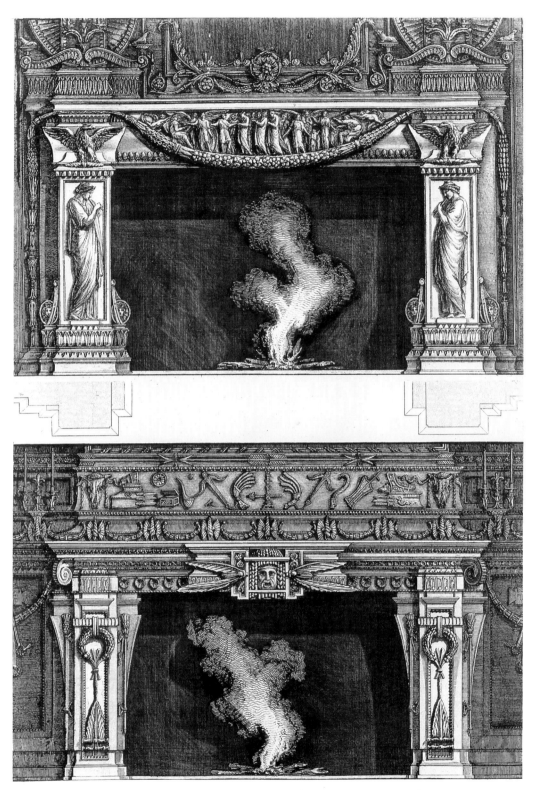

128. Plate with two chimneypiece designs: the upper with
figurative reliefs on lintel and stiles; the lower with maritime symbols
and bucranea on lintel. *Diverse Maniere,* 1769.

greater formal restraint among these antique compilations (Fig. 128, upper design). In this type of composition, as exemplified by an exploratory study in the Morgan Library (Fig. 129), Piranesi applies a series of discrete motifs to the lintel (cameos flanking a plaque in relief) and stiles (figures of Minerva) in such a manner that responsive designers who used the book could extract and rearrange these *pensieri* at will.[22] Such was the case of Robert Adam who, in the course of his extensive borrowing from the *Diverse Maniere*, abandoned the ponderously sculptural chimneypieces of the 1760s in favor of the elegant and delicately wrought works of the 1770s which made him a household name in chimneypiece design. Among a considerable quantity of Adam's surviving studies in the Soane Museum, we find a number of specific instances of his process of selection and combination of these Piranesian motifs.[23] Such imaginative exercises were to result in works which, although substantially different in final effect from the aesthetic character of their Piranesian source, closely followed the theoretical principles involved, as exemplified in the chimneypieces for Wynn House of 1772–74 (Fig. 130) and Drummond's Bank of 1777–78, both in London.[24] Indeed, this sympathetic process of extraction is so striking that Piranesi may be considered the prime influence on the formation of the Adam style as a widely diffused idiom in the applied arts of the later eighteenth century.

On a broader front, this is also true of Piranesi's catalytic impact on Adam's approach to a totally integrated modern system of interior design. The imaginative exercises in devising fantasy interiors which Piranesi encouraged in Adam and his collaborator Charles-Louis Clérisseau during the 1750s, as we have seen, found swift application in Adam's first major commissions in England, especially at Kedleston and Syon. By the following decade, Adam had begun to develop an original style which, further reinforced by the plates of the *Diverse Maniere*, was to result in a series of at least eight Etruscan rooms, epitomized by the one produced between 1775 and 1777 at Osterley Park, near London (Fig. 131).[25] The striking unity in design of this particular ensemble—including walls, ceiling, door, furniture, carpet (unexecuted), chimneyboard, and the curtain cornice—achieved the complete coherence of the modern style advocated only a few years earlier in Piranesi's prefatory *Essay*.

Apart from the synthetic exercises presented by the Exeter and Hope chimneypieces, there are some works in the *Diverse Maniere*, also represented extensively by studies in the Morgan Library, which are far more adventurous in their sculptural and organic character. While these may be seen as a development of the late baroque tradition in Rome, in the 1760s, they also owe their inspiration and notable vitality to antiquity. Take, for example, the theme of the dolphin—that beast specially fashioned by nature for the Baroque—which Piranesi derived from a fragmentary frieze in the Palazzo Farnese (a red chalk study for the plate in *Della Magnificenza* is in the Morgan Library) as well as from a capital found near the Circus Maximus.[26] This is given considerable expression in an etched chimneypiece developed from a design in

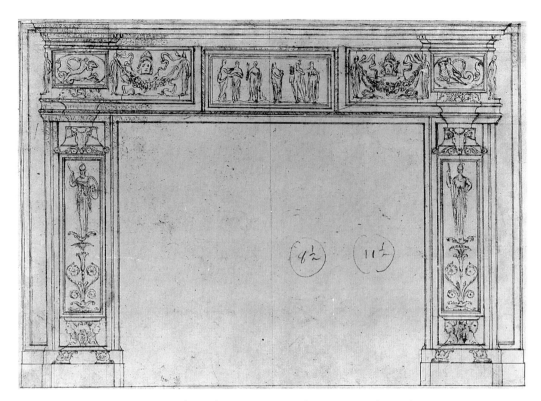

129. Design for a chimneypiece with cameos and panels
containing figurative reliefs.

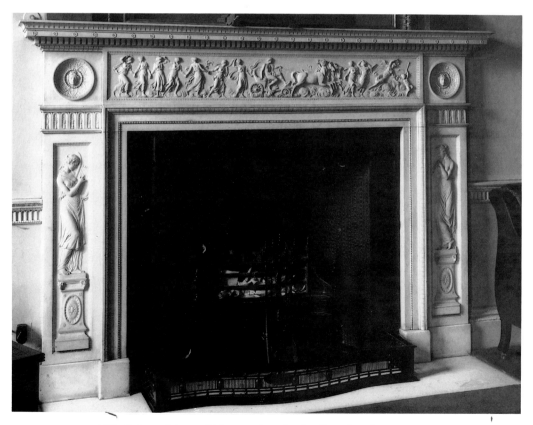

130. Robert Adam. Chimneypiece in the first drawing room
at Wynn House, 20 St. James's Square, London, ca. 1772-74.

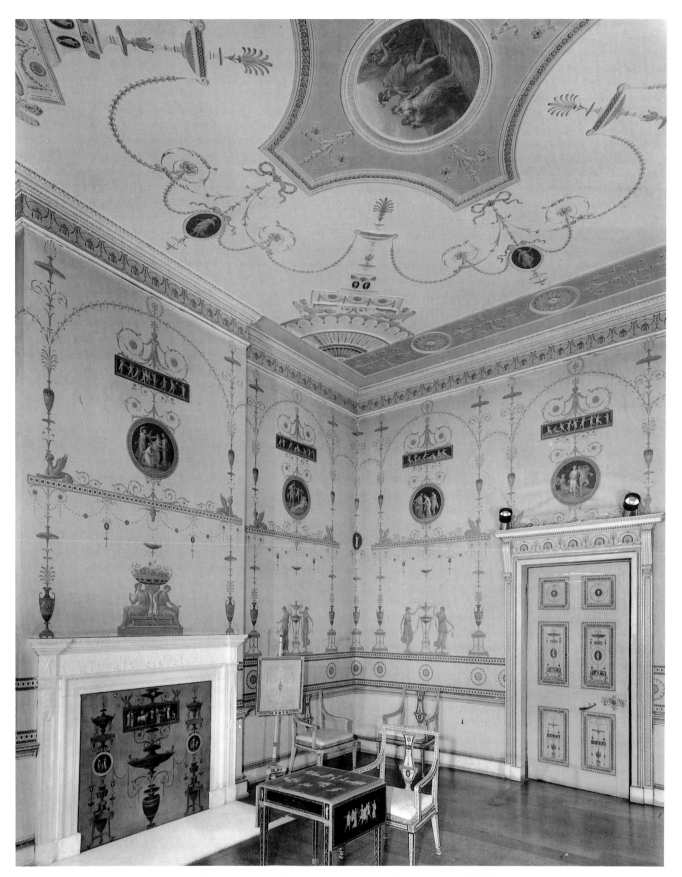

131. Robert Adam. Etruscan dressing room, Osterley Park, Middlesex, ca. 1775.

Berlin.[27] In one of his finest decorative studies, also in the Morgan Library, Piranesi used another antique source to apply confronted elephant heads on the lintel of an unexecuted chimneypiece (color plate 6).[28] While this bold expression proved predictably alien to the majority of contemporary designers, something of the baroque energy of these particular designs was reflected in a series of chimneypiece designs by the French architect Jean-Charles Delafosse (now in the Musée des Arts Décoratifs, Paris, Fig. 132).[29]

Another of Piranesi's favorite motifs from antiquity—the lion or leopard monopod derived from fragments of Roman table supports—was to have far-reaching appeal to designers of Late Neoclassicism because of its opulent simplicity. This motif is featured in an etched design (Fig. 134), preceded by a particularly fine preparatory study in red and black chalk, with additional work in ink, in the Morgan Library (Fig. 133).[30] (The same plate, incidentally, later furnished François-Joseph Bélanger with inspiration for a design for andirons, executed for Marie Antoinette, now in the Cooper-Hewitt Museum.[31]) Thus disseminated by Piranesi's prints, this motif was also taken up enthusiastically in the Empire style of Percier and Fontaine (Fig. 135) and in the works of the Regency designer Thomas Hope (for whose father Piranesi had produced the chimneypiece which is now in Amsterdam).[32]

As might be expected from the evidence for the Lateran and Aventine commissions, Piranesi's more extreme experiments in this area of design were given practical encouragement by the Rezzonico family. Besides designing interiors and furniture for Clement XIII at Castel Gandolfo and for Cardinal Giovambattista Rezzonico at the

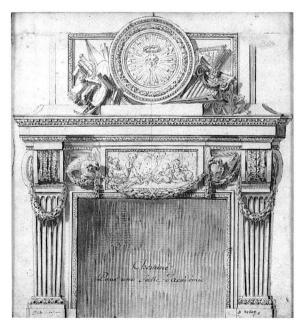

132. Jean-Charles Delafosse. Chimneypiece design for
an academy, with eagles supporting a swag and
architectural symbols above, mid-1770s.

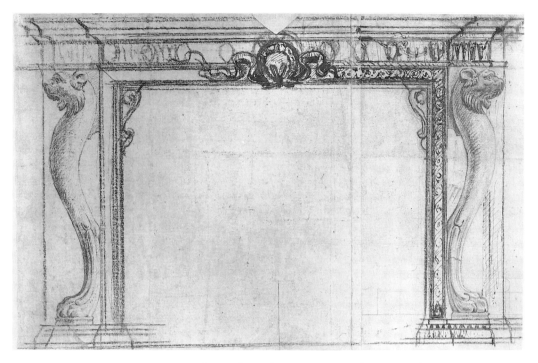

133. Preparatory design for a chimneypiece with monopods.

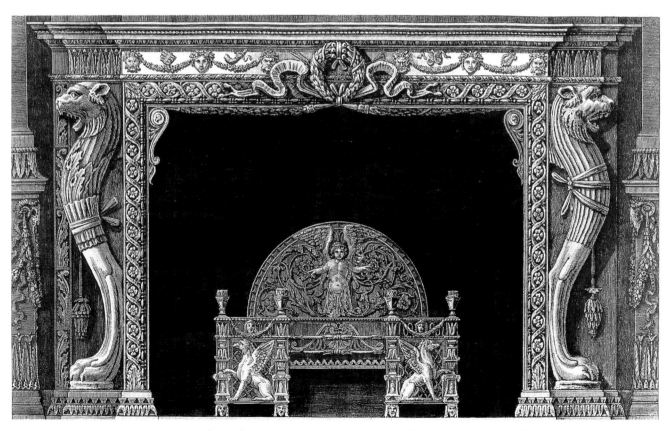

134. Design for a chimneypiece with monopods, *Diverse Maniere,* 1769.

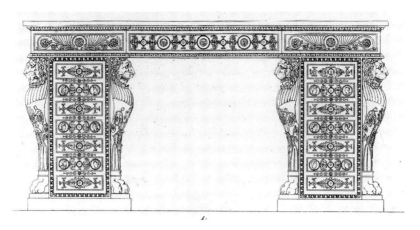

135. Charles Percier and Pierre Fontaine.
Design for a table with monopods, 1801.

Quirinal (no trace of either remain, except for the two tables), Piranesi devised an interior scheme for Senator Abbondio's official apartments on the Capitoline Hill. Although recent research has so far failed to uncover any trace in the main salon of the chimneypiece etched in the *Diverse Maniere*, a crucial pen sketch in Berlin (Fig. 136) outlines a similar setting for one of the most complex etched chimneypiece designs Piranesi ever devised (see Fig. 61), including color notes for eventual execution.[33] Apart from this tantalizing reminder of the need to see such works within a total ensemble, the relationship of such designs to Piranesi's other commissions is underlined by the sketch of an *acerra* (incense box) motif for one of the etched chimneypiece designs on the same sheet in Berlin that also contains an early project for the Aventine screen.[34]

During the early 1760s, according to a surviving design in the Morgan Library (Fig. 137), Piranesi also appears to have contributed to the decorative scheme within Cardinal Alessandro Albani's villa, situated just outside the walls of Rome on the Via Salaria.[35] A group of preparatory designs for portions of the interior by the villa's architect, Carlo Marchionni, now in the Cooper-Hewitt Museum, incorporates original antique reliefs, restored fragments or ornamental pastiches, and displays a conventional late baroque system of ornament.[36] In marked contrast to Marchionni's somewhat florid surviving proposal for the upper part of the side door to the main salon (Fig. 138), containing Meng's celebrated *Parnassus* ceiling, Piranesi's chosen and executed design (Figs. 137 and 139) for the lunette and spandrels in relief for the same door shows a more robust, if severe, deployment of trophies derived from Roman sources, such as the Trophies of Marius and Trajan's Column. Significantly, the French Empire designers Charles Percier and Pierre Fontaine, studying at the French Academy in Rome during the 1780s, were to include an engraving of this particular lunette relief as a heading to the chapter "Fragments antiques tirés de la Villa Albani" in their book *Choix des plus célèbres Maisons de Plaisance de Rome et des Environs*, published in Paris in 1809. (As William Collier has suggested, this feature may have subsequently provided a source of inspiration for part of the ceiling design

136. Sketch design for part of an interior scheme with
chimneypiece (see Fig. 61) and portrait above.

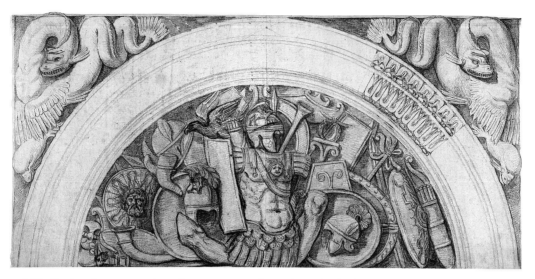

137. Design for an overdoor decoration, with trophies in the lunette and winged serpents
and dolphins in spandrels, for the main salon of Villa Albani.

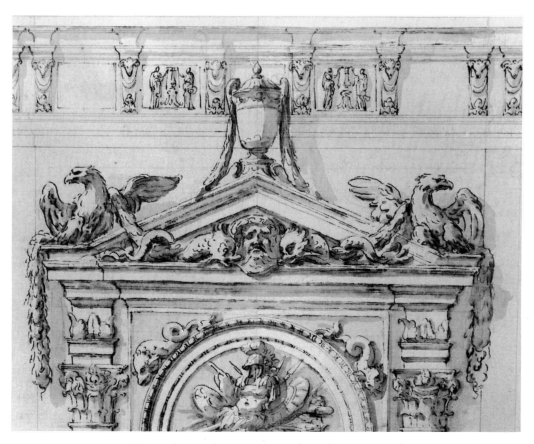

138. Carlo Marchionni. Design for a door surround
in the main salon of Villa Albani.

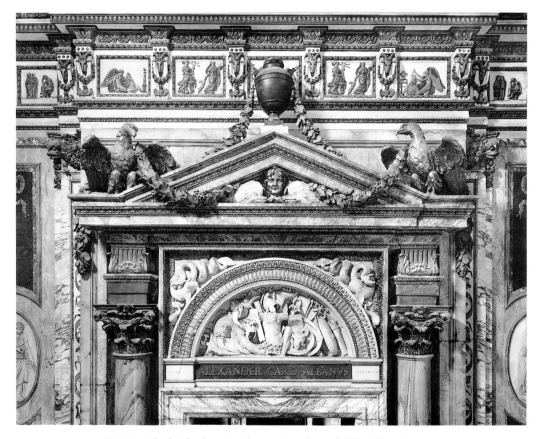

139. Detail of side door in the main salon of Villa Albani, Rome.

for their Salle de Venus in the Louvre.) Be that as it may, no written record of Piranesi's involvement in the embellishment of the stronghold of Philhellenism has yet come to light. However, his adversary, Winckelmann, makes no mention of Marchionni either in his frequent and enthusiastic references in correspondence about his patron's lavish villa, where he was then serving as librarian and self-appointed arbiter of taste.

Undoubtedly, however, the boldest flights of fantasy in the *Diverse Maniere* are the thirteen designs in the Egyptian taste, mainly chimneypieces (Fig. 141), which relate to a considerable portion of the introductory *Essay* and which were to prove one of the most influential legacies of Piranesi's work.[37] Not surprisingly, the initial influence of this exotic taste was limited in early neoclassical design. Bélanger, for instance, in his *Livre de Cheminées* (now in the Bibliothèque Nationale) inserted a selection of Piranesi's motifs within the geometric forms of the Louis Seize style during the 1770s (Fig. 142).[38] However, toward the end of the century, as the weightier taste of Neoclassicism gradually emerged in the Regency and Empire periods, the full effects of Piranesi's bold and sculptural Egyptian forms were more readily adopted. This can be seen, for example, in George Dance's unexecuted design for the library of Lansdowne House in London (a work partially reflected in the unattributed chimney-

140. Sketch for a chimneypiece in the Egyptian taste with
standing figures addorsed to the stiles, confronting sphinxes on the lintel,
and a bird with outspread wings at the angle.

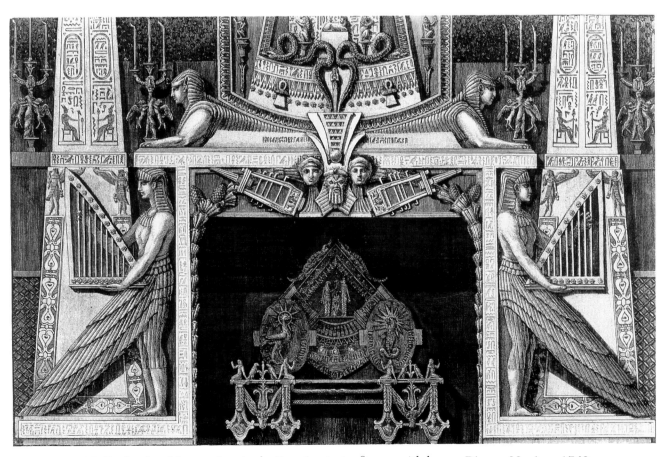

141. Design for chimneypiece in the Egyptian taste, figures with harps. *Diverse Maniere,* 1769.

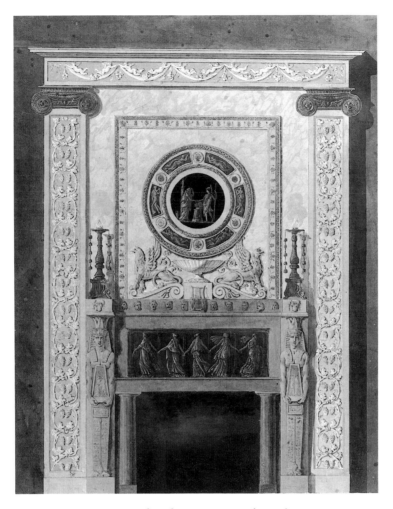

142. François-Joseph Bélanger. Design for a chimneypiece
in the Egyptian taste with figures on the stiles, ca. 1770-80.

piece of Egyptian granite installed around 1810 at Bayfordbury House in Hertfordshire).[39]

The influence of Piranesi's Egyptomania also owed much to the fact that hundreds of artists and connoisseurs were familiar with it through his painted decorations in the Caffè degli Inglesi (the English Coffee House) in Piazza di Spagna. Our knowledge of this sadly vanished work, probably carried out during the early 1760s, comes from at least two plates in the *Diverse Maniere* (Figs. 143 and 144).[40] The location of the establishment, ascertained by tax returns, is shown in a drawing made in 1775 by the Scottish artist David Allan.[41] Since the site of the Caffè was on the right-hand corner of Via delle Carozze, it is possible to make a tentative reconstruction of its interior which, at the time, appears to have received an extremely negative reception. According to the young Welsh painter Thomas Jones in 1776, it was "a filthy vaulted room the walls of which were painted with sphinxes, obelisks and pyramids from capricious designs of Piranesi, and fitter to adorn the inside of an Egyptian sepulchre, than a room of social conversation."[42]

While a number of Egyptian interiors were derived from Piranesi's ideas during the next quarter of a century, the style was given additional impetus by Napoleon's

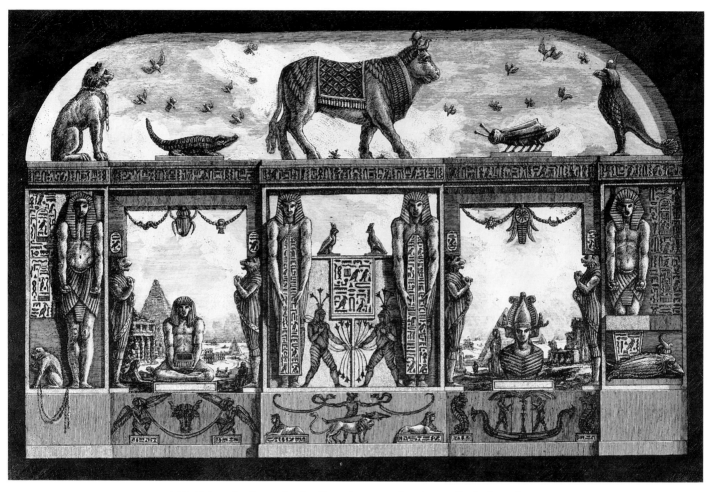

143. Painted scheme in the Egyptian taste for the Caffè degli Inglesi,
Rome (longer wall). *Diverse Maniere,* 1769.

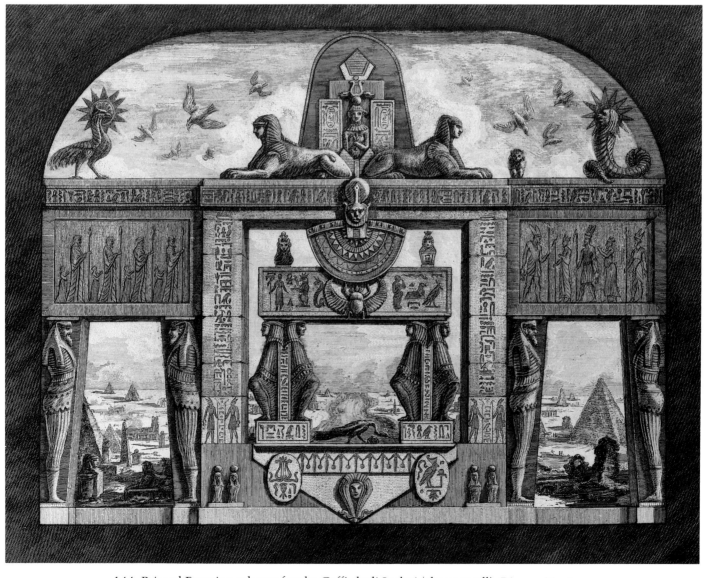

144. Painted Egyptian scheme for the Caffè degli Inglesi (shorter wall). *Diverse Maniere.*

expedition to the Nile. The Regency arbiter of taste Thomas Hope was among the first to apply Piranesi's principles to a totally integrated Egyptian interior with matching furniture in the richly colored Egyptian Room of his London house in Duchess Street (Fig. 145), carried out around 1800, and published in *Household Furniture* (1807).[43] Making allowance for the formal restraint of this particular phase of Neoclassicism, Hope also found inspiration in the *Diverse Maniere* for individual items of furniture, for example, the surviving Egyptian clock (Fig. 146) from his Flaxman Room, which featured the sculptor's marble group of Aurora and Cephalus. The clock is distantly related to a design in the final plate of Piranesi's book (Fig. 147).[44] It is particularly instructive, incidentally, to compare Robert Adam's adaptation of another of Piranesi's engraved designs for a monumental clock, which according to the Adam brothers' *Works* was produced for their own house at the Adelphi, London, in the 1770s.[45]

By the final decade of Piranesi's life, the architectural fantasy had ceased to represent a means of active inquiry, particularly in the presence of so many other outlets for his experimental cast of mind. The drawings produced at this time—for example, the pair probably acquired by the Walters along with their chimneypieces (and also at Gorhambury)—appear to have been done by Piranesi as presentation works for clients visiting his *museo* (showrooms) at Palazzo Tomati.[46] There, in addition to his

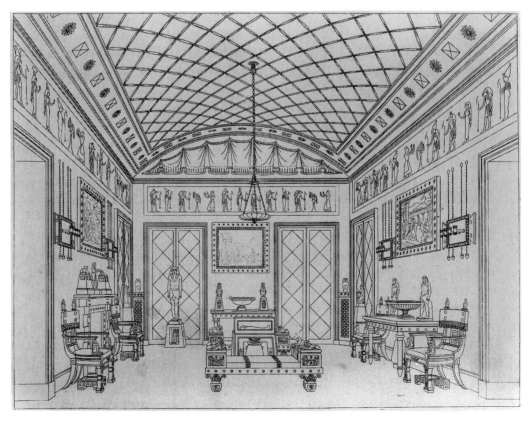

145. Thomas Hope. The Egyptian Room, Duchess Street, London, 1807.

146. Thomas Hope. Clock with figure of Isis
from the Flaxman Room, Duchess Street, London.

printselling business (now run by a team of assistants, including his elder son
Francesco, born in 1752), he was developing a highly profitable business in the
restoration of classical antiquities. Connoisseurs and collectors of the late eighteenth
century, such as William Weddell, Sir William Hamilton, and Charles Townley,
expected their acquisitions to be complete even if the degree of restoration was con-
siderably more than they were occasionally led to believe.[47] Piranesi, collaborating
with the antiquary and dealer Gavin Hamilton, and aided by sculptors like the young
Nollekens, Cavaceppi, and Malatesta, was beginning to benefit from a new series of
excavations in the Pantanelo area of Hadrian's Villa, Tivoli.[48] Recent researches into
the history of the Warwick Vase, sold to William Hamilton from Piranesi's show-
rooms, have established that for all its undoubted grandeur, this work was largely a
product of this kind of enterprise.[49] Again with considerable studio assistance,
Piranesi published a series of individual plates of these antiquities (Fig. 148), which
served as advertisements and provided a lucrative source of income from proud own-
ers as well as the dedicatees. Gathered together by 1778 in the publication *Vasi,
Candelabri, Cippi, Sarcofagi*, these handsome etchings not only provide a guide to
the impressive range of the Piranesi firm (in time Laura and Pietro Piranesi were

147. Various designs for ornamental clocks.
Diverse Maniere, 1769.

trained to continue their father's business), but detailed captions serve to indicate the nature of their restoration as well as to locate the sites of the discoveries and their eventual destination in private collections.[50]

Since the Tivoli excavations uncovered a considerable quantity of decorative fragments, Piranesi's capacity for "fantasia" gradually led him to create works where such technical explanations became superfluous if not, indeed, embarrassing. Among the more elaborate was the alleged funerary monument of Augustus Urbanus, featuring a rhyton (Figs. 149 and 150), which was eventually sold to Gustav III of Sweden by Francesco Piranesi in 1785 with other pieces from his father's *museo.*[51]

A particular type of antique confection which possessed a special attraction for Piranesi, and which was to have a considerable influence on other designers, was the ornamental candelabrum. Already these are featured in the preparatory sketch for the altar of the Aventine church (see Fig. 102), and in another sheet of drawings in the Morgan Library, which shows a detailed study for a candelabrum alongside contem-

*Si è dimostrata la Pianta della stessa gran-
dezza del manico per far vedere l'archi-
tettura delle scanalature.*

*Dimostrazione in piana superficie delle foglie,
che adornano il gran corpo del Vaso.*

148. The Warwick Vase. *Vasi,* 1778.

149. Funerary monument of Augustus Urbanus with boar's head rhyton.

porary *concetti* for chimneypieces.[52] A particularly ambitious example which was advertised by an etched plate (Fig. 151) was eventually acquired, together with a companion piece, by the connoisseur Sir Roger Newdigate in May 1775; he then presented them to the University of Oxford (now in the Ashmolean Museum, see Fig. 152).[53] There, these objects were described as providing "a perfect school in themselves, of Sculpture and Architecture."[54] Moreover, it can be shown that these demonstrations of imaginative eclecticism (represented by other surviving sketch designs) were to have considerable impact during the 1770s on innovative furniture designs such as Adam's torchères and candlestands.[55] Similar candelabra by Piranesi were to find their way into the collections of other neoclassical designers and architects. Notable among these, again, was Thomas Hope, who recognized these productions as invaluable stimuli for the faculties of invention.[56]

By the era of Thomas Hope, Percier, and Fontaine, the eclecticism of Neoclassicism, for all its increasing reliance on antiquity as a source of decorative design, had lost its essential spirit of imaginative transposition which had died with Piranesi. However, in comparison with the chaste austerity of the line engravings illustrating classical antiquities in Winckelmann's *Monumenti Inediti* of 1767, the rich pictorial character of the etched plates of Piranesi's *Vasi* continued to offer Regency designers a fund of ideas and motifs for interior decoration. For instance, Henry Holland, architect to the Prince of Wales, sent the young designer Charles Heathcote Tatham to Italy in the early 1790s to gather material for the interiors and furnishings of Carlton House, London. As David Udy has shown, Tatham was among the first to apply antique forms rigorously to contemporary furniture and plate. Significantly, while praising Piranesi in his work *Etchings, representing the Best Examples of Ancient Ornamental Architecture . . .* of 1799, Tatham added that "Fired with a genius which bad[e] defiance to controul [sic], and rejected with disdain the restraints of minute observation, he has sometimes sacrificed accuracy, to what he conceived the richer productions of a more fertile and exuberant mind."[57]

The plates of the *Vasi* offered silversmiths the equivalent of working drawings. Such was particularly the case where several views of the same object existed, as with the marble vase excavated at Tivoli in 1769 and later acquired by the future Marquess of Buckingham for Stowe in Buckinghamshire.[58] This particular work, by means of Piranesi's *Vasi* plates (Fig. 153), was able to be transposed into the silver-gilt Doncaster Racing Cup, executed in 1828 by Rebecca Emes and Edward Barnard (Fig. 154). Many other such instances can be shown in the work of leading silversmiths, for example, Paul Storr and Robert Garrard.[59] They not only used the engraved antiquities to make faithful copies (such as the Warwick Vase reduced in scale to the form of ice pails) but also as a stimulus for fresh invention.

Piranesi's creative influence as a designer, however, was to wane with the advance of the archaeological rectitude of Neoclassicism as promoted by the succes-

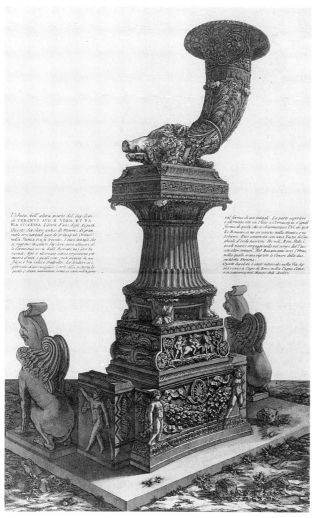

150. Marble funerary monument of Augustus Urbanus
with boar's head rhyton. *Vasi,* 1778.

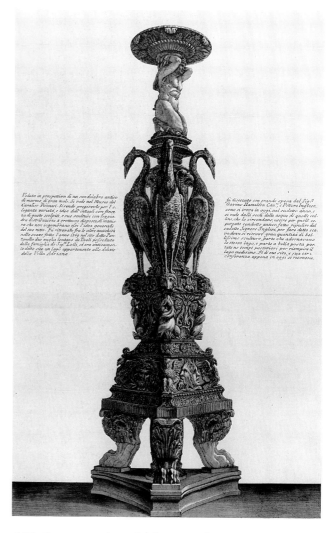

151. Ornamental candelabrum with cranes. *Vasi,* 1778

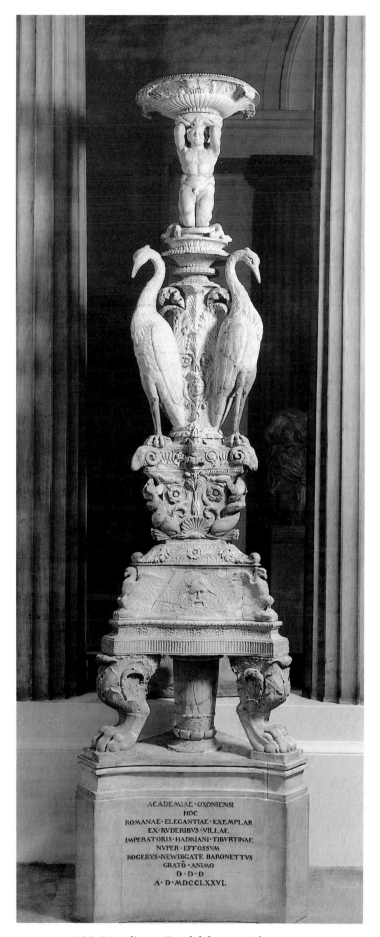

152. Newdigate Candelabrum with cranes.

sors of Winckelmann, yet the impact of his original mode of architectural thinking lasted longer. Apart from designers such as George Dance and Jean-Charles Delafosse, Piranesi's ideas were absorbed by architects who had no direct contact with him except through his widely disseminated etchings. Such was the case with Ledoux and Boullée—two of the most original designers working in France at the end of the century. They shared Piranesi's belief in the prerogative of the architect's imagination to create new forms by pictorial means.[60] To give but two examples, some of the most unusual concepts of Ledoux's *barrières* (toll houses) of 1783 in Paris (Fig. 155) took their starting point from the etched fantasies of the 1760s (see Fig. 49), and Boullée was greatly indebted to similar sources from the 1740s, such as the *Temple of Vesta* (see Fig. 6), for his visionary plans and concepts, evident in the design for a museum, also of 1783 (see Fig. 156).[61]

But as a new academic orthodoxy replaced flights of imagination as the basis of architectural education, a fresh race of theorists was swift to condemn Piranesi's visionary language, both in his etchings and buildings. Francesco Bianconi, a devoted

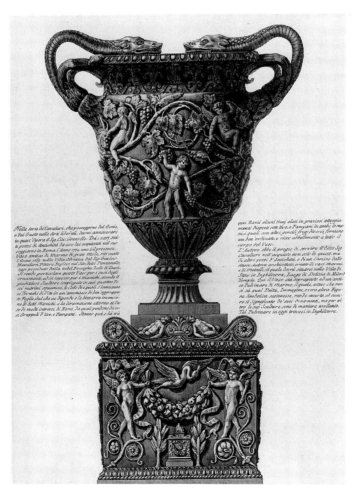

153. Marble vase with vine leaves, cupids, and serpent handles,
supported by a cinerary urn. *Vasi,* 1778.

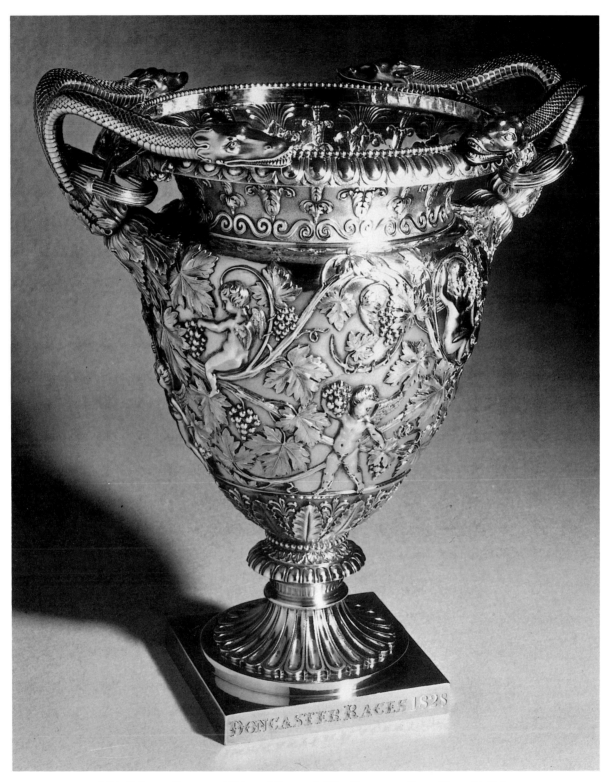

154. Rebecca Emes and Edward Barnard. The Doncaster Race Cup of 1828.

155. Claude-Nicolas Ledoux. Early photograph of the demolished
Barrière des Bonshommes, Paris, erected ca. 1783.

156. Etienne-Louis Boullée. Sectional design for a projected museum, 1783.

follower of Winckelmann, criticized the Aventine buildings when composing Piranesi's obituary in 1779:

> Oh how different is the design from the actual execution of the building! The work turned out to be overloaded with ornaments which, even though taken from antiquity, were not in harmony with one another. The church of the Priorato will certainly please many, as it must above all have pleased Piranesi who always regarded it as a masterpiece, but it wouldn't have pleased either Vitruvius or Palladio if they returned to Rome.[62]

Francesco Milizia, in his book *Roma nelle belle arti del disegno,* some nine years later, could not even bring himself to mention the author of the Aventine buildings by name.[63] And in London by the early years of the nineteenth century, John Soane, professor of architecture at the Royal Academy, cautioned his students as follows:

> That men, unacquainted with the remains of Ancient Buildings, should indulge in licentious and whimsical combinations is not a matter of surprise, but that a man, who had passed all his life in the bosom of Classic Art, and in the contemplation of the majestic ruins of Ancient Rome, observing their sublime effects and grand combinations, a man who had given innumerable examples how truly he felt the value of the noble Simplicity of those buildings, that such a man, with such examples before his eyes, should have mistaken Confusion for Intricacy, and undefined lines and forms for Classical Variety, is scarcely to be believed; yet such was Piranesi.[64]

Ironically, it was largely Soane's contact with Piranesi and his works that made him by 1800 one of the most original designers in Europe. This ambivalence in Soane emphasizes the paradox underlying the nature of Piranesi's achievement. The idiosyncratic nature of his experimental approach to design was completely alien to the grand academic systems deemed necessary to implement progressive nineteenth-century architectural theory.

While studying in Rome in 1778, the twenty-year-old Soane had met Piranesi and subsequently acquired some fifteen preparatory designs for the views of Paestum (Fig. 157), a series of images which ironically was to make a major contribution to the development of the Greek Revival.[65] As his collection grew throughout his house in Lincoln's Inn Fields, London, Soane gradually constructed a sequence of chambers and galleries in which he arranged his heterogenous museum of architectural fragments into a series of Piranesian fantasies, intended both as a source of inspiration and didactic display (Fig. 158).[66] The vast undertaking of reconstructing the Bank of England occupied Soane from 1788 to 1833, during which he evolved a style as personal as that defended in Piranesi's *Parere.* Indeed, with a mind comparable to Piranesi himself—uninhibited by classical conventions and ingenious in structure

and lighting—Soane was to make this complex of buildings the most advanced work of its time (Fig. 159).[67]

In the course of this book, some of the sources, achievements, and immediate influences of Piranesi as an innovative architect and designer have been considered in terms of the visual arts over the last half of the eighteenth century. The legacy of Piranesi's architectural genius through his speculative imagination, however, was to prove of far broader consequence in the literary world of the last two hundred years. A roll call of writers would have to include Balzac, Hugo, Poe, de Musset, Gautier, Melville, Baudelaire, Mallarmé, Proust, and Huxley, to mention only a few of the more prominent. Indeed, it was to take a contemporary poet rather than an aesthetic theorist like Milizia to recognize the analogy of Piranesi's febrile imagery to the phenomenon of endless creation. During the same years that Soane's Bank of England was receiving its complex and original interiors, Thomas de Quincy recalled a memorable conversation with Samuel Taylor Coleridge in which the latter described his first encounter with the *Carceri d'invenzione* (Fig. 160):

157. Preparatory drawing of the Temple of Neptune, Paestum,
for Plate XVII of *Différentes vues...de Pesto,* 1778.

158. Joseph Gandy. View of the crypt in Sir John Soane's house, 1813.

159. Henry Seward after Sir John Soane. Interior perspective
of the 3% Consols Office, Bank of England, London, 1799.

Many years ago, when I was looking over Piranesi's *Antiquities of Rome*, Mr.
Coleridge, who was standing by, described to me a set of plates by that artist,
called his *Dreams,* and which record the scenery of his own visions during
the delirium of a fever. Some of them (I describe only from memory of Mr.
Coleridge's account) represented vast Gothic halls: on the floor of which
stood all sorts of engines and machinery, wheels, cables, pulleys, levers, cata-
pults, &c., &c. expressive of enormous power put forth and resistance over-
come. Creeping along the sides of the walls, you perceived a staircase; and
upon it, groping his way upwards, was Piranesi himself: follow the stairs a lit-
tle further, and you perceive it come to a sudden abrupt termination, without
any balustrade, and allowing no step onwards to him who had reached the
extremity, except into the depths below. Whatever is to become of poor
Piranesi, you suppose, at least, that his labours must in some way terminate
here. But raise your eyes, and behold a second flight of stairs still higher: on
which again Piranesi is perceived, by this time standing on the very brink of
the abyss. Again elevate your eye, and a still more aerial flight of stairs is
beheld: and again is poor Piranesi busy on his aspiring labours: and so on,
until the unfinished stairs and Piranesi are both lost in the upper gloom of
the hall. With the same power of endless growth and self-reproduction did my
architecture proceed in dreams.[68]

160. Prison interior: "The Drawbridge." *Carceri,* 1761 edition, pl. VII.

Notes

1. *Parere su l'Architettura*, 10. Ironically the word *pazzo* is used about Piranesi himself in disparaging comments by the architect Vanvitelli in letters to his brother Urbano; see Chapter 3, note 27.

2. See Pietrangeli 1954; see also Wilton-Ely 1976b, 594-95.

3. Wilton-Ely 1976b, 593. Until recently the bust in the Accademia di San Luca was ascribed also to Angelini.

4. See Chapter 1, note 21. According to Legrand (1799), "Vainement le jeune artiste avait commencé differens travaux d'architecture et de décoration dans l'intérieur des palais de quelques séna-teurs et nobles vénitiens." (See Brunel 1978a, 225.) For the group of Venetian decorative drawings, see Stampfle 1978, x, xxii, nos. 8, 10-14. See also Chapter 1, notes 20 and 21.

5. Stampfle 1978, xxii, nos. 12 (verso), 8, and 10.

6. Watson 1965, 19 ff.; Honour 1969, 146-147; Wilton-Ely 1990b.

7. Praz 1972, 70 ff.; Eriksen 1974, *passim*.

8. For the table and commode designs in the Gahlin collection, see Rieder 1973, 309 ff., figs. 56-58.

9. For the three mirror designs, see Stampfle 1978, xiv, xxx, nos. 107-9.

10. The Earl of Carlisle's letter is quoted in Jesse 1882, 312. For the preparatory study for a coach, see Stampfle 1978, xxix, no. 97. This appears to be an early and possibly rejected sketch (red lines across the drawing suggest this) for the design in *Diverse Maniere* (Focillon 1918, no. 920; Wilton-Ely, 1993, no. 875). Significantly this is drawn on the verso of a fragment of an etching from the same publication.

11. See Chapter 1, note 25.

12. Stampfle 1978, xxx, no. 106; Focillon 1918, no. 923; Wilton-Ely 1993, no. 878

13. Stampfle 1978, xxix, no. 103; Focillon 1918, no. 924; Wilton-Ely 1993, no. 879. According to the inscription on this par-ticular plate, the main clock featured was among a number of objects depicted in other plates of *Diverse Maniere* which were specially produced for Senator Abbondio Rezzonico's apartments in Palazzo Senatorio.

14. See Chapter 4, note 17.

15. See Rieder 1975 and Fischer 1975.

16. For the Hamilton letter originally written in French (October 3, 1767), see Parks 1961, 36, and Chapter 2, note 28. Another similar correspondent was the English antiquary Thomas Hollis (see note 37).

17. Focillon 1918, nos. 861 and 862. The Burghley chimneypiece was probably commissioned during the Earl of Exeter's second visit to Rome in March 1769. (For this latter information I am indebted to Charles Pugh.)

18. Stillman 1977, 86, figs. 2 and 3.

19. Rieder 1975; Stillman 1977, 88-91, figs. 10-15. Among the most closely related drawings in the Morgan Library are Stampfle 1978, xxvii-xxviii, nos. 77 and 85 (Fig. 129 in this book).

20. Scott 1983a.

21. Rowan 1974, 356; Stillman 1977, 91, fig. 16. It cannot be a coincidence that the Adam brothers were remodeling the west front of the house in their Castle style from 1770 to 1778 and could well have advised on the purchase and the installa-tion of the chimneypiece.

22. Stampfle 1978, xxxviii, no. 85; Rieder 1975, 585. A concordance of all known drawings related to the plates of the *Diverse Maniere*, including twelve others in the Morgan Library, is provided in Rieder 1973, 317.

23. For a detailed discussion of Adam's adaptation of Piranesian chimneypiece designs, see Stillman 1966, *passim*; Still-man 1967, 203-6.

24. For Wynn House, see Stillman 1966, 93, figs. 107-8, and for Drummond's Bank see King 1991, 52, fig. 57.

25. Adam's Etruscan rooms in general are discussed in Stillman 1966, *passim*; idem 1967; Wilton-Ely 1989, G1-3.

26. Stampfle 1978, xxiii, no. 21; *Della Magnificenza*, pl. XVIII (upper left, capital labeled "In cavo aedium Farnesianarum"). The dolphin capital found near the Circus Maximus is shown in pl. XVI (second from top in center of plate) and another found near Porta Salaria, in pl. XIX (marked 4).

27. For the Kunstbibliothek design, see Fischer 1975, 173-74, no. 876-77; Focillon [1918], no. 908; Wilton-Ely 1993, no. 850. Dolphins also feature in the design, see Focillon, no. 882; Wilton-Ely, no. 831.

28. Stampfle 1978, xxvi, no. 61.

29. Musée des Arts Décoratifs, Paris (D 21609). Piranesi's impact on Delafosse, particularly his published designs such as the *Nouvelle iconologie historique*, is discussed in Marconi 1978, 315 ff., and Pressouyre 1978, 423 ff. See also Eriksen 1974, *passim*.

30. Stampfle 1978, xxvi, no. 63. Other studies involving this particular motif among the Morgan drawings are nos. 80, 84, and 89.

31. For the drawing in the Cooper-Hewitt Museum, see Wunder 1961, 171-74.

32. For Piranesi's influence on later French and English neoclassical design, see Grandjean 1966; Watkin 1968, 209, 292, note 40. The etched plate of the Hope chimneypiece (Focillon 1918, no. 862; Wilton-Ely 1993, no. 817) shows lit-tle difference from the executed work.

33. Recent research into the original form taken by Piranesi's interiors for Senator Rezzonico is discussed in Pietrangeli 1963. The pen sketch for the setting of an interior (Fischer 1975, 173, no. 873) incor-porates a full-length portrait. The late Anthony M. Clark was unable to identify the overall character of the sketched fig-ure with any known Rezzonico portrait. What may be a preliminary sketch for the chimneypiece in the Berlin drawing is in the Morgan Library, see Stampfle 1978 (xxviii, no. 86), which was worked into a finished *Diverse Maniere* design (Focillon 1918, no. 883; Wilton-Ely 1993, no. 832).

34. See Chapter 4, note 13.

35. Villa Albani and the Marchionni designs in the Cooper-Hewitt Museum are discussed and illustrated in Rykwert 1980, 342-55. For a remarkably thorough contemporary record of the villa, made in drawings by the architect Pierre-Adrien Pâris during the early 1770s (including a view of the salon with the door in ques-tion), see Gruber 1978, 282-88. The archi-tectural history of the villa is examined in Collier 1987, 338-47, n. 28, pls. XXIIIa and b.

36. Stampfle 1978, no. 35. See also Rykwert 1980, 345-48.

37. Piranesi's influence on the European Egyptian revival is considered in Honour 1955, 242 ff.; Pevsner and Lang 1968, 215-16; Wittkower [1967] 1975. See also Wilton-Ely 1978b, 107-11. As in the case of Sir William Hamilton (see note 16), Piranesi appears to have circulated trial proofs of his chimneypiece designs to the London antiquarian Thomas Hollis. Pasted inside the copy of the *Diverse Maniere* presented by Hollis to the Society of Antiquaries on May 25, 1796 (Evans 1956, 126), is a letter from Piranesi of November 18, 1768, in which he asserts: "Vederete in quest'Opera usato ciò che peranche in questo genere non era conosciuto. L'Architettura Egiziana, per la prima volta apparisce; la prima volta, dico, perchè in ora il mondo ha sempre creduto non esservi altro che piramidi, guglie, e giganti, escludendo non esservi parti sufficienti per adornare e sostenere questo sistema d'architettura" (You will see employed in this work something hitherto unknown in the genre. Egyptian architecture appears here for the first time; the first time, because until now the world has always believed that there was nothing in Egypt but pyramids, obelisks, and colossi, and that this system of architecture had insufficient elements to adorn and sustain it), as quoted in Pevsner and Lang 1968, 216.

38. Cabinet des Estampes, Bibliotèque Nationale (Ha, 58f, Vol. VII, Cheminées, fol. 3). See Brunel and Arizzoli 1976, 50.

39. For a discussion of Dance's design for the Lansdowne House Library and the Egyptian chimneypiece, see Stillman 1970, 79-80; idem 1988, I, 276-77; idem 1988, 326, 518-19, fig. 222. The Bayfordbury chimneypiece is discussed in Trevelyan 1972, 308-9, fig. 22, note 34; Tipping 1925, 92-99 and 124-132.

40. Focillon, 1918, nos. 906 and 907; Wilton-Ely 1993, nos. 868 and 869. The Caffè is discussed in the literature referred to in note 37. Vicenzo Rubbigliard exhibited a painting of it at the Royal Academy (no. 303) in 1777, but this is still untraced. See Stainton 1974, no. 14.

41. Oppé 1950, (25), 23.

42. Ford (1946-1948), 54.

43. Watkin 1968, 114-18, figs. 38-40.

44. For the Hope clock, see Wilton-Ely 1978b, 111 (282a).

45. Robert and James Adam, *The Works in Architecture,* 1773, I, pt. IV, pl. 32. A preparatory design (Sir John Soane's Museum) is reproduced in King 1991, 83, fig. 97.

46. In one of the two Gorhambury drawings concerned (see Wilton-Ely 1978b, 114 [289]), the artist includes a monument to one of his business associates, Matthew Nulty, sculptor, cicerone, and antiquarian, who is recorded as acting as an agent for the Walters, who probably acquired these designs as well as the chimneypieces (see Scott 1975, 294, fig. 343).

47. The world of sculpture restoration and dealing is discussed in Howard 1990, 142-53. On Thomas Jenkins see Ford 1974, 416-25, and James Byers, idem, 446-61. See also Haskell and Penny 1981, *passim,* and Picon 1983.

48. With respect to excavations at Tivoli, see Smith 1984, *passim.*; Scott 1983b, and MacDonald and Pinto 1994.

49. Marks and Blench 1979; Scott 1975, 343-45; idem 1983b.

50. See Wilton-Ely 1978b, 114-16.

51. Geffroy 1896; Kjellberg 1920.

52. See Chapter 4, note 37. For the sheet of drawings, see Stampfle 1978, xxix, no. 92. Sketch designs for candelabra are also found in another Morgan drawing, see idem, xxix, no. 95.

53. The circumstances of Newdigate's acquisition of the two candelabra and their subsequent influence is discussed in McCarthy 1972a.

54. Ibid., 472 (from a letter to Newdigate from George Horne of Magdalen College, Oxford, February 20, 1777).

55. See Stillman 1966, *passim*; Wilton-Ely 1978a 113-16; idem 1978b, 106 (272).

56. Watkin 1968, 171, fig. 65. Two marble candelabra from Hope's Deepdene collection are now in the Lady Lever Art Gallery, Port Sunlight (I am indebted to Nicholas Penny for drawing attention to them).

57. Charles Heathcote Tatham, *Etchings, Representing the Best Examples of Ancient Ornamental Architecture drawn from the Originals, in Rome and other Parts of Italy during the years 1794, 1795 and 1796* (London, 1799), 1; Udy 1971, 269. Proudfoot and Watkin 1972, 1481-84. See also Penny 1978, 14.

58. (For the marble "Buckingham Vase," now in the Los Angeles County Museum of Art, I am indebted to the archivist of Stowe School, Michael Bevington, for this information) see Vermeule 1981, 204, fig. 169; Scott 1983a, 53. The Doncaster Cup is discussed in Wilton-Ely 1978b, 120 (316).

59. Udy 1978, 820-37.

60. Piranesi's varied and far-reaching impact on French eighteenth-century architects, especially Ledoux and Boullée, is examined in Conard 1978, 162-75, and other contributions to the Rome colloquium of 1976 (see Brunel 1978a); see also Braham 1980, *passim.*

61. For Ledoux see Gallet 1980. See also Chapter 2, note 14. For Boullée see Pérouse de Montclos 1969, 178.

62. Bianconi 1779 [1802], 133-34.

63. Milizia, *Roma nelle belle arti del disegno* (Bassano, 1787), 197.

64. Soane 1929, 131; Wilton-Ely 1988.

65. For the uncertain circumstances relating to Soane's acquisition of the fifteen Paestum drawings, see McCarthy 1972b. Soane's early years in Italy and relationship with Piranesi are covered in du Prey 1982.

66. This Piranesian aspect of Soane's arrangement of his collection was first indicated in Saxl and Rudolf Wittkower 1948, sec. 75. See also contemporary illustrations reproduced in Summerson, Watkin, and Mellinghoff 1983, 24 ff.

67. Summerson, in Summerson, Watkin, and Mellinghoff 1983, 11 ff. (For the attribution to Henry Seward I am indebted to Christine Scull, librarian of Sir John Soane's Museum, London.)

68. De Quincey [1821] 1971, 105-6.

List of Illustrations

Works in the Pierpont Morgan Library collection were photographed by David A. Loggie. Discrepancies in dates of various Piranesi editions between the photo captions and the list of illustrations below are due to the fact that later nineteenth-century editions have served as sources for photographs, whereas the captions remain faithful, in the name of scholarly precision, to the original editions.

44. Technical diagrams showing the drainage outlet, or *emissarium*, of Lake Albano and its supposed construction. *Descrizione e Disegno dell'Emissario del Lago Albano*, 1762. British Library

45. View of tunnel entrance of the *emissarium*. *Descrizione e Disegno dell'Emissario del Lago Albano*, 1762. British Library

46. Prison interior: "The well." *Carceri*, 1761 edition, pl. XIII. British Library

47. George Dance the Younger. The Debtor's Door, Newgate Prison, London, 1769-78 (photo: Royal Commission on the Historical Monuments of England, BB77/2803; Copyright: B.T. Batsford Ltd.)

48. Additional plate, "The man on the rack." *Carceri*, 1761 edition. British Library

49. Fantasy composition featuring the remains of ancient baths with Greek Doric columns. *Opere Varie*, after 1760. British Library

50. Architectural fantasy with monumental portico before a palace, ca. 1763. Pen and brown ink and wash over red chalk. Biblioteca Comunale dell'Archiginnasio, Bologna, 7/1190

51. Title page of *Osservazioni sopra la lettre de M. Mariette*, 1765 (detail). British Library

52. Tailpiece with imaginary architectural composition. *Parere su l'architettura*, 1765. British Library

53. Study for imaginary architectural composition in the style of plates added to the *Parere* after 1767. Pen and brown ink with wash over red and black chalk outline. British Museum, 1908-6-16-44

54. Imaginary architectural composition with quotation from Sallust, added to the *Parere* after 1767. British Library

55. James Adam. Design of a lion and unicorn capital for a British order, 1762. Pen and ink with watercolor. Avery Architectural and Fine Arts Library, Columbia University in the City of New York

56. Piranesi after Robert Adam. Longitudinal section of entrance hall, Syon House, Middlesex. *The Works in Architecture of Robert and James Adam*, II, 1779. British Architectural Library, RIBA, London

57. Study of antique capital with confronted sphinxes from Villa Borghese for *Della Magnificenza ed Architettura de' Romani*, 1761, pl. XIII. Red chalk over black chalk, 90 x 139 mm. The Pierpont Morgan Library, bequest of Junius S. Morgan and gift of Henry S. Morgan, 1966.11:19

58. Detail from the view of the main fountain of the Acqua Felice showing the Egyptian lions. *Vedute di Roma*, ca. 1760 (photo: The Pierpont Morgan Library, *Opere Varie*, XVI, PML 45370)

59. Comparative diagram showing "Etruscan" vases and shell forms. *Diverse Maniere*, 1769. Collection: Simon Houfe

60. Chart of inventions attributed by Piranesi to the Etruscans. *Diverse Maniere*, 1769. Collection: Simon Houfe

61. Design for chimneypiece, with flanking chairs, involving Etruscan motifs. *Diverse Maniere*, 1769. Collection: Simon Houfe

62. Piranesi with Domenico Cunego. Portrait of Clement XIII. *Della Magnificenza ed Architettura de' Romani*, 1761. British Library

63. View of the nave looking west toward the high altar. *Vedute di Roma*, ca. 1770 (photo: The Pierpont Morgan Library, *Opere Varie*, XVI, PML 45370)

64. View of the east front of S. Giovanni in Laterano. *Vedute di Roma*, mid 1770s. British Architectural Library, RIBA, London

65. Plan and section of proposed tribune looking west, Presentation drawing (Tavola 4). Pen and gray ink with brown ink. Avery Architectural and Fine Arts Library, Columbia University in the City of New York

66. Preliminary sectional study for the tribune (for Tavola 5) showing south wall of sanctuary. Pen and dark brown ink with india ink washes over pencil, 347 x 388 mm. The Pierpont Morgan Library, bequest of Junius S. Morgan and gift of Henry S. Morgan, 1966.11:57

67. Preliminary study for a longitudinal section of the tribune (for Tavola 3) showing the south wall of the sanctuary and transept. Pen and brown ink with wash and traces of pencil, 320 x 545 mm. The Pierpont Morgan Library, bequest of Junius S. Morgan and gift of Henry S. Morgan 1966.11:56

68. Plan and section of proposed tribune for the ambitious third scheme looking west toward the sanctuary (Tavola 7). Pen and gray ink with additions in brown ink. Avery Architectural and Fine Arts Library, Columbia University in the City of New York

69. Preliminary sectional study (detail) for Tavola 8 (Fig. 70) of third scheme showing longitudinal section with south wall of sanctuary and part of the transept. Pen and brown ink over pencil with brown and gray washes, 534 x 1481 mm. The Pierpont Morgan Library, bequest of Junius S. Morgan and gift of Henry S. Morgan, 1966.11:55

70. Longitudinal section of the third scheme showing south wall of sanctuary with transept and beginning of nave (Tavola 8). Pen and gray ink over pencil with gray wash and touches of brown ink. Avery Architectural and Fine Arts Library, Columbia University in the City of New York

71. Elevation of the third scheme looking east, showing the colonnade separating the ambulatory from the presbytery (Tavola 10). Pen and gray ink over pencil with brown ink. Strongly illusionistic features and vignette subsequently added by Piranesi. Avery Architectural and Fine Arts Library, Columbia University in the City of New York

99. The high altar (photo. Gabinetto Fotografico Nazionale, Rome)

100. Carlo Marchionni. Projected design for high altar of S. Maria del Priorato. Pen and brown ink. Cooper-Hewitt Museum, New York, 1938.88.4193

101. Attributed to Piranesi. Preparatory sketch for figure group of an altar. Pen and brown ink. Private collection, New York

102. Preliminary compositional sketch for the high altar, flanked by candelabra. Pen and brown ink, 118 x 117 mm. The Pierpont Morgan Library, 1952.26

103. Preparatory study for the high altar. Black chalk with pen and ink. Kunstbibliothek, Berlin, Hdz 6331

104. Detail of the high altar (photo: Gabinetto Fotografico Nazionale, Rome)

105. Compositional diagram of the high altar (from Pediconi 1956)

106. Detail of column capital with Rezzonico eagle (photo: Gabinetto Fotografico Nazionale, Rome)

107. Detail of sanctuary vault with reliefs depicting scenes from the Life of the Baptist surrounding the oculus (photo: Gabinetto Fotografico Nazionale, Rome)

108. Central relief panel of nave vault symbolizing the naval history of the Maltese order with stucco decorations executed by Tommaso Righi (photo: Gabinetto Fotografico Nazionale, Rome)

109. Design for central relief panel of nave vault. Pen and brown ink, india- ink wash over black chalk, 532 x 317 mm. The Pierpont Morgan Library, bequest of Junius S. Morgan and gift of Henry S. Morgan, 1966.11:50

110. Detail of relief panel of nave vault (photo: Gabinetto Fotografico Nazionale, Rome)

111. Francesco Borromini. Compositional capriccio, incorporating medieval fragments, of the tomb of Pope Sergius IV (d. 1012) in S. Giovanni in Laterano, after 1655 (photo: Gabinetto Fotografico Nazionale, Rome)

112. Detail of the tomb of Admiral Frà Sergio Seripando (d. 1465) showing Piranesi's ornamental reliefs involving naval symbols (photo: Gabinetto Fotografico Nazionale, Rome)

113. Pietro Labruzzi. Portrait of Piranesi, ca. 1778. Oil, 74 x 72 cm. Museo di Roma, Palazzo Braschi (photo: Gabinetto Fotografica Nazionale, Rome)

114. Sketch design for part of a table. Pen and brown ink over traces of red chalk. Victoria and Albert Museum, London

115. Study for a title page incorporating a design for a pulpit. Pen and golden-brown wash over black chalk, 508 x 750 mm. The Pierpont Morgan Library, bequest of Junius S. Morgan and gift of Henry S. Morgan, 1966.11:8

116. Side table for Cardinal Giovambattista Rezzonico with clock, urns, and sconces (including sconce related to a design in Fig. 120). *Diverse Maniere*, 1769. Collection: Simon Houfe

117. Bronze tripod from the Temple of Isis, Pompeii. *Vasi, Candelabri, Cippi, Sarcofagi*, 1778. British Library

118. Design for a coach. Pen and brown ink with cancellation marks in red chalk, 131 x 138 mm. The Pierpont Morgan Library, bequest of Junius S. Morgan and gift of Henry S. Morgan, 1966.11:97

119. Detail of coach from view of Piazza di S. Pietro. *Vedute di Roma*, ca. 1771-73 (photo: The Pierpont Morgan Library, *Opere Varie*, XVI, PML 45370)

120. Design for sconces. Red chalk over black, 234 x 132 mm. The Pierpont Morgan Library, bequest of Junius S. Morgan and gift of Henry S. Morgan, 1966.11:106

121. Design for a clock in the form of a pineapple. Red chalk over black, 115 x 62 mm. The Pierpont Morgan Library, bequest of Junius S. Morgan and gift of Henry S. Morgan, 1966.11:103

122. Large clock for Senator Abbondio Rezzonico with other clocks (including the pineapple design of Fig. 121) and urns. *Diverse Maniere*, 1769. Collection: Simon Houfe

123. Chimneypiece design for the 9th Earl of Exeter (see color plate 7). *Diverse Maniere*, 1769 (photo: The Pierpont Morgan Library, PML 12611)

124. Chimneypiece design for John Hope. *Diverse Maniere*, 1769 (photo: The Pierpont Morgan Library, PML 12611)

125. Chimneypiece for John Hope (detail). Marble. Rijksmuseum, Amsterdam, 13/18:5430

126. Chimneypiece in the drawing room at Gorhambury House, St. Albans, Hertsfordshire, early 1770s. White marble with inset reliefs in rosso antico. Courtesy of the Earl of Verulam (photo: Courtauld Institute of Art, London)

127. Chimneypiece in the drawing room at Wedderburn Castle, Berwickshire, Scotland, ca. 1774. White marble with inset reliefs and cameos of rosso antico (photo: *Country Life*)

128. Plate with two chimneypiece designs: the upper with figurative reliefs on lintel and stiles; the lower with maritime symbols and bucranea on lintel. *Diverse Maniere*, 1769 (photo: The Pierpont Morgan Library, 12611)

129. Design for a chimneypiece with cameos and panels containing figurative reliefs. Pen and brown ink over black chalk, 246 x 340 mm. The Pierpont Morgan Library, bequest of Junius S. Morgan and gift of Henry S. Morgan, 1966.11:85

130. Robert Adam. Chimneypiece in the first drawing room at Wynn House, 20 St. James's Square, London, ca. 1772-74. White marble (photo: Courtauld Institute of Art, London)

131. Robert Adam. Etruscan dressing room, Osterley Park, Middlesex, with painted decorations attributed to Pietro Maria Borgnis and Antonio Zucchi, ca. 1775. Courtesy of the National Trust (photo: A. F. Kersting)

Bibliography

Alfieri 1979
Massimo Alfieri. "Il complesso del Priorato all'Aventino," in P. Santoro et al., eds., *Piranesi nei Luoghi di Piranesi.* Rome 1979, 4-23.

Andrews 1968
Keith Andrews. *National Gallery of Scotland* [Edinburgh], *Catalogue of Italian Drawings.* 2 vols. London, 1968.

Bacou 1971
Roseline Bacou, ed. *Venise aux Dix-Huitième Siècle* (drawings). Exhibition catalogue. Paris, Orangerie des Tuileries, 1971.

Bassi 1962
Elena Bassi. *Architettura del Sei e Settecento a Venezia.* Naples, 1962.

Bertelli 1976a
Carlo Bertelli. "Un progetto per 'Poets' Corner' e una picca all' Accademia—Lettera di Piranesi a Mengs," *Grafica* 2 (1976), 117-23.

Bertelli 1976b
_____ . "Visita a Santa Maria del Priorato (S. Maria Aventina)," *Paragone* XXVII, 317-19 (1976), 180-88.

Bettagno 1978a
Alessandro Bettagno, ed. *Piranesi. Incisioni, rami, legature, architetture.* Bicentenary exhibition catalogue. Venice, Fondazione Giorgio Cini, 1978.

Bettagno 1978b
_____ . *Piranesi. Disegni.* Exhibition catalogue no. 41. Venice, Istituto di Storia dell'Arte, Fondazione Giorgio Cini, 1978.

Bettagno 1983
_____ , ed. *Piranesi tra Venezia e l'Europa.* Conference proceedings, Istituto di Storia dell'Arte, Fondazione Giorgio Cini, Venice, 1978; Florence, 1983.

Bianconi [1779] 1976
Gian Lodovico Bianconi. "Elogio Storico del Cavaliere Giambattista Piranesi," *Antologia Romana* 31-36 (Rome, February-March, 1779). Reprinted in Bianconi, *Opere* II, 127-40, Milan, 1802, and more recently in *Grafica* 2 (1976) 127-35.

Blunt 1979
Anthony Blunt. *Borromini.* London, 1979.

Boëthius and Ward-Perkins 1970
Axel Boëthius and J[ohn] B[ryan] Ward-Perkins. *Etruscan and Roman Architecture.* Harmondsworth, 1970.

Bottarelli and Monterisi 1940
Gottardo Bottarelli and Mario Monterisi. *Storia politica e militare del Sovrano Ordine di S. Giovanni di Gerusalemme detto di Malta.* 2 vols., Milan, 1940.

Braham 1978
Alan Braham. "Piranesi as Archaeologist and French Architecture in the Late Eighteenth Century," in Brunel 1978a, 67-76.

Braham 1980
Alan Braham. *The Architecture of the French Enlightenment.* London, 1980.

Brauer 1961
Heinrich Brauer. "Giovanni Battista Piranesi Verwirklicht einen Traum: Eine Zeichnung zum St. Basilius-Altar in Sta. Maria del Priorato," *Miscellanea Bibliothecae Hertzianae* (1961), 474-77.

Brunel and Arizzoli 1976
Georges Brunel and Pierre Arizzoli, eds. *Piranèse et les Français, 1740-1790.* Exhibition catalogue. Rome, Académie de France à Rome, Villa Medici; Dijon, Palais des Etats de Bourgogne; and Paris, Hôtel de Sully, 1976.

Brunel 1978a
Georges Brunel, ed. *Piranèse et les Français, 1740-1790.*
Rome: conference proceedings, Académie de France à Rome,
Villa Medici (1976), 1978.

Brunel 1978b
_____. "Recherches sur les débuts de Piranèse a Rome: Les
Frères Pagliarini et Nicola Giobbe," in Brunel 1978a, 77-146.

Brusatin 1969
Manlio Brusatin, ed. *Illuminismo e architettura del '700
veneto.* Exhibition catalogue. Palazzo del Monte, Comune di
Castelfranco Veneto, Treviso, 1969.

Burney 1969
Charles Burney. *Music, Men and Manners in France and
Italy.* London, 1770; 1969 ed.

Caetani-Lovatelli 1897
Ersilia Caetani, contessa Lovatelli. "L'Armilustrium sull
'Aventino'," *Scritti Vari.* Rome, 1897, 178 ff.

Calvesi 1965
Maurizio Calvesi. "Architettura Fantastica—Giovanni
Battista Piranesi," *Restauri d'Arte in Italia.* Rome, 1965.

Calvesi 1967
_____. *Giovanni Battista e Francesco Piranesi.* Exhibition
catalogue. Rome, Calcografia Nazionale, 1967.

Cavicchi and Zamboni 1983
Adriano Cavicchi and Silla Zamboni, "Due `taccuini' inediti
di Piranesi," in Bettagno 1983, 177-216.

Clark 1965
Anthony M. Clark. "Brief Biography of Cardinal Giovanni
Battista Rezzonico," in *Minneapolis Institute of Arts Bul-
letin,* LIV (1965), 30-31.

Cochetti 1955
Lorenza Cochetti. "L'opera teorica di Piranesi," *Commentari*
6 (1955), 35-49.

Collier 1987
William O. Collier, "The Villa of Cardinal Alessandro
Albani, Hon. FSA," *Antiquaries Journal,* LXVII, pt. II (1987),
338-47.

Conard 1978
Serge Conard. "De L'Architecture de Claude-Nicolas Ledoux,
considérée dans ses rapports avec Piranèse," Brunel 1978a,
161-80.

Contardi and Curcio 1991
Bruno Contardi and Giovanna Curcio, eds. *In Urbe Architec-
tus: Modelli, Disegni, Misure: La professione dell'architetto,
Roma, 1680-1750.* Exhibition catalogue. Rome, Museo
Nazionale di Castel Sant'Angelo, 1991.

Cook 1985
B[rian] F[rancis] Cook. *The Townley Marbles.* London,
British Museum, 1985.

Craig 1948.
Maurice James Craig. *The Volunteer Earl, Being the Life and
Times of James Caulfield, First Earl of Charlemont.* London,
1948.

Croft-Murray 1968
Edward Croft-Murray, ed. *Giovanni Battista Piranesi: His
Predecessors and His Heritage.* Exhibition catalogue. Lon-
don, British Museum, 1968.

Crook 1972
Joseph Mordaunt Crook. *The Greek Revival.* London, 1972.

Crous 1933
Jan Willem Crous. "Florentiner Waffenpfeiler und Armilus-
trium," *Mitteilungen des deutschen archäologischen Insti-
tuts,* Römische Abteilung XLVIII (1933), 1-119. ff.

Den Broeder 1991
Frederick A. Den Broeder, ed. *Old Master Drawings from the
Collection of Joseph F. McCrindle.* Exhibition catalogue. The
Art Museum, Princeton University, 1991.

De Quincey [1821] 1971
Thomas De Quincey. *Confessions of an English Opium
Eater,* 1821, Alethea Hayter, ed. Harmondsworth, 1976.

De Seta 1981
Cesare De Seta. *Architettura, Ambiente e Società a Napoli
nel '700.* Turin, 1981.

De Seta 1983
_____. *Luigi Vanvitelli e Giovan Battista Piranesi: un
ipotesi integrativa del ruolo sociale dell'artista a metà sette-
cento,* in Bettagno 1983, 103-25.

Di Castro 1961
E. Di Castro. "Giovanni Battista Piranesi e i mobili del Sette-
cento romano," *L'Urbe* 2 (1961), 23-28.

Donati 1950
Lamberto Donati. "Giovanni Battista Piranesi e Lord
Charlemont," *English Miscellany Rome* 1 (1950), 321-42.

Du Prey 1982
Pierre de la Ruffinière du Prey. *John Soane: The Making of an Architect.* Chicago, 1982.

Eisenstein 1976
Sergei M. Eisenstein. "Piranèse ou la fluidité des formes," *La non-indifférente nature* 1, Paris (1976), 211-38.

Eitner 1971
Lorenz Eitner, comp. *Neoclassicism and Romanticism, 1750-1850, Sources and Documents.* London, 1971.

Eriksen 1974
Svend Eriksen. *Early Neo-classicism in France.* London, 1974.

Evans 1956
Joan Evans. *A History of the Society of Antiquaries.* London, 1956.

Fasolo 1956
Vicenzo Fasolo. "Il Campo Marzio di G. B. Piranesi," *Quaderni dell'Istituto di Storia dell'Architettura* 15 (1956), 1-14.

Fischer 1968a
Manfred F. Fischer. "Die Umbaupläne des G. B. Piranesi für den Chor von S. Giovanni in Laterano, Rom," *Münchner Jahrbuch der bildenden Kunst* 19 (1968), 207-8.

Fischer 1968b
_____ . "Piranesis Projekte für den Neubau des Chores von S. Giovanni Laterano," *Kunstchronik* 21, no. 12, (1968), 378.

Fischer 1975
Marianne Fischer. "Piranesis radiertes Oeuvre und die zuge-hörigen Entwürfe in der Kunstbibliothek," *Berliner Museen* XVI, no. 2 (1966) 17-24. Expanded into author's catalogue in *Italienische Zeichnungen der Kunstbibliothek Berlin. Architectur und Dekoration 16. bis 18. Jahrhundert,* ed. S. Jacob. Berlin, 1975, 169-77.

Fleming 1962
John Fleming. *Robert Adam and His Circle in Edinburgh and Rome.* London, 1962.

Focillon 1918
Henri Focillon. *Giovanni-Battista Piranesi, Essai de catalogue raisonné de son oeuvre.* Paris, 1918. Reprint ed. Mayenne, 1964.

Focillon [1918] 1967
_____ . *Giovanni-Battista Piranesi,* Paris, 1918, new ed., Paris, 1928; reprint Paris, 1963; translated into Italian by Guiseppe Guglielmi with additions by eds. Maurizio Calvesi and Augusta Monferini, Bologna, 1967.

Ford 1946-48
Brinsley Ford, ed. "The Memoirs of Thomas Jones," *Walpole Society* 32 (1946-48).

Ford 1974
Brinsley Ford. "Six Notable English Patrons in Rome," *Apollo* 94 (June 1974), 408-61.

Gallet 1980
Michel Gallet. *Claude-Nicolas Ledoux.* Paris, 1980.

Gavuzzo-Stewart 1971
Silvia Gavuzzo-Stewart. "Nota sulle Carceri piranesiane," *L'Arte* 15-16 (1971), 56-74.

Geffroy 1896
A. Geffroy. "Essai sur la formation des collections d'antiques de la Suède," *Revue Archéologique* XXX (1896).

González-Palacios 1969
Alvar González-Palacios. *Il mobile nei secoli—Italia,* vol. 3, Rome, 1969.

González-Palacios 1976
_____ . "I Mani del Piranesi," *Paragone* 315 (1976), 33-48.

González-Palacios 1984
_____ . *Il Tempio del Gusto. Le Arti decorativi in Italia fra classicismi e barocco: Roma e il regno delle Due Sicilie.* Milan, 1984, I, 110, 113-48; II, 102-36.

Gotch 1951
Christopher Gotch. "The Missing Years of Robert Mylne," *Architectural Review* CX (September 1951), 179-82.

Grandjean 1966
Serge Grandjean. *Empire Furniture, 1800 to 1825.* London, 1966.

Gruber 1978
Alain-Charles Gruber. "La Villa Albani vue par un artiste du XVIIIe siècle," in Brunel 1978a, 282-88.

Harris 1967
John Harris. "Le Geay, Piranesi and International Neoclassicism in Rome, 1740-1750," in *Essays in the History of Art Presented to Rudolf Wittkower.* London: eds. Douglas Fraser, Howard Hibbard, and Milton J. Lewine, 1967, 189-96.

Harris 1970
_____ . *Sir William Chambers, Knight of the Polar Star.* London, 1970.

Haskell [1963] 1980
Francis Haskell. *Patrons and Painters: A Study in the Relations between Italian Art and Society in the Age of the Baroque.* 1963, 2nd rev. ed., New Haven, 1980.

Haskell and Penny 1982
Francis Haskell and Nicholas Penny. *Taste and the Antique: The Lure of Classical Sculpture, 1500-1900.* New Haven, 1981, rev. ed. 1982.

Hermanin 1922
Federico Hermanin. *Giambattista Piranesi: Architetto ed Incisore.* Turin, 1915. 2nd ed., Rome, 1922.

Herrmann 1962
Wolfgang Herrmann. *Laugier and Eighteenth-Century French Theory.* London, 1962.

Hind 1978
Arthur Hind. *Giovanni Battista Piranesi: A Critical Study with a List of His Published Works and Detailed Catalogues of the Prisons and the Views of Rome.* London, 1922, reprinted 1978.

Hodgkinson 1958
Terence Hodgkinson. "Christopher Hewetson, an Irish Sculptor in Rome," *Walpole Society* XXXIV, 1952-54 (1958), 42 ff.

Honour 1955
Hugh Honour. "The Egyptian Taste," *Connoisseur* 135 (May 1955), 242-46.

Honour 1968
_____ . *Neo-classicism.* Harmondsworth, 1968.

Honour 1969
_____ . *Cabinet Makers and Furniture Designers.* London, 1969.

Howard 1990
Seymour Howard. *Antiquity Restored: Essays on the Afterlife of the Antique.* Vienna, 1990.

Irwin 1962
David Irwin. "Gavin Hamilton. Archeologist, Painter and Dealer," *Art Bulletin* 44 (1962), 87-102.

David Irwin 1972
David Irwin, ed. *Winckelmann, Writings in Art.* London, 1972.

Jackson-Stops 1985
Gervase Jackson-Stops, ed. *The Treasure Houses of Britain: Five Hundred Years of Private Patronage and Art Collecting.* Exhibition catalogue. National Gallery of Art, Washington. Washington and New Haven, 1985.

Jesse 1882
John Heneage Jesse. *George Selwyn and His Contemporaries.* London, 1882.

Jones 1912
H. Stuart Jones, ed. *A Catalogue of the Ancient Sculpture Preserved in the Municipal Collections of Rome, Vol. I - The Sculptures of the Museo Capitolino.* Oxford, 1912.

Justi 1923
Carl Justi. *Winckelmann und seine Zeitgenossen.* 3 vols., Leipzig, 1923 ed.

Kaufmann 1955
Emil Kaufmann. "Piranesi, Algarotti and Lodoli. A controversy in 18th-century Venice," *Gazette des Beaux-Arts* 46 (1955), 21-28.

Kennedy 1831
James Kennedy. "Life of the Chevalier Giovanni Battista Piranesi," in *Library of the Fine Arts or Repertory of Painting, Sculpture, Architecture and Engravings,* vol. 2, no. 7, London, 1831, 8-13.

King 1991
David King. *The Complete Works of Robert and James Adam.* Oxford, 1991.

Kimball 1958
Fiske Kimball. "Piranesi, Algarotti and Lodoli," in *Essays in Honour of Hans Tietze.* New York, 1958, 309-16.

Kjellberg 1920
Ernst Kjellberg. "Piranesis antiksamling i Nationalmuseum," *Nationalmusei Årsbock,* Stockholm 2 (1920), 156-69.

Körte 1933
Werner Körte. "Giovanni Battista Piranesi als praktischer Architekt," *Zeitschrift für Kunstgeschichte* 2 (1933), 16-33.

Lang 1950
Suzanne Lang. "The Early Publications of the Temples at Paestum," *Journal of the Warburg and Courtauld Institutes* 13 (1950), 48-64.

Laugier [1753] 1977
Marc-Antoine Laugier. *An Essay on Architecture* [1753], trans. by Wolfgang and Anni Herrmann. Los Angeles, 1977.

Legrand 1799

Jacques Guillaume Legrand. *Notice sur la vie et les Ouvrages de J. B. Piranesi ... Redigée sur les notes et les pièces communiqueés par ses fils, les Compagnons et les Continuateurs de ses nombreaux travaux.* Paris, 1799, Bibliothèque Nationale 1020, nouv. acq. fr. 5968. Transcribed in Gilbert Erouart and Monique Mosser, "A prepos de la `Notice historique sur la vie et les ouvrages de J.-B. Piranesi': origine et fortune d'une biographie," in Brunel 1978a, 213-56.

Lewis 1961

Lesley Lewis. *Connoisseurs and Secret Agents in 18th Century Rome.* London, 1961.

Lo Bianco 1983

Anna Lo Bianco, ed. *Piranesi e la Cultura Antiquaria: gli Antecedenti e il Contesto.* Rome: Conference proceedings, Comune di Roma and Istituto Storia dell'Arte, Università degli Studi di Roma (1979), 1983.

London 1972

London, Arts Council of Great Britain. *The Age of Neoclassicism.* Exhibition catalogue. London, Royal Academy of Arts (Fine Arts and Architecture) and the Victoria and Albert Museum (Decorative Arts), 1972.

Lugari 1896

Giovanni Battista Lugari. *L'Aventino e le origini pagane e cristiane di Roma.* Dissertazioni della Pontif. Accad. di Archeol., II, VI, Rome, 1896.

McCarthy 1972a

Michael McCarthy. "Sir Roger Newdigate and Piranesi," *Burlington Magazine* 114 (July 1972), 466-72.

McCarthy 1972b

_____ . "Documents of the Greek Revival in architecture," *Burlington Magazine* 114 (November 1972), 760-68.

McCarthy 1986

_____ . "The Theoretical Imagination in Piranesi's Shaping of Architectural Reality," *Impulse Magazine* (Toronto) (Winter 1986), 6-12.

McCarthy 1991

_____ . "Thomas Pitt, Piranesi and Sir John Soane: English Architects in Italy in the 1770s," *Apollo* 134 (December 1991), 380-86.

McCormick 1990

Thomas J. McCormick. *Charles-Louis Clérisseau and the Genesis of Neo-Classicism.* Cambridge, Mass., 1990.

McCormick and Fleming 1962

Thomas J. McCormick and John Fleming, "A Ruin Room by Clérisseau," *Connoisseur* 149 (1962), 239-43.

MacDonald 1979

William L. MacDonald. *Piranesi's "Carceri": Sources of Invention.* Twenty-first Katherine Asher Engel Lectures, Smith College. Northampton, Mass., 1979.

MacDonald and Pinto 1994

William L. MacDonald and John Pinto. *Hadrian's Villa and Its Legacy.* Princeton, 1994 (in press).

Marconi 1978

Paolo Marconi. *"Ricerca sulle fonti della cultura d'immagine Piranesiana,"* in Brunel 1978a, 315 ff.

Mariani 1938

Valerio Mariani. *Studiando Piranesi.* Rome, 1938.

Marks and Blench 1979

Richard Marks and Brian J. R. Blench. *The Warwick Vase.* Glasgow, 1979.

Mayor 1952

A. Hyatt Mayor. *Giovanni Battista Piranesi.* New York, 1952.

Meeks 1966

Carroll L. V. Meeks. *Italian Architecture, 1750-1914.* New Haven, 1966.

Melis 1975

Paolo Melis. "G. B. Piranesi: un 'Ampio Magnifico Collegio' per l'architettura. Intenzionalità iconologica in un documento storico dell'illuminismo," *Psicon* 4 (July-October 1975), 85-100.

Mercatelli 1991

M. Mercatelli. "L'architetto si presenta: Note iconografiche su alcuni ritratti nel Secolo XVIII," in Contardi and Curcio 1991, 229-34.

Merlin 1906

Alfred Merlin. *L'Aventin dans l'Antiquité.* Bibliothèque des Ecoles d'Athènes et de Rome, fasc. 97. Paris, 1906.

Messina 1971

Maria Grazia Messina. "Teoria dell'architettura in Giambattista Piranesi: l'affermazione dell'eclettismo," *Controspazio* II, 8/9 (1970), 6-13; III, 6 (1971), 20-28.

Mezzetti and Catelli-Isola 1959

Amalia Mezzetti and Maria Catelli-Isola, eds. *Il Settecento a Roma.* Exhibition catalogue. Rome , 1959.

Michaelis 1882

Adolf Michaelis. *Ancient Marbles in Great Britain.* Cambridge, 1882.

Middleton and Watkin 1980

Robin Middleton and David Watkin. *Neoclassical and 19th-Century Architecture.* London, 1980.

Milizia 1787

Francesco Milizia. *Roma delle belle arti del disegno.* Bassano, 1787.

Millon 1978

Henry A. Millon. "Vasi-Piranesi-Juvarra," in Brunel 1978a, 345-54.

Molajoli 1963

Bruno Molajoli. "Piranesi Architetto," *Bolletino del Centro Internazionale di Studi di Architettura "Andrea Palladio,"* (1963), 212-14.

Montaiglon and Guiffrey 1901

Anatole de Montaiglon and Jules Guiffrey. *Correspondance des Directeurs de l'Académie de France à Rome avec les Surintendants des Bâtiments,* XI, Paris, 1901.

Montini 1959

Renzo Umberto Montini. *S. Maria del Priorato.* Rome, 1959.

Morazzoni 1921

Giuseppe Morazzoni. *Giovan Battista Piranesi, Architetto ed Incisore, 1720-1778.* Rome and Milan, 1921.

Mormone 1952

Raffaele Mormone. "Una lettera dal Vanvitelli al Piranesi," *Bolletino di Storia dell'Arte* (Salerno), no. 2 (1952), 89-92.

Murray 1971

Peter Murray. *Piranesi and the Grandeur of Ancient Rome.* London, 1971.

Nyberg 1972

Dorothea Nyberg, ed. *Giovanni Battista Piranesi. Drawings and Etchings.* Exhibition catalogue. New York, Low Library, Columbia University, 1972.

Nyberg and Mitchell 1975

Dorothea Nyberg and Herbert Mitchell, eds. *The Arthur M. Sackler Collection, Piranesi: Drawings and Etchings at the Avery Architectural Library, Columbia University, New York.* Exhibition catalogue. New York, Columbia University, 1975.

Oechslin 1971

Werner Oechslin. "Pyramide et sphère. Notes sur l'architecture révolutionnaire du XVIIIe siècle et ses sources italiennes," *Gazette des Beaux-Arts* 77 (April 1971), 201-38.

Oppé 1950

Adolf Paul Oppé. *English Drawings, Stuart and Georgian Periods, in the Collection of His Majesty the King at Windsor Castle,* 1950 (25).

Pane 1973

Roberto Pane. "Luigi Vanvitelli - l'uomo e l'artista," *Napoli Nobilissima,* XII, fasc. 1 (1973).

Parks 1961

Robert O. Parks, ed. *Piranesi.* Exhibition catalogue with essays by Philip Hofer, Karl Lehmann, and Rudolf Wittkower. Northampton, Mass., Smith College Museum of Art, 1961.

Pastor 1950

Ludwig von Pastor. *The History of the Popes,* Vol. 36, ed. and trans by E. F. Peeler. St. Louis, 1950.

Pauli 1927

Gustav Pauli. *Zeichnungen Alter meister in der Kunsthalle zu Hamburg. Italiener.* Frankfurt, 1927.

Pediconi 1956

Giulio Pediconi. "Un Particolare Piranesiano," *Quaderni dell' Istituto di Storia dell'Architettura, Roma* 15, (1956), 15-16.

Penny 1978

Nicholas Penny. *Piranesi.* London, 1978.

Pérouse de Montclos 1969

Jean Marie Pérouse de Montclos. *Etienne-Louis Boullée (1728-1799), de l'architecture classique à l'architecture révolutionnaire.* Paris, 1969.

Pevsner 1968

Nikolaus Pevsner. "The Doric Revival," in Pevsner, *Studies in Art, Architecture and Design.* Vol. I, London, 1968.

Pevsner and Lang 1968

Nikolaus Pevsner and Suzanne Lang. "The Egyptian Revival," in Pevsner, *Studies in Art, Architecture and Design.* Vol. I, London, 1968.

Picon 1983

Carlos A. Picon. *Bartolomeo Cavaceppi: 18th-century Restorations of Ancient Marble Sculpture from English Private Collections.* Exhibition catalogue. London, Clarendon Gallery, 1983.

Pietrangeli 1954
Carlo Pietrangeli. "Sull iconografia di G. B. Piranesi," *Bolletino dei Musei Comunali di Roma* 1 (1954), nos. 3-4, 40-43.

Pietrangeli 1963
———. "La Sala Nuova di Don Abbondio Rezzonico," *Capitolium* 38 (1963), 244-46

Portoghesi 1967
Paolo Portoghesi. *Borromini, Architettura come un Linguaggio.* Rome, 1967.

Portoghesi 1982
Paolo Portoghesi. *Roma Barocca.* Rome, 1982.

Praz 1972
Mario Praz. *On Neoclassicism.* London, 1972 (translated from *Gusto Neoclassico.* Florence, 1940).

Praz 1975
Mario Praz, ed. *G. B. Piranesi, Le Carceri.* Milan, 1975.

Pressouyre 1978
Sylvia Pressouyre. "La poétique ornementale chez Piranèse et Delafosse," in Brunel 1978a, 423-34.

Price 1965
R. Price. "Thomas Jenkins in Rome," *Antiquaries Journal* 45 (1965), pt. 2, 200-29.

Proudfoot and Watkin
Christopher Proudfoot and David Watkin. "The Furniture of C. H. Tatham," *Country Life* (June 8, 1972), 1481-84.

Reudenbach 1979
Bruno Reudenbach. *G. B. Piranesi: Architektur als Bild. Der Wandel in der Architekturauffassung des achtzehnten Jahrhunderts.* Munich, 1979.

Reutersvärd 1971
Oscar Reutersvärd. *The Neo-classic Temple of Virility and the Buildings with a Phallic shaped Ground-Plan.* University of Lund, Gleerup [Sweden], 1971.

Rieder 1973
William Rieder. "Piranesi's `Diverse Maniere,'" *Burlington Magazine* 115 (May 1973), 309-17.

Rieder 1975
———. "Piranesi at Gorhambury," *Burlington Magazine* 117 (September 1975), 582-91.

Roach 1978
Joseph R. Roach, Jr. "From Baroque to Romantic: Piranesi's Contribution to Stage Design," *Theatre Survey* 19, no. 2 (1978), 91-118.

Robison 1973
Andrew Robison. "Piranesi's Ship on Wheels," *Master Drawings* 11 (1973), 389-92.

Robison 1977
———. "Preliminary Drawings for Piranesi's Architectural Fantasies," *Master Drawings* 15 (1977), 387-401.

Robison 1986
———. *Giovanni Battista Piranesi: Early Architectural Fantasies: A Catalogue Raisonné of the Etchings.* Chicago and London, 1986.

Rosenblum 1967
Robert Rosenblum. *Transformations in Late Eighteenth Century Art.* Princeton, 1967.

Rowan 1974
Alistair John Rowan. "Wedderburn Castle, Berwickshire," *Country Life* 156 (August 8, 1974), 356.

Ruler 1991
Dick van Ruler. *Verbeeldingen van werelijkheid: Speurtochten vanuit de kerkers van G. B. Piranesi.* 3 vols., Rotterdam, 1991.

Rykwert 1980
Joseph Rykwert. *The First Moderns: The Architects of the Eighteenth Century.* Cambridge, Mass., 1980.

Sambricio 1972
Carlos Sambricio. "Piranesi y el `Parere,'" *Revista de Ideas Estéticas* (1972), 81-101.

Samuel 1910
Arthur Samuel. *Piranesi.* London, 1910.

Santoro et al. 1979
Pasquale Santoro, Renato Flenghi, Giovanna Martinelli, and Cecilia Valli, eds. *Piranesi nei Luoghi di Piranesi.* Exhibition catalogue in 5 vols. (1, *Archeologia piranesiana;* 2, *Camini;* 3, *Carceri;* 4, *Le Antichità del Lazio;* 5, *Rami*). Rome, Comune di Roma and Comune di Cori, 1979.

Saxl and Wittkower 1948
Fitz Saxl and Rudolf Wittkower. *British Art and the Mediterranean.* London, 1948.

Schéfer 1913
Gaston Schéfer. "Giovanni Battista Piranesi, un rénovateur de l'art décoratif," *Les Arts* 11, no. 128 (August 1912), 26-32; 12, no. 136 (April 1913), 18-25. Expanded from Schéfer, "Piranesi, un renouvateur de l'art décoratif," *Gazette des Beaux-Arts,* no. 39 (1897).

Scicluna 1955

Hamilton P. Scicluna. *The Church of St. John in Valletta.* Valletta, 1955.

Scott 1975

Jonathan Scott. *Piranesi.* New York and London, 1975.

Scott 1983a

Jonathan Scott. "Another Chimneypiece by Piranesi," in Bettagno 1983, 51 ff.

Scott 1983b

Jonathan Scott. "Some Sculpture from Hadrian's Villa, Tivoli," in Lo Bianco 1983, 339 ff.

Sekler 1962

Patricia May Sekler. "Giovanni Battista Piranesi's `Carceri' Etchings and Related Drawings," *Art Quarterly* 25, no. 4 (1962), 330-63.

Shaw 1951

James Byam Shaw. *The Drawings of Francesco Guardi.* London, 1951.

Smith 1901

A. H. Smith. "Gavin Hamilton's Letters to Charles Townley," *Journal of Hellenic Studies* 21, no. 2 (1901), 306-21.

Soane 1929

John Soane. *Lectures on Architecture,* ed. by A. T. Bolton. London, 1929.

Stainton 1974

Lindsay Stainton, ed. *British Artists in Rome, 1700-1800.* Exhibition catalogue. London, Iveagh Bequest, Kenwood, 1974.

Stampfle 1948

Felice Stampfle. "An Unknown Group of Drawings by G. B. Piranesi," *Art Bulletin* 30, no. 2 (1948), 122-41.

Stampfle 1949

_____ . *Giovanni Battista Piranesi: Drawings.* Exhibition catalogue. New York, Pierpont Morgan Library, 1949.

Stampfle 1978

_____ . *Giovanni Battista Piranesi: Drawings in the Pierpont Morgan Library.* New York, 1978.

Stillman 1966

Damie Stillman. *The Decorative Work of Robert Adam.* London, 1966.

Stillman 1967

_____ . "Robert Adam and Piranesi," in *Essays in the History of Architecture Presented to Rudolf Wittkower,* ed. by D. Fraser, H. Hibbert, and M. J. Lewine. London, 1967, 197-206.

Stillman 1970

_____ . "The Gallery for Lansdowne House: International Neoclassical Architecture and Decoration in Microcosm," *Art Bulletin* 52 (1970), 79-80.

Stillman 1977

_____ . "Chimney-pieces for the English Market: A Thriving Business in Late Eighteenth-Century Rome," *Art Bulletin* 59 (March 1977), 85-94.

Stillman 1988

_____ . *English Neoclassical Architecture.* 2 vols., London, 1988.

Stroud 1971

Dorothy Stroud. *George Dance, Architect, 1741-1825.* London, 1971.

Summerson, Watkin, and Mellinghoff 1983

John Newenham Summerson, David Watkin, and Tilman Mellinghoff, *John Soane.* London, 1983.

Tafuri 1972

Manfredo Tafuri. "G. B. Piranesi: l'architettura come 'utopia negativa'," *Angelus Novus* 20 (June 1971), 89-127 (republished in Turin, Accademia delle Scienze, *Bernardo Vittone e la disputa fra classicismo e barocco del settecento. Atti del convengo internazionale,* 2, Turin, 1972, 265-319, in English, *Architecture and Utopia,* trans. by Barbara Luigia La Penta. Cambridge, Mass., 1976.

Tafuri 1973

_____ . "Giovan Battista Piranesi: l'utopie négative dans l'architecture," *L'architecture d'aujourd'hui* 184 (March/April 1976).

Tafuri 1978

_____ . "Il Complesso di S. Maria del Priorato sull' Aventina," in Bettagno 1978a, 78-87, figs. 433-83.

Tafuri 1992

_____ . *The Sphere and the Labyrinth: Avant-Gardes and Architecture from Piranesi to the 1970s* (trans. by Pellegrino d'Acierno and Robert Connolly from *La sfera e il labirinto: Avanguardie e l'architettura da Piranesi agli anni '70.* Turin, 1980). Cambridge, Mass., 1992.

Tait 1984
A[lan] A[ndrew] Tait. "Reading the Ruins: Robert Adam and Piranesi in Rome," *Architectural History* 27 (1984), 524-33.

Tatham 1799
Charles Heathcote Tatham. *Etchings, Representing the Best Examples of Ancient Ornamental Architecture: Drawn from the Originals in Rome, and other parts of Italy....* London, 1799.

Teyssot 1974
Georges Teyssot. *Città e utopia nell'Illuminismo inglese: George Dance il Giovane.* Rome, 1974.

Thomas 1954
Hylton Thomas. *The Drawings of Giovanni Battista Piranesi.* London, 1954.

Tipping 1925
H. Avary Tipping. "Bayfordbury," *Country Life* 17/24 (January 1925), 92-99 and 124-32.

Trevelyan 1972
Raleigh Trevelyan. "Robert Fagan: An Irish Bohemian in Italy," *Apollo* 96 (October 1972), 298-311.

Udy 1971
David Udy. "The Neoclassicism of Charles Heathcote Tatham," *Connoisseur* 177 (August 1971).

Udy 1978
_____ . "Piranesi's `Vasi', the English Silversmith and His Patrons," *Burlington Magazine* 120 (December 1978), 820-37.

Varro
Marcus Terentius Varro. *De Lingua Latina.* Venice, 1470.

Vermeule 1953
Cornelius Vermeule. "Sir John Soane: His Classical Antiquities," *Archeology* (1953), 68-74.

Vermeule 1981
_____ . *Greek and Roman Sculpture in America.* Berkeley, 1981.

Vitali 1924
I. Vitali. "Le Quattro `Lettere di Giustificazione' di Piranesi, *Belvedere* 6 (1924), 29-33.

Vogt-Göknil 1958
Ulya Vogt-Göknil. *Giovanni Battista Piranesi: "Carceri."* Zurich, 1958.

Volkmann 1965
Hans Volkmann. *Giovanni Battista Piranesi, Architekt und Graphiker.* Berlin, 1965.

Watkin 1968
David Watkin. *Thomas Hope (1769-1831) and the Neoclassical Idea.* London, 1968.

Watson 1965
Francis J. B. Watson. "A Side Table by Piranesi: A Masterpiece of Neo-classic Furniture," *Minneapolis Institute of Arts Bulletin* 54 (1965), 19-29. Expanded in Watson, "A Masterpiece of Neo-classic Furniture: A Side-table Designed by Piranesi," *Burlington Magazine* 108 (1965), 102.

Wiebenson 1969
Dora Wiebenson. *Sources of Greek Revival Architecture.* London, 1969.

Wilton-Ely 1972
John Wilton-Ely, ed. *Giovanni Battista Piranesi: The Polemical Works. Includes reprints of Lettere di Giustificazione, Della Magnificenza ed Architettura de' Romani. Parere su l'Architettura and Diverse Maniere.* Farnborough, 1972.

Wilton-Ely 1976a
_____ . "Piranesian symbols on the Aventine," *Apollo* 103 (March 1976), 214-27. Republished in *Annales de l'Ordre Souverain Militaire de Malte* 34, nos. 1-2 (January-June 1976), 8-23.

Wilton-Ely 1976b
_____ . "A Bust of Piranesi by Nollekens," *Burlington Magazine* 118 (August 1976), 593-95.

Wilton-Ely 1978a
_____ . *The Mind and Art of Piranesi.* London and New York, 1978.

Wilton-Ely 1978b
_____ . *Piranesi.* Bicentenary exhibition catalogue. London, Arts Council of Great Britain, Hayward Gallery, 1978.

Wilton-Ely 1978c
_____ . "Vision and Design: Piranesi's 'fantasia' and the Graeco-Roman Controversy," in Brunel 1978a, 529-52.

Wilton-Ely 1979
_____ . "The Relationship between Giambattista Piranesi and Luigi Vanvitelli in Eighteenth-Century Architectural Theory and Practice," in *Luigi Vanvitelli e il '700 Europeo,* ed. Cesare De Seta. Naples: conference proceedings, Istituto di Storia dell'Architettura, Università di Napoli (1973), 1979, vol. 2, 83-99.

Wilton-Ely 1983a

_____ . "Utopia or Megalopolis? The 'Ichnographia' of Piranesi's 'Campus Martius' Reconsidered," in Bettagno 1983, 293-304.

Wilton-Ely 1983b

_____ . "Piranesi and the Role of Archeological Illustration," in Lo Bianco 1983, 317-38.

Wilton-Ely 1988

_____ . "Soane and Piranesi" in _Late Georgian Classicism_, eds. Roger White and Caroline Lightburn, London: Symposium papers, The Georgian Group, 1988, 45-57.

Wilton-Ely 1989

_____ . "Pompeian and Etruscan Tastes in the Neo-classical Country House Interior" in _The Fashioning and the Functioning of the British Country House_. ed. Gervase Jackson-Stops. Washington: conference proceedings, National Gallery of Art (1985). Washington and London, 1989, 51-73.

Wilton-Ely 1990a

_____ . "Piranesi." _Arquitectonica_ [Bilbao] 6 (June 1990), 72-102.

Wilton-Ely 1990b

_____ . "Nature and Antiquity: Reflections on Piranesi as a Furniture Designer," _Furniture History_ 26 (1990), 191-97.

Wilton-Ely 1991

_____ . "The Art of Polemic: Piranesi and the Graeco-Roman Controversy," in _La Grecia Antica: Mito e simbolo per l'età della grande rivoluzione..._, ed. Phillippe Boutry et al. Rome: conference proceedings, Dipartimento di Analisi delle Componenti Culturali del Territorio, Università di Salerno (1989), Milan, 1991, 121-30.

Wilton-Ely 1993a

_____ . "Giovanni Battista Piranesi," in _Exploring Rome: Piranesi and His Contemporaries_. Exhibition catalogue. Montreal, Centre Canadien d'architecture, and New York, Pierpont Morgan Library, 1993.

Wilton-Ely 1993b

_____ . _Giovanni Battista Piranesi: A Catalogue of the Complete Etchings_. 2 vols., San Francisco, 1993.

Wilton-Ely and Connors 1992

John Wilton-Ely and Joseph Connors. _Piranesi Architetto: disegni 1764-67_. Exhibition catalogue. Rome, American Academy, 1992.

Wittkower [1938-39] 1975

Rudolf Wittkower. "Piranesi's 'Parere su l'Architettura'," _Journal of the Warburg Institute_ 2 (1938-39), 147-58. Republished as "Piranesi's Architectural Creed" in Wittkower, _Studies in the Italian Baroque_, London, 1975, 235-46.

Wittkower [1957] 1975

_____ . "S. Maria della Salute: Scenographic Architecture and the Venetian Baroque," _Journal of the Society of Architectural Historians_ 16 (1957), 3 ff. Reprinted in Wittkower, _Studies in the Italian Baroque_, London, 1975, 126 ff.

Wittkower [1961] 1975

_____ . "Piranesi as Architect," in _Piranesi_, ed. O. Parks, Smith College, Northampton, Mass., 1961, 99-109. Reprinted in Wittkower, _Studies in the Italian Baroque_, London, 1975, 247-58.

Wittkower [1967] 1975

_____ . "Piranesi e il gusto egiziano," in _Sensibilità e razionalità nel Settecento_, ed. V. Branca. Venice: conference proceedings, Fondazione Giorgio Cini. Florence, 1967, 659-74. Republished as "Piranesi and Eighteenth-Century Egyptomania" in Wittkower, _Studies in the Italian Baroque_, London, 1975, 260-73.

Wittkower 1973

_____ . _Art and Architecture in Italy, 1600-1750_. Harmondsworth and Baltimore, revised 1973.

Wunder 1961

Richard P. Wunder. "Bagatelle and Two Drawings by Bélanger in the Cooper Union," _Connoisseur_ 148 (1961), 171-74.

Wunder 1967

_____ . "A Forgotten French Festival in Rome," _Apollo_ 85 (May 1967), 354 ff.

Wunder 1968

_____ . "Charles M-A. Challe: A Study of His Life and Work," _Apollo_ 87 (January 1968), 22 ff.

Zamboni 1964

Silla Zamboni. "Il percorso di Giovanni Battista Piranesi," _Arte Antica e Moderna_ 25 (1964), 66-85.

Zwollo

Ana Zwollo. _Hollandse en Vlaamse Veduteschilders te Rome, 1675-1725_. Assen, 1973.

Index

185

Index

Piranesi as Architect and Designer

was designed by Sylvia Steiner, Guilford, Connecticut. Southern New England Typographic Service, Hamden, Connecticut, set the text in Trump Mediaeval, designed by Georg Trump in 1953 for the C. E. Weber foundry; the display type is Walbaum, designed by Justus Erich Walbaum in the nineteenth century.

The book was printed by Imprimeries Réunies, Lausanne, Switzerland, on 170 g/sm acid-free Tenero Puro. The jacket is printed on 150 g/sm. acid-free "GS" glossy stock.

Mayer & Soutter, Lausanne, bound the book in Brillianta cloth by Scholko with 170 g/sm Rives Tradition endpapers.